LIVE... SUBURBIA

Anthony Pappalardo
Max G. Morton

pH powerHouse Books

Brooklyn, NY

Live...Suburbia!

Compilation & editing © 2011 Max G. Morton & Anthony Pappalardo
Text © 2011 Max G. Morton & Anthony Pappalardo
Foreword ©2011 Craig Finn

Published in the United States by powerHouse Books,
a division of powerHouse Cultural Entertainment, Inc.
37 Main Street, Brooklyn, NY 11201-1021
Telephone 212.604.9074, fax 212.366.5247
E-mail: livesuburbia@powerhousebooks.com
Website: www.powerhousebooks.com

First edition, 2011

Library of Congress Control Number: 2011930377

Paperback ISBN 978-1-57687-580-3

Printed and bound through Asia Pacific Offset

A complete catalog of powerHouse Books and Limited Editions is
available upon request; please call, write, or visit our website.

10 9 8 7 6 5 4 3 2 1

Printed and bound in China

Live...Suburbia!

Produced and written by Max G. Morton & Anthony Pappalardo
Design and Art Direction – Jeremy Dean
Text Edited by – Alessandra De Benedetti
Additional Copy Editing – Angela Gaimari
Represented by – Alyssa Reuben and Jason Yarn for the Paradigm Agency

Special thanks to featured photographers:
Andy Jenkins
Angela Boatwright
Casey Chaos
Davo Scheich
Gail Rush
Harald Oimoen
Jeff Terranova
JJ Gonson
Justine Demetrick
Kenneth Gibbs
Kevin Hodapp
London May
Michael Galinsky and rumur.com/malls
Mike and Randy Slipped Disc – slippeddiscrecords.com
Rusty Moore
Ryan Murphy
Theresa Kelliher
Thomas Dupere

The authors would like to thank:
World Industries
Paradigm Agency
Shogun Screen Printing
Craig Mathis
Matt Galle
Revelation Records
Mark Ryan
Wesley Eisold
Candy Drewson

Anthony Pappalardo would like to personally thank: the Pappalardo family, Al DeFusco, Amy Eisenberg, Anthony Shelter, Christine Elise McCarthy, David Tate, Diego Sanchez Santana, Erik Snyder, Gibby Miller, Jacob Hoye, Jamie Manza, Jeff Neumann, Jeralyn Mason, Jessica Humphrey, Jim Siegel, Jim Thiebaud and Real Skateboards, Jordan Cooper, Lance Dawes, Larry Ransom, Laura Harris, Mark Whiteley, Brian Lotti, Mike Courcy, Mike Denny, Mike Vallely, Nathan Nedorostek, Noah Butkus, Ray Lemoine, Richard Mulder and Heel Bruise, Ryan Martin, Sam Siegler, Sean Dorsey, Steve Lowenthal, Toby Morse, Vernon Laird, Vique Martin, and Walter Schreifels.

Max G. Morton would like to personally thank: Alessandra DeBenedetti, Ruby, Mother, Peter Morcey, Casey Chaos, Ron Grimaldi, Wesley Eisold, Craig Finn, Jimmy Policastro, Rob Lind, and the Wolves.

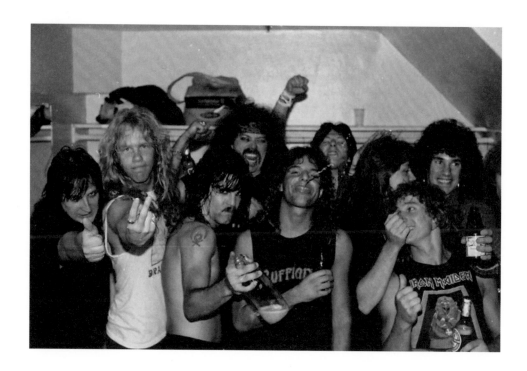

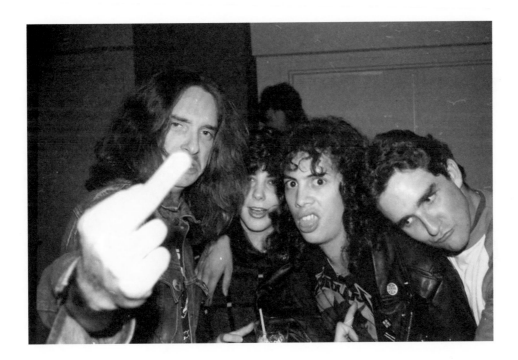

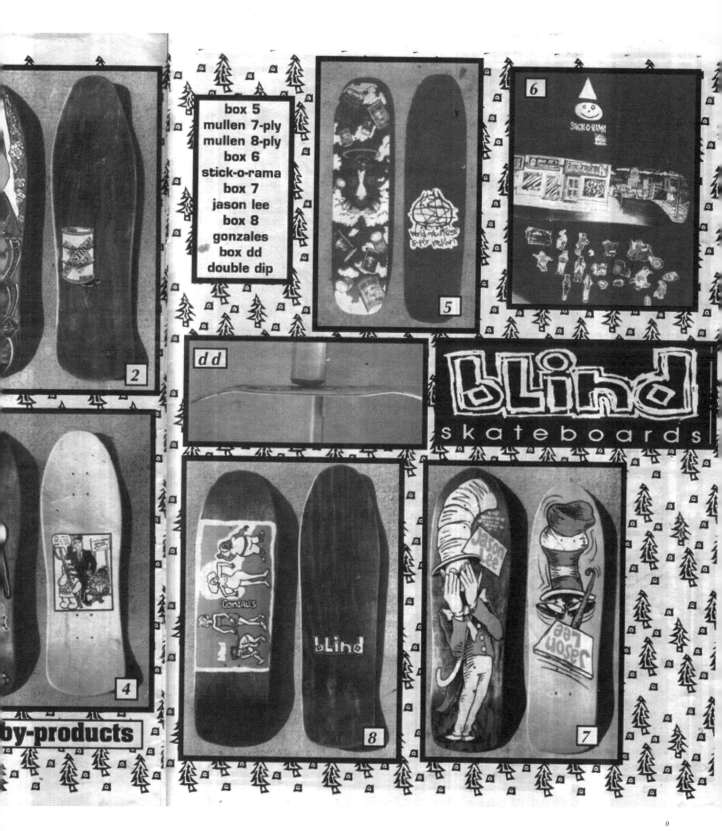

box 5
mullen 7-ply
mullen 8-ply
box 6
stick-o-rama
box 7
jason lee
box 8
gonzales
box dd
double dip

by-products

bLihd
s k a t e b o a r d s

FOREWORD

Craig Finn

When I was four years old, I saw Ray Charles singing on television. He banged on the piano and sang soulfully while wearing—of course—his dark shades. I called to my mother in the kitchen and asked her, "Mom, is this man cool?"

She took a quick look and said, "Yes, that is Ray Charles. I suppose he is cool."

I thought for a moment, and asked another question. "Mom, do we know anyone cool?"

She paused, laughed, and then replied, "No. I don't think we know anyone cool."

Every good story starts with a challenge and mine started with the challenge of finding this elusive "cool" in the world. I had heard about "cool" from Fonzie on *Happy Days*, and I had long suspected that he was talking about something that I didn't have much access to. Cool wasn't much to be found in our suburb, except for in glimpses on television. Besides Fonzie, there were the Monkees, who had funny accents and were a bit dizzy, but girls seemed to really like them. This fact seemed tied somewhat to their ability to play music, and I soon learned that it felt pretty good to grab a tennis racket, spin it around, and make it a guitar. While rock and roll rebellion wasn't at our doorstep, it could always (and always will) prance around in my mind.

Elementary school took us one step closer to what we were after. While second grade wasn't exactly a hedonistic affair, it was when KISS entered my life. They were not just rock stars; they could fly, breathe fire, travel through space, and do whatever it was Paul Stanley was supposed to do. Lunchtimes were filled with KISS lunch boxes and trading cards, and after school we played their records. I got *Dressed to Kill* first, and it remains my favorite, while *Destroyer* was the people's choice amongst the other kids in class.

We huddled around our school library's copies of *Skateboarding* magazine. I didn't have older brothers or sisters, but my friends did, and they cranked Aerosmith and Boston out of stereos sitting under framed blacklight posters. Roller skating trips allowed me a peek at even more—a multi-racial crowd skating around to alternating disco and hard rock songs. There was a Ted Nugent pinball machine in the arcade. My beautiful babysitter cried when John Bonham died, and we quietly listened to KQRS play Led Zeppelin songs A–Z while she sobbed and brushed her hair. While remaining a shy, good student, I was taking mental notes on all of this. Something was out there, and even if I couldn't put my finger on it, I wanted a piece of it.

In time, it became important not just to listen to rock and roll, but to let everyone know that you were listening to rock and roll. In the sixth grade, I attended my first real rock concert. It was Styx, on the *Kilroy Was Here* tour. In hindsight, it was predictably overwrought, permed, and flaccid, but at the time I was impressed. There were hot, rock chicks, kids throwing up, and pot smoke. Most importantly, I bought a black Styx tour t-shirt. I wore it to school the next day, of course. People were impressed and I felt as if I myself had rocked the St. Paul Civic Center.

This was a breakthrough. My suburban world was very small and insular. I barely knew anyone who didn't go to my school. Wearing the Styx t-shirt was the first time I snatched something cool (in my mind) from the greater world and tried it out on the people around me. I wasn't very rock and roll, but I could try to be the most rock and roll guy in my sixth grade class. There was much more of this to come.

Junior high hit like a bomb and everything increased to hyperspeed. Parties went coed and I wasn't invited. Drugs and alcohol came around. While my school was still safe and suburban, it boasted a typical array of cliques: burnouts, punks, heavy metallers, goths, and of course, jocks. I was small and timid; an easy target. While unhappy at school, I took further comfort in rock music. I learned about the Ramones, and then local bands The Replacements and Hüsker Dü. I couldn't believe they were from the Twin Cities; so close to me, yet light-years away.

One day at school, a kid sitting next to me showed me a flyer for an all ages T.S.O.L. show he had attended the night before at the 7th St. Entry. The flyer was crude and exciting. I pressed him for more details and he explained that First Ave and the Entry often had all ages shows. My first show was not so hardcore: The Violent Femmes at First Avenue. I got dropped off by my parents, and picked up afterwards. It wasn't very punk, but it was a start.

After that, I became a regular at all ages shows. I went to every one I could. Most of them were hardcore, but some were college rock or local bands. I would go to the shows before doors opened. I would find a place up front and watch every band carefully. Oftentimes, there were four bands or more. I had a group of friends that were as passionate about it as I was, and we would ride the bus downtown together. After the shows we would hit a record store, where we would plot our purchases together. There was no point in us buying any of the same records. Home taping allowed us to share music and maximize intake. Later on, we might loiter at a fast food restaurant for a few hours. While the music was great, the experience was often better.

Through it all, the band merchandise was very important to everyone. Just like after the Styx concert, it was important that everyone knew what you were into. While it was no longer cool to wear the t-shirt the very next day, it was good to have it. I had never felt cooler than when I was wearing my new 7 Seconds, Descendents, or Naked Raygun t-shirt. It told my little suburban world that I was just a tiny bit different, a tiny bit more dangerous, a tiny bit cooler than the other kids.

There was a highly-developed code of honor surrounding bringing punk back to our world. For instance, amongst friends, you weren't allowed to write a band name on your school folder unless you owned the album. You weren't allowed to wear the t-shirt unless you had seen the band live. There was no grey area on these rules. They were written in stone.

Of course, in the time before the internet there was a wonderful amount of misinformation. Just as we heard about Rod Stewart blowing his band and Ozzy killing puppies, punk rock had its own mythology. Someone told me the Dead Kennedys was for posers, and I carried that

information as gospel for a few years before I realized its error. Most bands whose members had short hair were rumored to be Nazis. Our main source for upcoming show information was flyers taped to telephone poles. There was forever going to be a final showdown between the rival skinhead gangs, and it was always going to happen at the next big show. In the pit.

Even as I got further into it, I was much more of a punk enthusiast than I was a punk. Someone around me coined the term, "As punk as you can be without your mom knowing about it," to describe a few of us. Besides the punk obsession, I was a normal looking kid who got good grades, got along with his parents, and was heading towards college. It was no surprise that I dove wholeheartedly into the youth crew scene when it peaked around 1988. That was the summer Youth of Today came to town and played the Entry. I really dug the positive energy around the Revelation bands of that time, although I wasn't so much interested in the straight edge message. I wore my Underdog t-shirt every other day during this period, along with my red, white, and blue Nike Air Forces. The local band Blind Approach was a musical powerhouse and a pillar of this scene. I rarely missed one of their shows, and I still remain good friends with some of the members of the band. If punk rock has brought me nothing else, it has made for some lasting friendships.

Punk was far from the only subculture around, though. Going drinking down by the Mississippi River or underneath a railroad bridge in Uptown Minneapolis, you would find yourself amongst metal dudes, skins, skaters, goths, b-boys, and whatever else. Sunday Night Dance Party at First Avenue was always all ages, and although we didn't get much out of the dance music they played, it was a great place to see all kinds of different people, especially the cute girls who loved Bauhaus, the Cure, and the Smiths. I even remember some punks and skins taking the floor when the DJ would play Boogie Down Productions' "Self Destruction."

Those Sunday nights made me realize that while there were slight differences between a Cro-Mags fan and a goth, what we had in common was that we were all a little different than the kids at our own schools. This was a community of outsiders, and there was comfort in those evenings, knowing that everywhere around the city there were kids

living for the weekend, for Sunday Night Dance Party and the punk shows in the connecting Entry. We were all in it together. Even the rival skinhead gangs couldn't help but show up at the same parties for some reason. If there were differences between us, they were slighter than we wanted to admit.

I went off to college in Boston in 1989. I started going to shows at the Rat and Bunratty's to see bands like Slapshot and Wrecking Crew, but I lost focus and predictably spent more time on beer and school. I was still into music, but my horizons were broadening, and I lost a lot of my enthusiasm for hardcore. I still loved the classics, but other things were taking up more time.

More than anything, I was out of the suburbs. It seemed that every time I had gone to a show, bought a record, or hung out at a punk rock party, I took a little of it back with me into the suburbs. It became a part of me. I was no longer acting out the role of a seasoned scene vet, I was something close to one. I had five years of shows under my belt. I had seen influential bands that had long since broken up. I had replaced some of that green with knowledge and experience, and was even a little bit jaded.

In 1991, punk "broke" while I was in college. It was hard to know what to think. Had we won? Was it progress to have the guys you didn't like trade their hockey jerseys for flannel? Was it good to hear bands you liked on FM radio? It was a tough few years, but they passed pretty quickly. I graduated and moved back to Minneapolis. I kept going to shows, but after turning 21 they seemed different. They were more about drinking and picking up than they were about any scene. We watched the headlining bands but deliberately missed the openers. We had better things to do.

In the mid-90s, after Kurt Cobain's suicide, a family moved into the house next door to me. Their teenage son wore fat raver pants, a Fugazi t-shirt, and a stocking cap. The family dog was named "Kurt." I was, at the time, appalled at the crossing of genres. I thought he should take a stand as one thing only: a raver, a Dischord records hardliner (pay no more than $5...) or a Pacific Northwest grunge dude. Later, I realized that he might have been, at a young age, aware of only slight differences

between the subcultures. And certainly, he was taking his own stand against whatever mainstream existed in his junior high school.

Nick Hornby, in his book *Fever Pitch*, says it better than I ever could: "Some things were better, some were worse, and the only way one can ever learn to understand one's own youth is by accepting both halves of the proposition." While *Fever Pitch* is, on the surface, about Hornby's love of football, it really is about any obsession, including punk rock. Everything moves on, but in each of us exists a sweet spot of a few years when it seemed so important, all encompassing, and even magical.

Right now I'm about the age of my parents when they dropped me off at my first all ages show. They were very supportive, but could not possibly imagine as I left the car how much my life was about to change. Music is still a driving force in my life, and I even get to tour around the world with my own band. My only hope is that the day after one of our shows, some kid is taking it back to his suburb, proudly wearing our t-shirt at his school, smugly telling his friends what they missed last night. I hope he is taking a little bit of a world that isn't quite his yet, and trying it out on the one in which he currently lives.

Live...Suburbia! is that kid's story. It's also my story and your story. It's thousands of different stories happening simultaneously across the country and the world. It's about how we all went looking for something a little different than what was happening in our towns, what we found, what we brought back, and how it changed us forever. It's about our suburban lives, what they were, and what they've become; where we might go from here.

Craig Finn
March 23, 2011

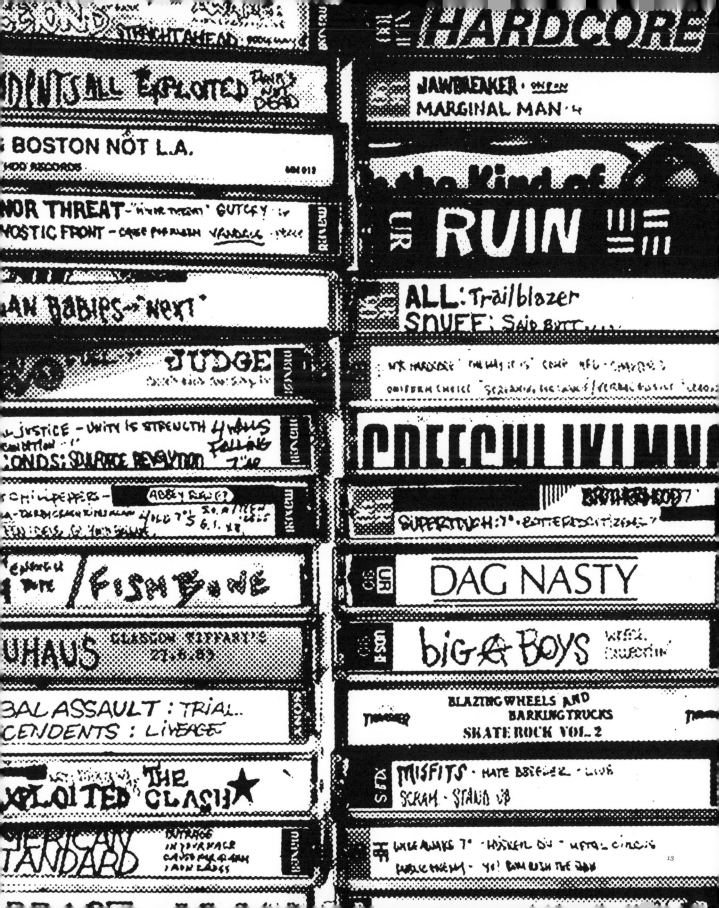

HARDCORE

EXPLOITED

BOSTON NOT L.A.

...NOR THREAT

...OSTIC FRONT

...AH BABIES - "NEXT"

JUDGE

JAWBREAKER

MARGINAL MAN

RUIN

ALL: Trailblazer
SNUFF: Said...

...JUSTICE - UNITY IS STRENGTH
...ONDS: SEPARATE REVOLUTION

...CHILI PEPPERS -
ABBEY ROAD (?)

/FISHBONE

...UHAUS

...BAL ASSAULT : TRIAL...
...CENDENTS : LIVEAGE

...XPLOITED THE CLASH

...ANDARD

SUPERTOUCH

DAG NASTY

BLAZING WHEELS AND
BARKING TRUCKS
SKATE ROCK VOL. 2

MISFITS

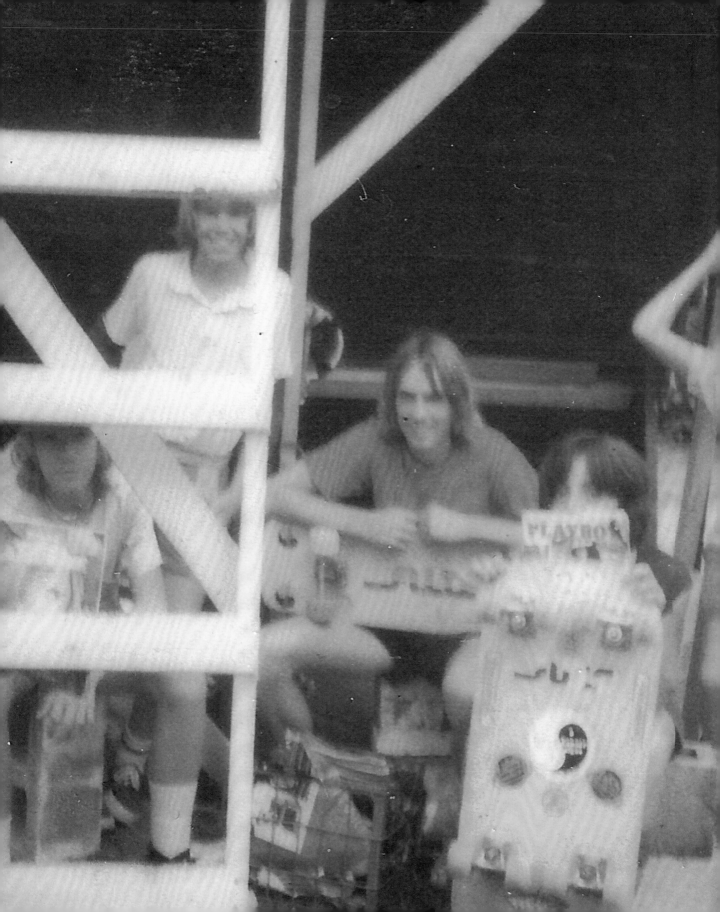

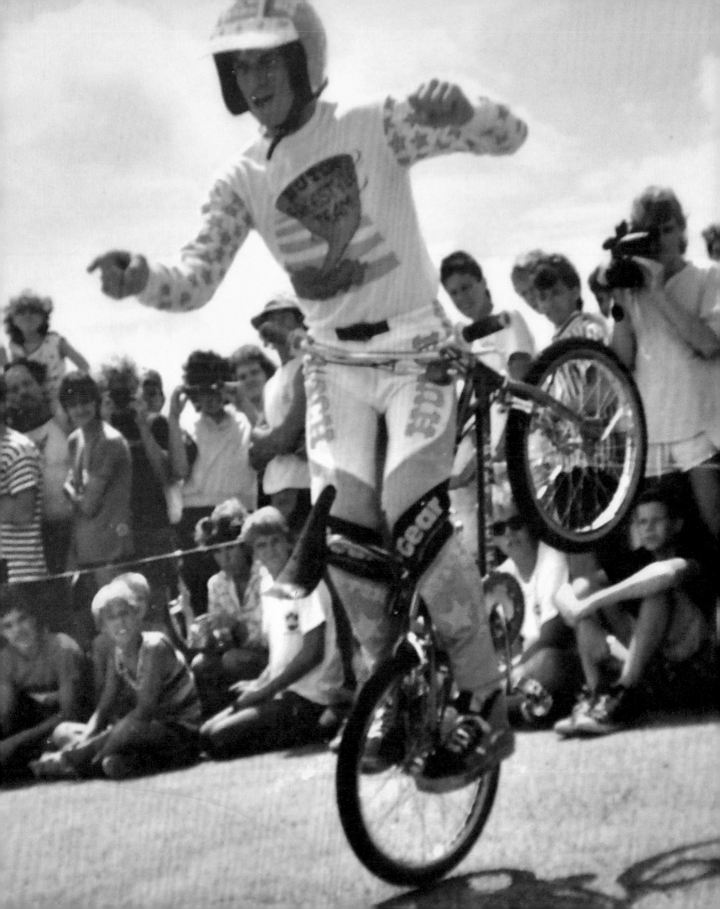

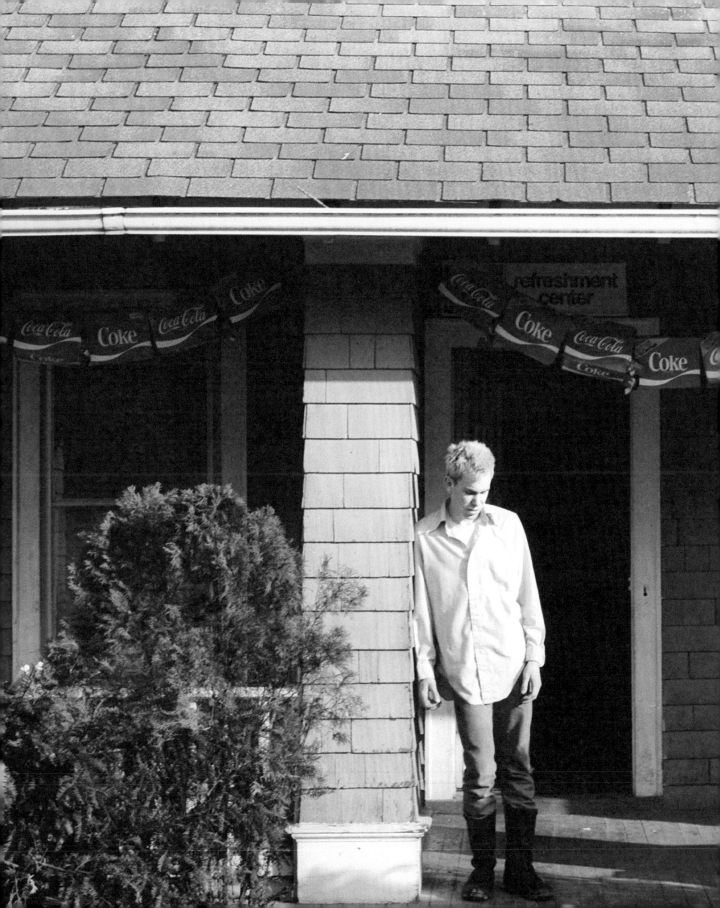

U.C.

RAIGHT AND ALERT
RAIGHT AND ALERT
RAIGHT AND ALERT
RAIGHT AND ALERT
RAIGHT AND ALERT
RAIGHT AND ALERT

WELCOME TO NEW GRANADA

Max G. Morton

Some of us enter this world prematurely. After peaking on parent-approved science fiction, you find yourself with a pocketful of quarters pedaling your PK Ripper toward the inviting glow of a neon ARCADE sign. You feel invincible, adorned with a KISS iron-on from your most recent family vacation. Youth is enriched by voyeurism and impressionable minds warp like a record left in the back seat of a car. Perceptions change at lightning speed. Somewhere between dropping the quarter in and reaching the ominous game over, you learn that the bad, made-for-TV movie, disco record, and *People* cover have soiled KISS forever. Life has lost all meaning.

Joining karate is the next logical step for many subscribers of the unwritten manual to preteen survival. One might find himself kicking, chopping, and yelling *kiiiiiyyyyyyyaaaaa!* at everything in sight. The utter determination to destroy might even catch the eye of an older dojo transplant who has an afro and spars in war paint. You have never made friends with someone that wasn't from your town, but pretty soon Motley Crüe is placed in your tiny palm and a new door—complete with dry ice— is opened. You are too fast for love and everyone else around you. When you pledge your allegiance to *The Number of the Beast*, Mother gets a little nervous. The monster materializes after devouring everything metallic, but unfortunately in suburbia you need wheels to go anywhere outside your head. While others are content with the same grip of records, your overactive psyche craves something faster and louder. *You Can't Stop Rock 'N' Roll*...or can you?

The initial shock value of "Fuck Like a Beast" is immeasurable. Sadly, it's as ephemeral as the India ink Pachuco cross tattooed on the hand of the dude who played it for you. Mercyful Fate has imported a new breed of evil to your town and before long you are hiding Witchfinder General records under your mattress. Hanging out in cemeteries is cool as shit, making new friends with Ouija boards brings you closer to being in league with Satan and your new idol is a man who smashes television sets over his head. For a moment it feels as if you could retire on goats and inverted crosses.

Distracted by a page in *Thrasher*, where does one turn? Corrosion of Conformity's spiked skull logo doesn't just look cool, it looks powerful. A threat, even. *Animosity* sounds like a ten o'clock news segment where everyone is at war. It appears you've dug yourself further underground than the long-haired grave robbers you spent last summer rotting with. You make compulsive lists after analyzing band thank-you's and shirts in photos. Pretty soon the locks everyone wanted you to cut are all over the bathroom floor. When you are not sticking glue and gelatin in your hair, you appear to have mange. All this and more, while still owning your virginity. Hardcore is a frightening discovery for modern times. Twenty-seven songs in under 35 minutes... Who needs society? Fuck the world.

As is written in the stars, you and your new best friend will become teenage science projects together and raid all the medicine cabinets you can find. Even though your friend is still *Haunting the Chapel* while you are *Dealing With It!*, it ain't long until all your favorite bands start to sound like watered-down versions of his.

You meet a few stragglers and fellow explorers here and there, but nothing is as it seemed on *Night Flight*. Your mother begins dating some cover band drummer who is ten years older than you. While he's playing air guitar and blowing kisses to his only fan in the mirror, your real dad has taken up residence behind bars. The guy at the record store who turned you on to all your favorite hardcore bands declared the scene "dead" and gave you all of his records just before joining Thee Temple ov Psychick Youth. Disenchantment puts experience in a choke hold. After so many nights spent with lyric sheets, you put an X on your hand because you have seen firsthand what drugs do.

Lurking possible outlets for the innate suburban rage you've channeled, you stumble across *Strength Thru Oi!* Nicky Crane looks pissed. Mentally, you move away to England. At the next show you notice the same types of youth beating a guy under a car, then lifting the car to get in a few more steel-toed kicks... Arrival.

A few home tattoos and assault charges later, Geraldo has some skins on the TV and everyone thinks you're voting for Hitler. Your

regular-ass cousin has taken to riding a skateboard, your now-stepdad has a porno called *New Wave Hookers*, someone tells you that Anthrax is NYHC, and you are officially over it. You smoke a joint to *Paul's Boutique*, fuck a girl and lose a few years.

Baked at a fairground for some headbanging MTV butthead tour, you wonder why mutants are backed up and staring at you. Quicksand just played and you incorporated everything you learned in New York about dance floor justice. Suburbia is half-terrorized and the other half confused. Wasted and doing karate to live music—once again, you are on some next level shit. While White Zombie plays, you zone out on the back of a shirt.

Birth
School
Metallica
Death

Yup, there it is. Life explained. You are born, you serve detention for defiling a locker with the logo of some band who would betray you with their next record, and you discover *Kill Em All*; Cliff Burton dies; James, Lars, and Kirk fuck you over. Then you die.

Somehow I didn't die, but life caught up to me, and all of the little things I picked up along the way have become not only acceptable, but quite easy to obtain. My records and old t-shirts are worth so much that they could put my non-existent children through college. At any given matinee, more elbows than not own a spiderweb. Fred Perry, Ben Sherman, and Doc Martens stores are all within walking distance of my house. Sometimes I miss being an outcast. I miss the hunt, but more importantly — I miss the fight. All of the genres at the Record Bar, all the gambles and choose-your-own-adventures of burning out in suburbia have come full circle. Without warning or want, here I am. My feet burn and itch in antique Nikes. I own a denim vest with patches from travels all over the world. A few years ago my liver gave out, which made the straight edge tattoos more meaningful. The print on my Cro-Mags shirt is illegible, and

when I do venture into a show, I still skinhead skip like it's 1988.

We all go back to the first thing that really turned us on. For me, everything stemmed from music. There is always a soundtrack for the headphones of the forever young. Records inspired us all. Songs are markers for many significant moments in life. The ritual of the needle dropping kept me alive. That crackle still tells me that everything is going to be alright. Music blocked out the sounds of my parents fighting and gave me hope that other people out there hated pigs, teachers, and organized sports. There were anthems to prepare me for and get me through puberty blues, high school halls, and nuclear war. Records are the ultimate handbook for growing up. Whatever we were into, there was solidarity in being an outsider; allies against Reagan Country. A rite of passage for some was another wasted night for others, but ultimately we're all just shrapnel of the same explosion.

Over the years I've mellowed out of such extremes as ditching all my metal records for punk ones and then my punk ones for skinhead ones. Sure, I might look back periodically and blow a bunch of money trying to revisit Mentholated Suburbia, until I realize why I got rid of some records in the first place... My mom might have been right about the Dayglo Abortions. On the other hand, there are those staples in each genre that survive the test of time and now can sit peacefully together on my newfound, custom-built shelves, not unlike the eclectic collection of friends I've amassed over the years.

At the end of the day, when the highlight reel plays, one might go back to better times. We are all guilty of this. Victims of the past, we are still searching and still collecting. Dreaming through modern landscapes, I often visit road trips and long-forgotten record stores. We are astronauts, forever cataloging. Just last night I was restlessly thinking about some old Crumbsuckers shirt that disappeared to God knows where. Why that shirt means something 23 years later is beyond me. I guess certain things just stab themselves into our souls.

We can all say, in one way or another, that we still live suburbia. This is *Live...Suburbia!*

School's
Out
FOREVER

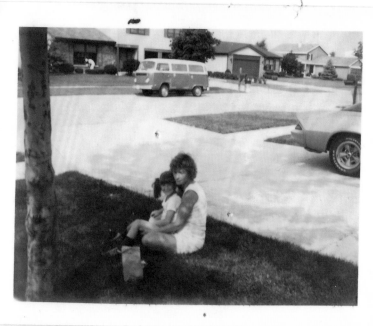

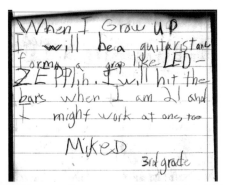

When I Grow up
I will be a guitarist and
forma grap like LED-
ZEPPLIn. I will hit the
bars when I am 21 and
I might work at one, too

MikeD

3rd grade

LONG-HAIRED ANDROGYNY AND OIL-BASED FACE PAINT

Max G. Morton

As usual at that time in my young life, I was wearing greasy Ace Frehley makeup when my mother and I flew to Ohio to visit her sister. I told the swinging stewardesses it was "cold gin time again" every time they came around with the drink cart and Mother chuckled while sipping her Tab.

Upon arrival, I used my space powers to convince my aunt and Mother to paint each other's faces like Gene Simmons and Paul Stanley. They ran to the corner pharmacy for some Polaroid film, while I stayed behind with a red-eyed, lackadaisical neighbor. I could not see how we were going to record *Alive in Columbus* without a drummer, after my uncle made it clear that blasphemy was not for him. Seriously, who was going to belt out "Beth"? It was only fair for the neighbor to fill out the band and put on some whiskers.

After the paint job, we procured some fireworks, and the cat-man and I walked around blowing up mailboxes and white picket fences until my mom and aunt finally arrived home in one foul mood. Apparently the cashier had panicked when they walked into the small-town drugstore in their KISS makeup, thrown all the money from the register at them, and began begging for his life. By the time my mom and aunt stopped laughing, the police had the building surrounded. It took quite a while to make the Midwestern redneck cops understand that my family members were not Knights In Satan's Service.

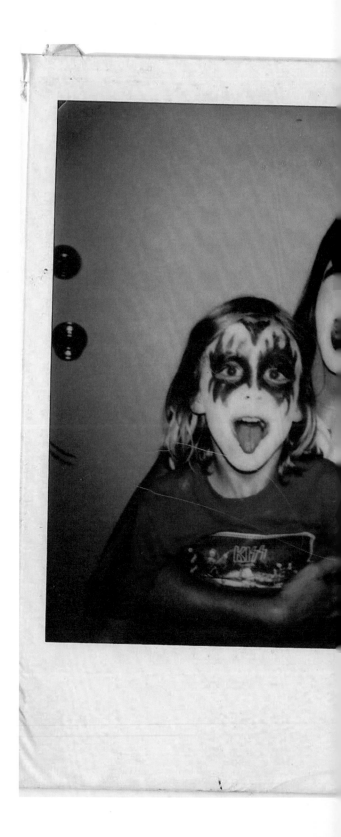

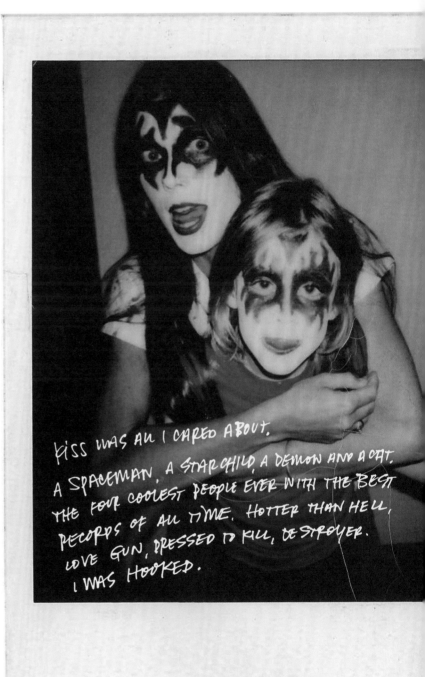

KISS WAS ALL I CARED ABOUT.
A SPACEMAN, A STAR CHILD, A DEMON AND A CAT.
THE FOUR COOLEST PEOPLE EVER WITH THE BEST
RECORDS OF ALL TIME. HOTTER THAN HELL,
LOVE GUN, DRESSED TO KILL, DESTROYER.
I WAS HOOKED.

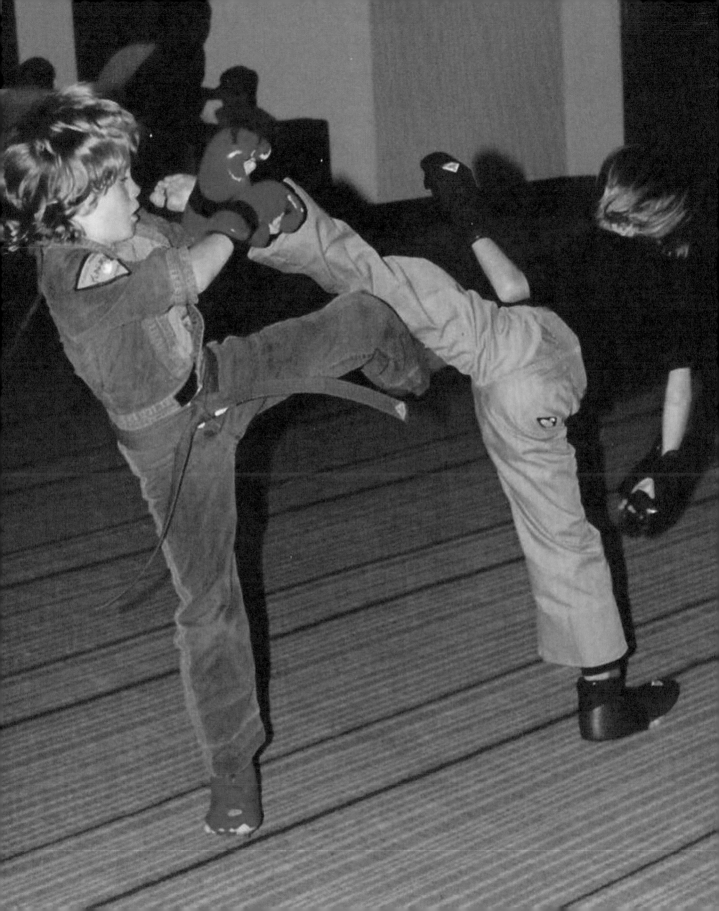

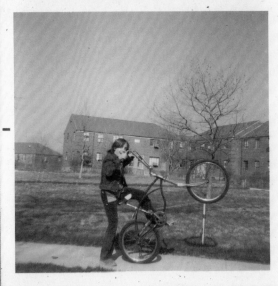

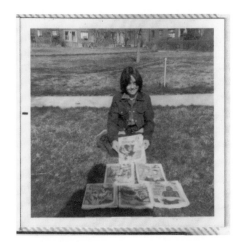

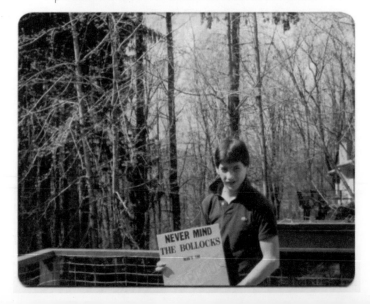

LICORICE PIZZA

Max G. Morton

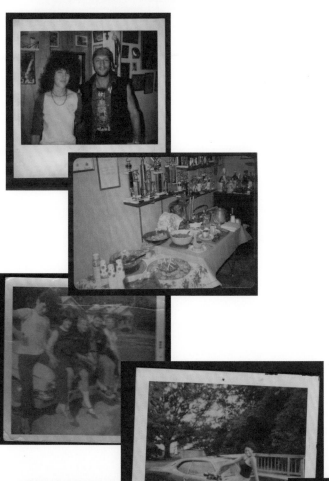

A few times a week, Mother would unleash me in the mall. I would scan the records before running straight into Stardust Dreams where I once licked the Solar Fox machine when no one was looking. The blood-red atmosphere of the mall arcade was ruined when you walked into the blinding galleria's fluorescent food court. The ladies from Hot Dog on a Stick sure put a damper on the suburban warrior vibe with their rainbow employee uniforms, paper hats, and robot smiles.

The best part about the mall was the girls. They were always there—mobs of them—and just like the food court there were all varieties. Feverish girls with Farrah hair and cheeks a color only seen on mustached muscle cars with a Journey cassette glued in the deck. Radioactive cheerleaders in blousy bitch cardigans and trampy tube tops. Girls that had sticky, over-blown chemical hair, smoked Marlboro Reds, cursed, and were poured into the tightest denim imaginable. Some were in gangs, some in sororities, while others were just sisters. Some had gold cards and others used the five-finger discount. Imagination in overdrive, I was convinced that once I was a few years older I would have more girlfriends than John Holmes and that they would all come from the mall.

I had to go to the mall at least once a week or I would start to go into withdrawal. I would ask my mom if she would please drive me down to the "chopping mall" in my most sinister voice, with a matching goofy laugh to follow. Seven days was just too long to go without a Strawberry Julius.

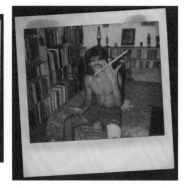

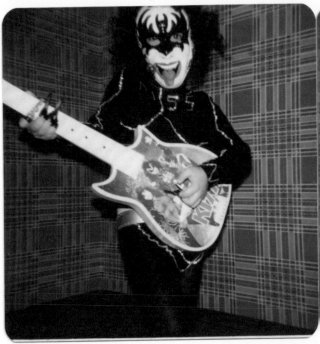

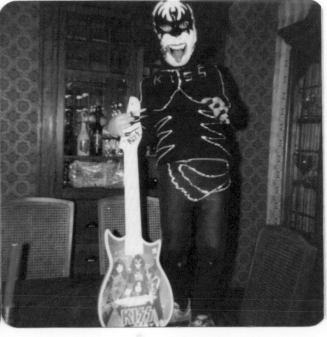

ESCAPE FROM MAGIC MOUNTAIN

Max G. Morton

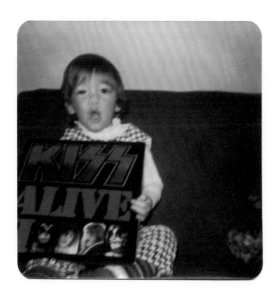

October 28, 1978: I had been waiting for weeks. This was guaranteed to be the greatest night of my life. The commercials blew my dirty blonde mind. I got the magazine from Super X and memorized every word. Mother painted my face just like Ace. I was wearing my KISS ARMY iron-on, Jiffy Pop was popped, and my father was out of the house. Nothing could go wrong for 96 minutes. *KISS Meets the Phantom of the Park* was the most anticipated spectacle to hit our TV since Atari. Right off the bat, I was obsessed with Magic Mountain.

Mickey, Minnie, Goofy, and Pluto were replaced with Paul, Gene, Ace, and Peter but from the moment Ace said "Ack!" my mother couldn't stop laughing. I had inherited all of her stubborn genes and was not about to let her ruin my night, however it was impossible to enjoy the film because it sucked. Obviously, all the powers of the Demon, Catman, Starchild, and Space Ace combined could not save this cybernetic clone catastrophe.

Life was over as I knew it. How could KISS make a movie that reeked of moldy Swiss? It was nearing time for me to wash off my makeup as I watched the KISS robots get destroyed by laser beams and fire balls shot from the weapons of the real members of KISS. I had never been so disappointed in my life. Crushed by all that I was living for. Halloween was a few days away and I needed to think of a new costume. Fast.

KOOL AND THE GANG

Max G. Morton

Huddled outside of the Lionel Train Museum with a few of my classmates, I dug into the pockets of my best fatigues, retrieving a BIC lighter. We were on an elementary school field trip. The conversation was innocent.

"What are you going to drink when you are older, beer, wine, or whiskey?"

Eric, who'd recently given me my very own ceremonial squirrel tail barked, "All!"

For some reason, the gift shop sold fireworks and was employed by a blind, almost-dead bat. Needless to say we were poorly monitored. My friends liberated a souvenir magnet, at best. I went big, taking it to the top, my multiple, deep war pockets overflowing with candy and explosives. As I aimed, lit, and fired a Roman candle into the speeding lane of oncoming traffic behind the parked school bus I answered. "I'm not ever going to drink, it makes the men in my family violent. I think I'm gonna smoke cigarettes though...Kools. Definitely Kools."

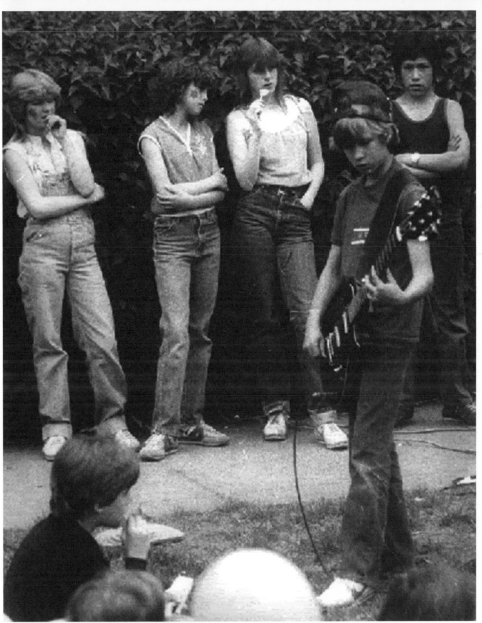

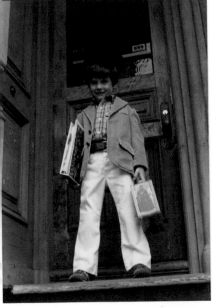

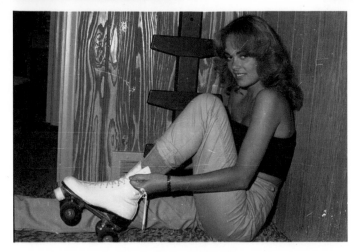

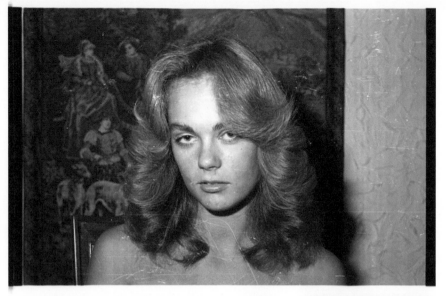

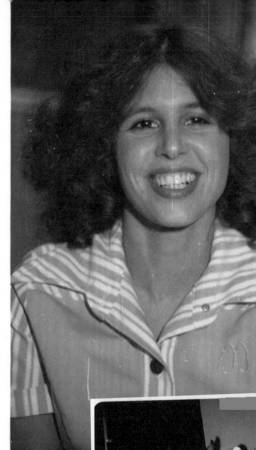

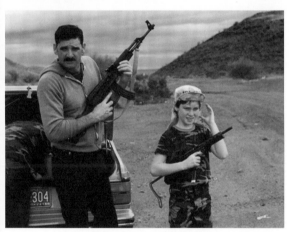

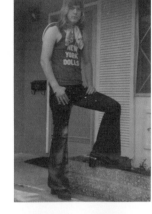

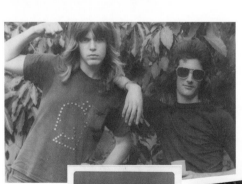

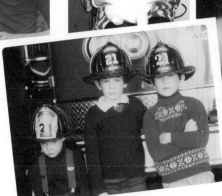

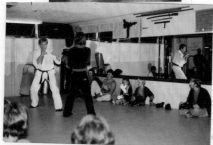

LIVING AT THE MOVIES

Max G. Morton

If you lived in suburbia you lived at the movies. In my family it was a weekly ritual. Birthdays, holidays, happy days, sad days, matinees, dollar nights, and even grandma days were spent bathing in the glow of a screen. Maybe for parents it was an excuse to zone out in peace and quiet for an hour and a half, but for the kids in America, it was a well-rounded education where we saw boobs, learned how to fight, witnessed new and better cities, and made long-standing connections with characters that extended far beyond the bounds of playground friendships.

In the morning we were medicated with cartoons. After school we were programmed by public service specials that prepared us for hormonal warfare. At dinnertime we saw how the other half lived on the news; robbing, raping, and raging. Primetime was for dates with our fantasy girlfriends and—once our parents fell asleep—those of us blessed with cable went all the way with our TV dream lovers. The point is that we young astronomers had a screen everywhere we went.

The car window was my personal favorite cinematic experience. Through downtown backseat glass I read nonfiction. True crime featuring hookers, pimps, players, private eyes, wild packs of cubs, legendary hobos, war vets fighting invisible forces, tube-topped hitchhikers celebrating their last few hours alive on planet Earth, men in skirts, chain gangs, and all the neon signs that spelled out their vices. Sex and liquor, the medicine of the underworld.

On the rolling transparent monitor I saw kids in concert shirts of bands that I needed to know about, ramps on suburban lawns complete with new styles and decks, different breeds of girls, and kids that were free to do actual things beyond just being a voyeur on the way to Grandmother's house. En route to karate tournaments I would inspect another town's comic store, record store, skating rink, arcade, and bowling alley. I would learn new words on movie theater marquees or crudely spray-painted on walls.

Suburbia is alive. A documentary of now. The cameras are always rolling and the proof is floating around all over the place. From films like *Over the Edge* and *Suburbia* to back issues of *Thrasher* and the scene reports in *Maximum Rocknroll*. Old, VHS-dubbed, late-night programming of *Night Flight* and *120 Minutes*. Fliers, t-shirts, ticket stubs, and Polaroids. Kids like me and you, with nothing better to do.

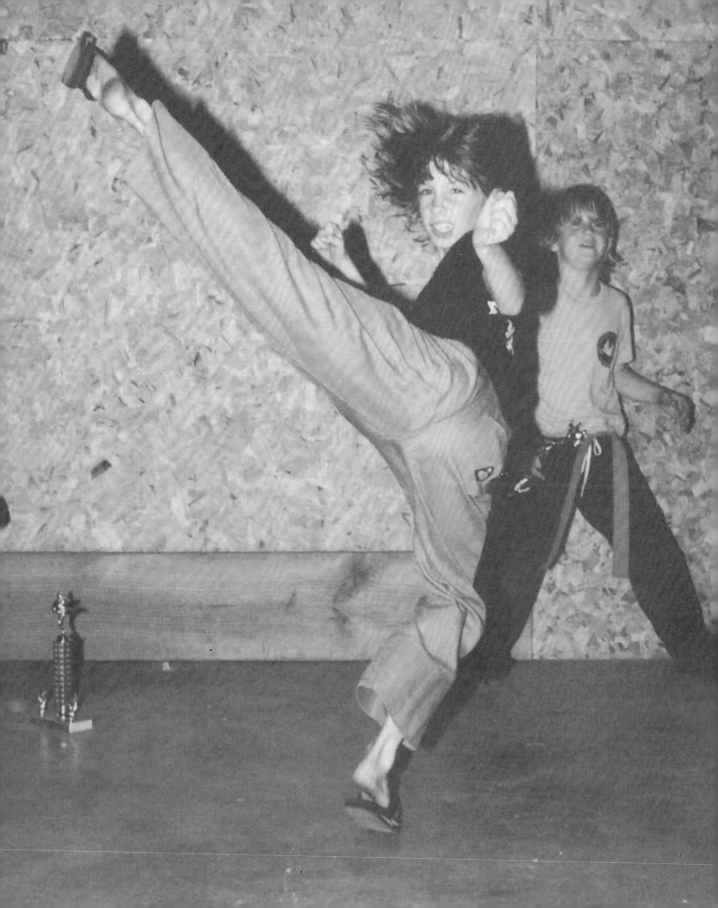

Every child running wild through the anything-goes 70s was
obsessed with kung fu. Fantasies of throwing stars, nunchakus,
ninja masks, samurai swords, smoke bombs, and poison darts
filled the mind of the young underdog. We wanted to break
boards with a high-powered chop, punch people so hard that
they went back in time, and cling to the ceilings of neighborhood
girls' bedrooms. The street gangs in their savage matching
denim vests, the ones who took the city as the sky grew dark,
played a major role in the imaginations of pretty much every-
one I knew or could relate to. At the time, as a pre-teen on the
outside looking in, I wasn't too focused on the philosophy or
beauty of martial arts. I just wanted to break everything in
sight and enter the new dark age of the eighties fully prepared
for any Gooch, Guido, or Gary that crossed my path. The dojo
also seemed like a good place for me to learn elementary motor
skills, since prior to karate I would have lost a fight to a palmetto
bug or a stuffed animal. The lure of being able to scale the
Empire State Building and kill a man with my fingertips was
too strong to pass up. That in mind, the most awkward and
uncoordinated child of the century signed up for a trial month
at the local dojo.

– *Max G. Morton*

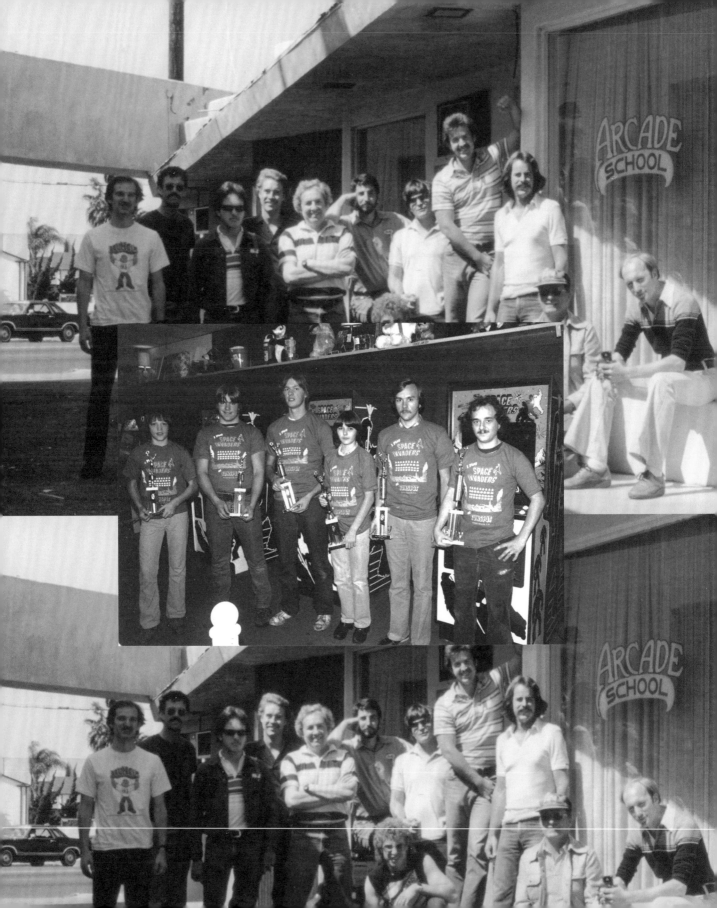

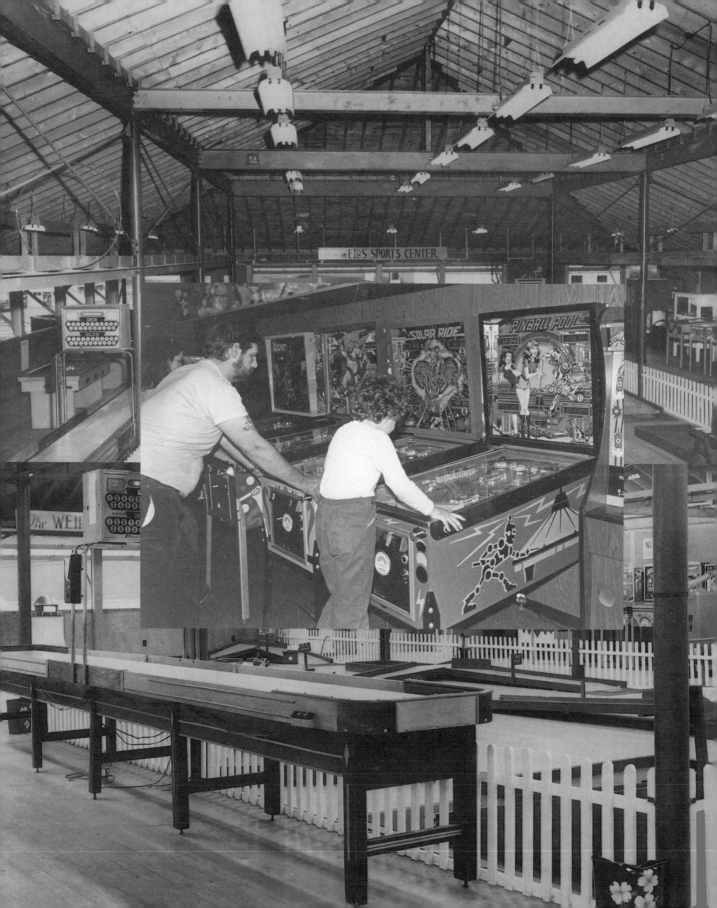

As a child I was a firm believer in tomorrow. I always knew it had to be just around the corner, waiting to come to life. Arcades grounded me and soothed my nerves. Spinning multicolored lights, buzzing, and space-age technology were the only source of tranquility for me. Petty crime and girls in tight jeans playing pinball in a futuristic game room worked as a strong aphrodisiac as well. Appropriately enough, the rattrap of my youth was called the Rat Trap. I always had bad dreams about that arcade but they were the kind that sometimes took a turn for the weird and ended as wet ones.

The dangerous stares, dark corners, and flickering pink light were scored by a soundtrack of pounding buttons, beeping, clanging machines, and the shouts of fistfights breaking out. I was young and needed adventure, so I sniffed the tracks of the downtown Wolves.

– Max G. Morton

FEBRUARY 1976	MARCH 1976
S M T W T F S	S M T W T F S
1 2 3 4 5 6 7	.. 1 2 3 4 5 6
8 9 10 11 12 13 14	7 8 9 10 11 12 13
15 16 17 18 19 20 21	14 15 16 17 18 19 20
22 23 24 25 26 27 28	21 22 23 24 25 26 27
29	28 29 30 31
..

FEBRUARY

18

~~WEDNESDAY~~ FRI

Today is the Birthday of _____

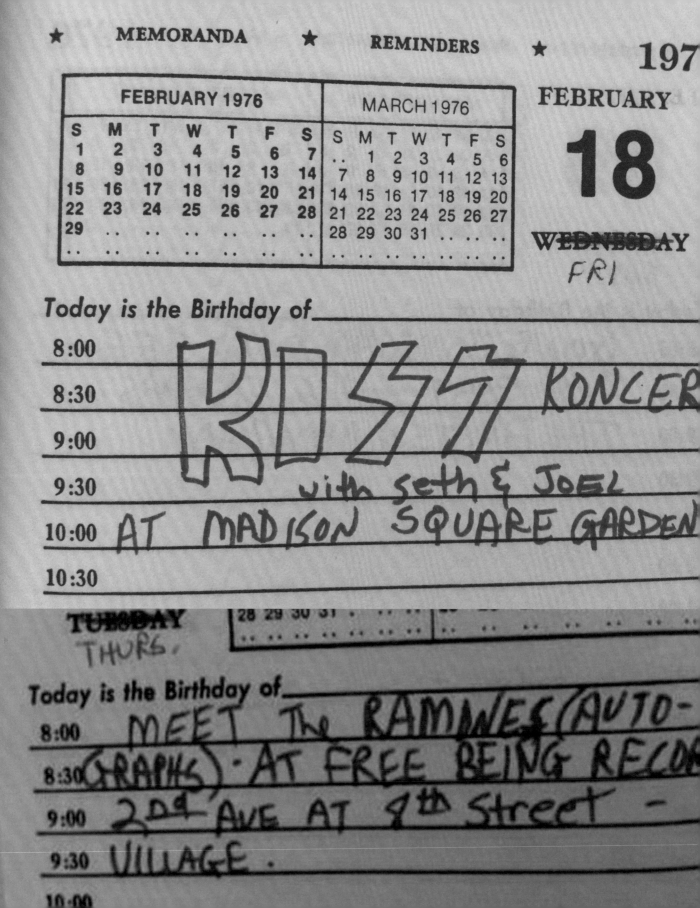

8:00 KISS KONCER

8:30

9:00

9:30 with seth & JOEL

10:00 AT MADISON SQUARE GARDEN

10:30

~~TUESDAY~~ THURS.

28 29 30 31

Today is the Birthday of _____

8:00 MEET The RAMONES (AUTO-

8:30 GRAPHS) AT FREE BEING RECO

9:00 2ᴺᴰ AVE AT 8th Street –

9:30 VILLAGE .

10:00

APPOINTMENTS ★ MEMORANDA ★ 1976

JANUARY

22

~~THURSDAY~~ SAT.

DECEMBER 1975							JANUARY 1976						
S	M	T	W	T	F	S	S	M	T	W	T	F	S
..	1	2	3	4	5	6	1	2	3
7	8	9	10	11	12	13	4	5	6	7	8	9	10
14	15	16	17	18	19	20	11	12	13	14	15	16	17
21	22	23	24	25	26	27	18	19	20	21	22	23	24
28	29	30	31	25	26	27	28	29	30	31

Today is the Birthday of_____

8:00 WENT TO SEE BLONDIE & THe

8:30 CRAMPS AT MAX'S.

9:00 SCI·FI & OCCULT CONVENTION.

9:30

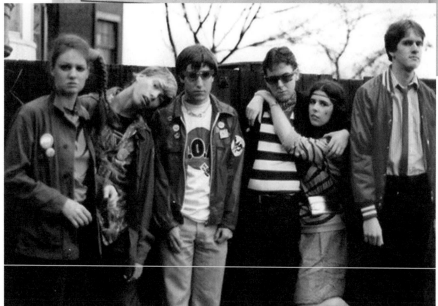

FREEWHEEL BURNING

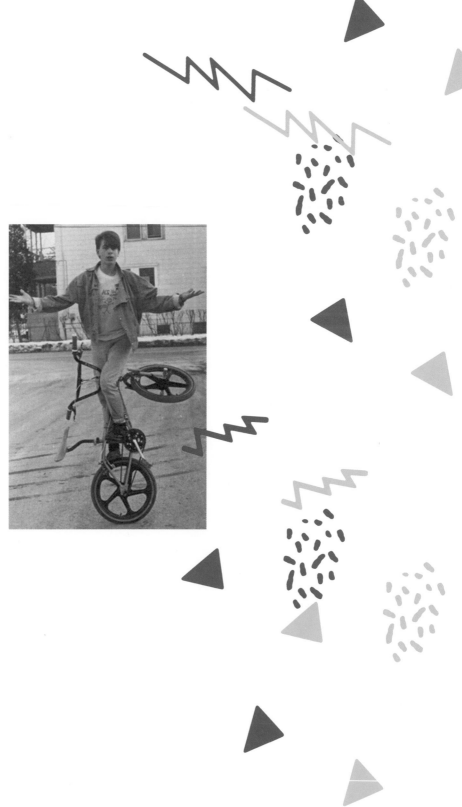

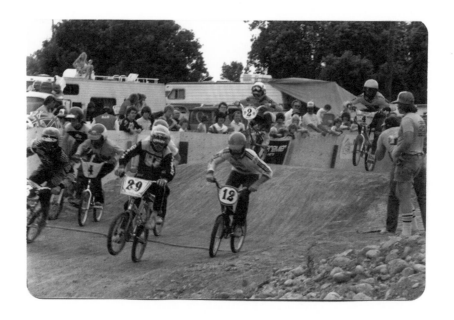

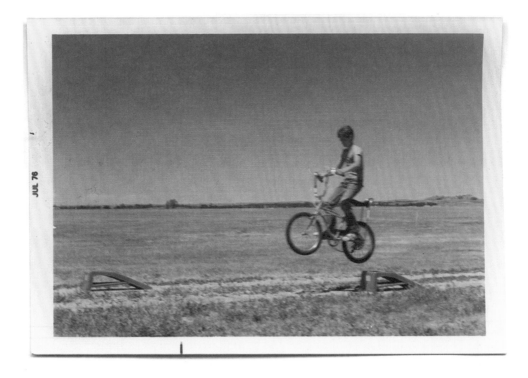

ON ANY SUNDAY

Max G. Morton

My father was an entrepreneur of the dirt-paved worlds. He was always on the move, and we knew better than to question him when he was feeling generous. One day he brought me a massive box turtle and once a toolbox, but the best was when I got a BMX. Mother glared when I made the mistake of pointing out that it was too big for me. I was around eight and the bike was full size. My feet didn't even reach the pedals. There's a first for everything, and surprisingly my father not only offered to exchange it, but actually asked me to go with him to pick out a new one.

A motorcycle shop in town had ventured into dealing BMX bikes and sponsoring local kids. This shop was much different than any I was used to going to. It was not a dark and sketchy outlaw outpost that smelled of leather. This was a brightly lit, legitimate business that smelled of rubber and sold "rice rockets." Somehow Satan had earned unlimited credit at the Suzuki shop.

I got half a dozen jerseys because they were all I wore. All varieties. I loved the polyester mesh. Concert quarter-length KISS and Rolling Stones jerseys, football jerseys with the Buccaneers and the Raiders, baseball jerseys of the Astros and the Pirates and, now, jerseys featuring JT Racing and Fox. That day I also got a Red Line BMX, complete with racing pads and most importantly, a sponsorship.

Maybe I was cursed by dreams, but I swore that sitting on my new bike in my room and visualizing myself winning my first race was as good as actually practicing. A few times, I dare-deviled, helmet-clad and sporting alternate jerseys, past the graffiti-adorned ravine where all the acid rock youth would hang and slingshot rocks at cars. My neighbor Shane and his India-inked crew laughed after I invited them to my pending race. "We were going to steal your bike, but we'll let you live because they are going to smear you at the track, queer."

Finally, the long-anticipated judgment day arrived. I would soon have a photo on my wall that captured the image of me hoisted upon the shoulders of my new friends, covered in sweat, howling, my trophy extended from the end of my trembling, clenched fist.

I was fresh meat in my sparkling new racing swag. Everyone was heckling me and glaring as I made it up the dirt mound with the other racers. The Suzuki shop owners were there, rooting me on, but my other teammates were not so supportive. All the bright lights, screaming, Southern humidity, and particles of dirt circling the air heightened my nausea.

A redneck in a mesh hat started counting back from ten and when he hit "one," the green-painted 2x4 barrier was dropped and a blank was fired into the air. I thought I was being shot at and was quickly caught off guard. Sensory overload reigned supreme as all the kids started to barrel down for my trophy. I was immobile at that point so one of the kids on my team gave me a karate kick of encouragement to get me going. The kick sent me tumbling down the hill and the bike's handlebar lodged itself into my throat. I did about five full flips and woke up blue on a stretcher. I never did get that photo.

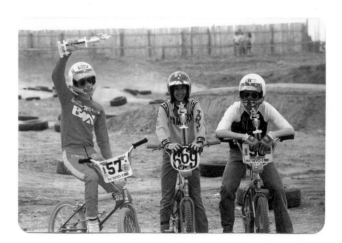

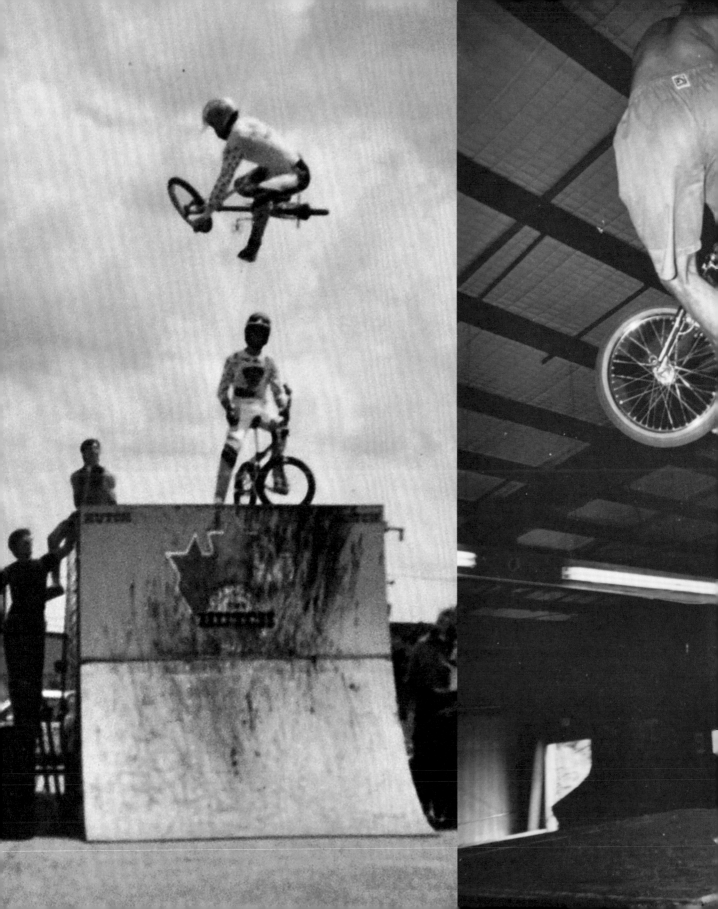

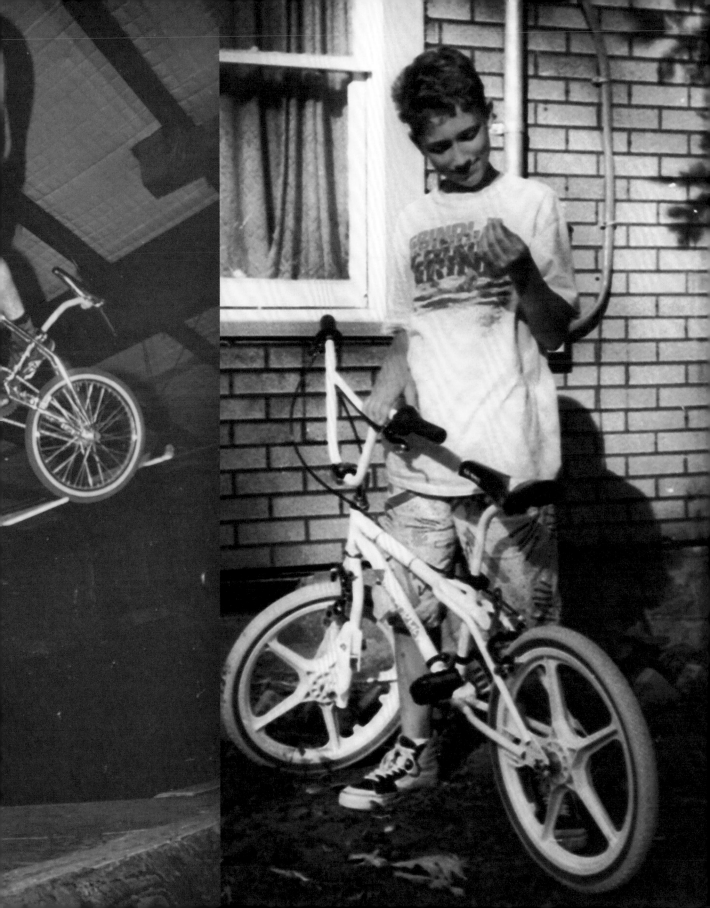

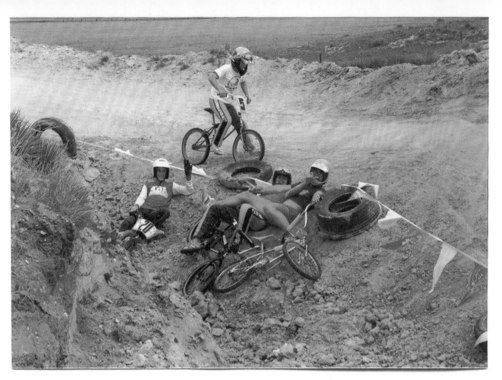

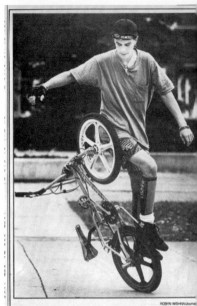

STUNTMAN: Justin Gauvin, 16, practices freestyle maneuvers in Dewitt Park on Sunday. Gau said he publishes a homemade magazine for freestyle cyclists and skateboarders and has abou people, nationwide, on his mailing list. He and the other freestyle riders in the park said they we like to have their own place to ride and skateboard legally in the city.

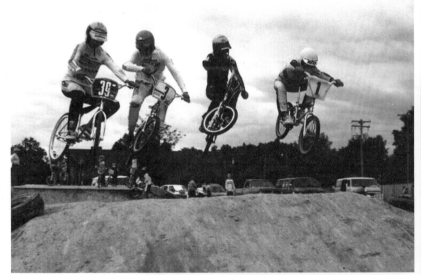

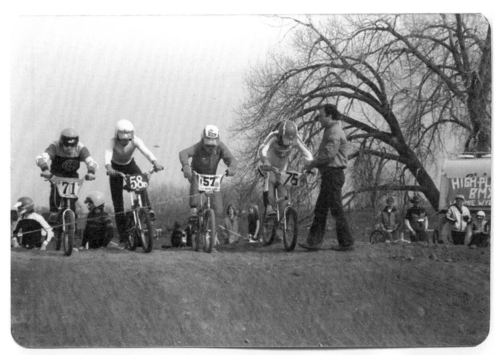

I CAN'T LIVE WITHOUT MY RADIO

Anthony Pappalardo

Calling it a boom box wouldn't be accurate—the small, plastic tape player I owned for most of my childhood barely boomed, but it did watch me roll around daily on cardboard attempting the worm to the *Beat Street* soundtrack. If I pointed the antenna in the right direction I could get the good college radio station, the one that played vulgar heavy metal late Tuesday nights. The dual-cassette deck and springy pause button were all I needed to make mix tapes complete with inane soundbites via its built-in microphone.

My Realistic brand radio provided a Sabbath soundtrack to crashing my BMX attempting to jump dirt mounds. Its two bug-eyed speakers watched as I tried to grind off my frustrations all winter in my basement as the Descendents sang about girls I'd never meet.

Over the years, my radio was like a snake in reverse, constantly being covered up by a new skin. It started with stickers from radio stations, rainbows, and scratch-and-sniff slices of pizza. Later it was Megadeth, Testament, and Anthrax before a layer of crack-and-peel stickers made at Kinkos covered every inch of my radio. I rarely flipped it to FM or AM during its twilight years. The sounds spinning on Memorex tapes were of bands I found in the pages of zines and dubbed by pen pals with funny nicknames. There was a new skateboard company logo stuck on my radio every week, a new band name, and some graffiti that I usually couldn't read.

Somewhere in the bowels of my parent's basement, it's still there, in a moldy box kept company by lawn darts, a Crystar action figure without the translucent sword that I lost the first day, and a copy of *The Anarchist Cookbook* that my sister's cat pissed on. These are the kinds of things you can never throw away.

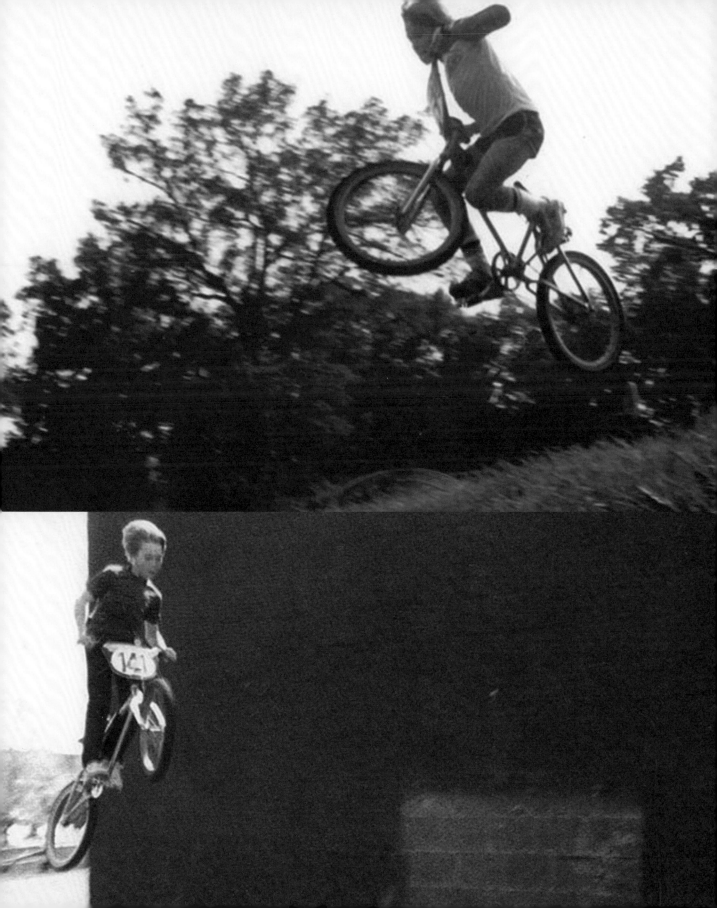

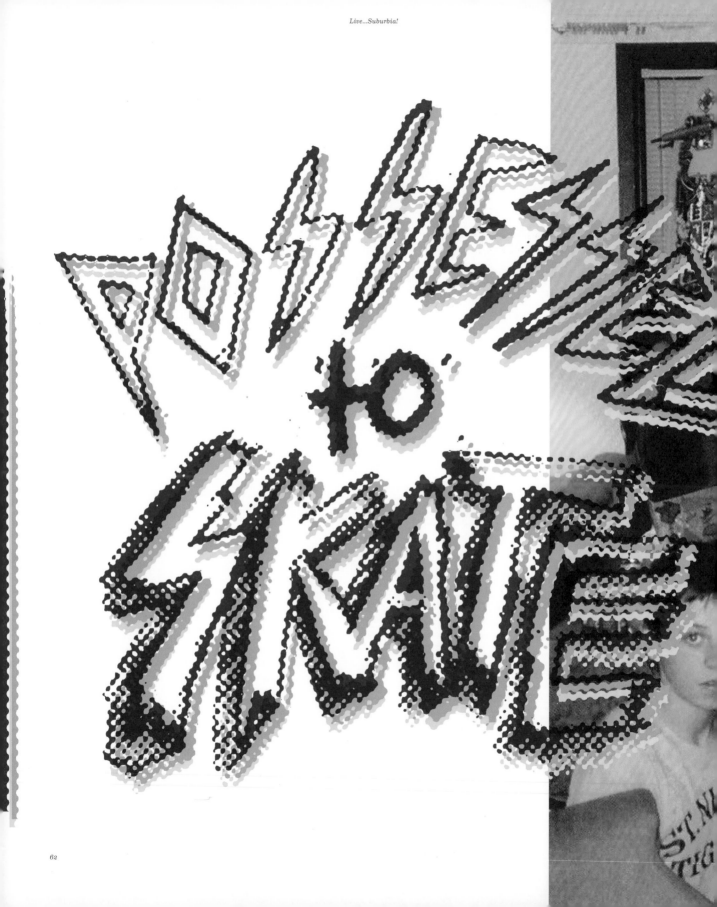

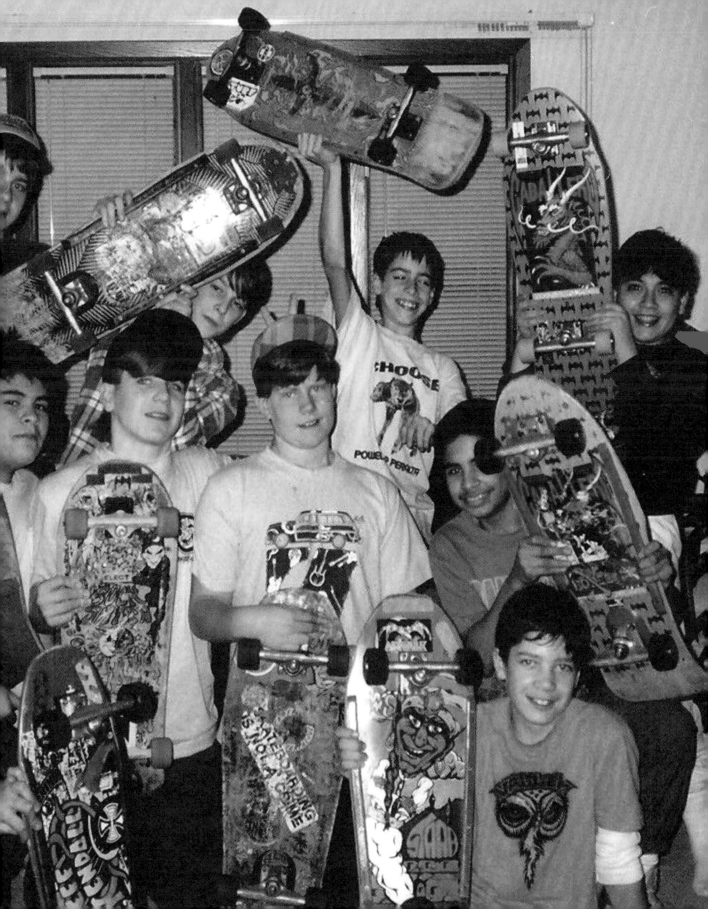

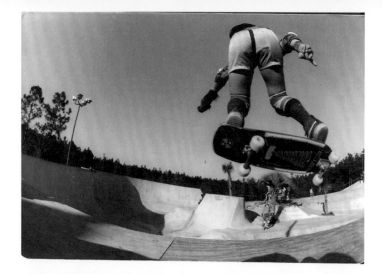

NAME
C. Chmielinski
MEMBERSHIP #
1042
EXPIRATION
4/14/80
CHERRY HILL SKATEPARK

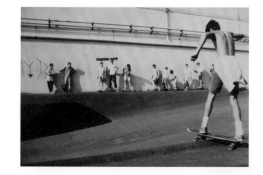

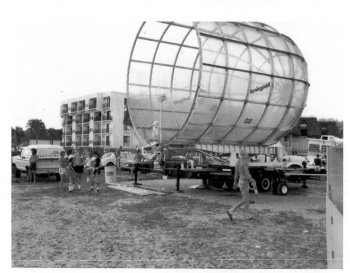

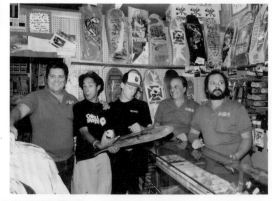

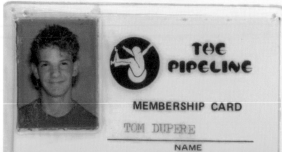

THE PIPELINE
MEMBERSHIP CARD

TOM DUPERE

NAME

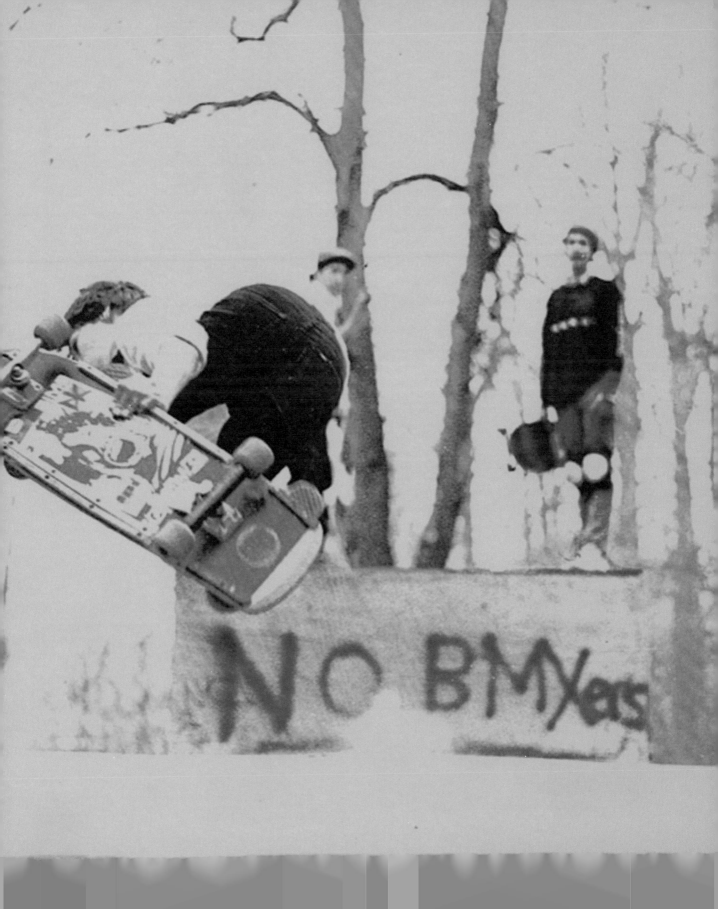

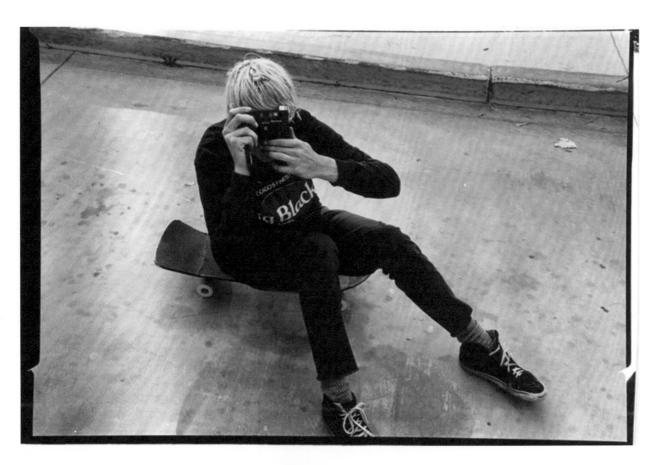

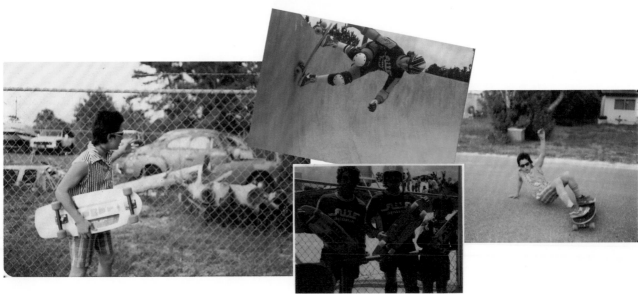

THE EXECUTIONER

Max G. Morton

Sitting in triple-digit temperatures on a humid beach for ten hours, I listened to the people of the local arts and crafts fair accuse my mother of witchcraft for peddling her ceramic, glow-in-the-dark unicorn horns. That day, she sold a painting of herself crossed with a lizard riding a Harley through a lightning storm of dragon flies and rainbow goblins. For my hard work-slash-patience I got a Kryptonics Ripstik. It was love at first sight with that skateboard. A one-eyed bleeding skull being cleaned out by a vulture was too good to resist. I would have bought it had it been an album cover. I liked it so much I actually swore it was going to be my first tattoo. I wish it would have been.

The skate shop was in a small wood-paneled strip mall a few towns over. It was too far to go drool in via bicycle and definitely too far for my mother to go grocery shopping nearby. I had only been there once before and had thought about it every second after. It was like an ad from *Thrasher* had come to life.

Within seconds of walking in, I pointed to my deck. Mother wasn't a fan, but she was a good sport. While the gym coach-looking, mustached owner put together my deck, he tried to tack some nose, tail and rail guards onto the purchase, bringing us way over budget. While I was still young enough to think the Kryptonics Ripstik was cooler than any Powell deck and that it would earn me fear and respect in the neighborhood, I was old enough to know that nose guards were gay. Mother was falling for the sales pitch but somehow I convinced her that the rail guards were enough to protect the choice artwork and we spent the remaining cash on some stickers.

While envisioning myself as the suburban Robbie Knievel, my board went flying into traffic and was chopped in half. I also returned home severed. Mother felt bad but made it clear that skateboarding was dangerous and too expensive. A long month later, she returned home from a mother-daughter shopping excursion at Zayre's with a Nash Executioner skateboard.

"It was a quarter of the price of your last board... AND it's complete!" she glowed. A complete piece of shit, maybe...

"This board weighs double and came from a department store that Grandma shops at."

"Max, this is better. The guy there told me it's the best one. It's not going to break in a day like your last one. I thought you liked scorpions..."

A fun new challenge presented itself. I had only a few hours to break the Executioner and prove Mother wrong. First stop, the bowling alley roof. Being the designated spot for mass destruction, it was easy enough to climb. Many cars passing by swerved into a ditch or fence from dodging the nail-ridden planks of wood that were tossed below as homemade speed bumps. Flaming dog shit, wimps' bikes, wimps, shopping carts, school books, you name it. It was all hurled off that roof, and most of the time, it broke. My Nash was turning out to be a little trooper.

Second stop was a construction site. The Nash outlived blocks of cement. Third was pellet-gun target practice in my friend Bobby's yard which only proved the Executioner to be bullet proof, nearly blinding us with ricochet. Finally, Bobby and I went to the garage where his dad repaired cars. When he used an electric saw on the board, sparks flew. Once it hit the rail guards, the saw stopped mid-grind.

"Dude no chickening out!"

"No way man. I am done. This thing is too *Christine*. It just melted my dad's favorite saw."

It was settled. I was stuck with the Executioner. The Executioner was indestructible.

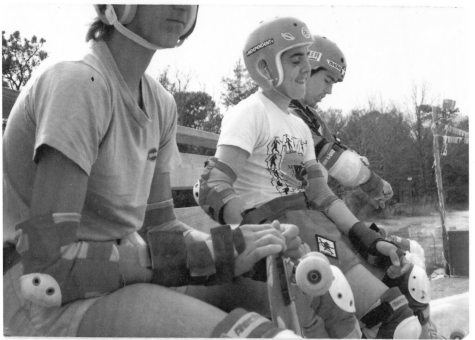

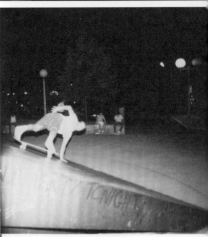
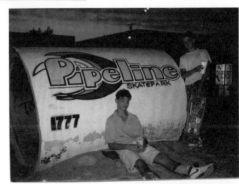

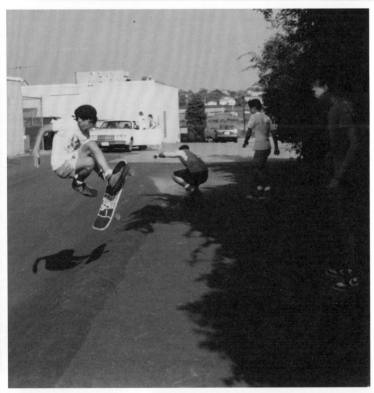

Pipeline SKATEPARK
1777

Cadillac Wheels
SKATEBOARD CONCOURSE
C. CHMIELINSKI

CASEY Chmielinski
Name 2027
Member #

SENSATION BASIN

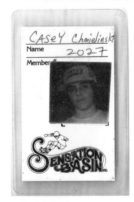

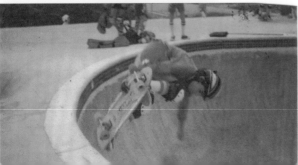

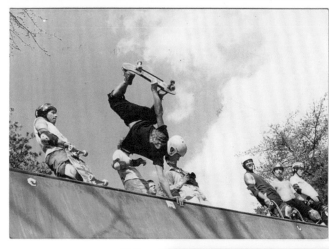

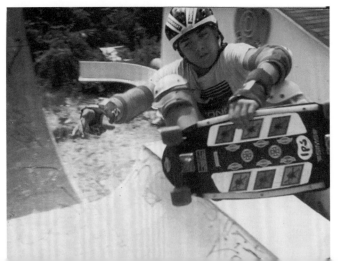

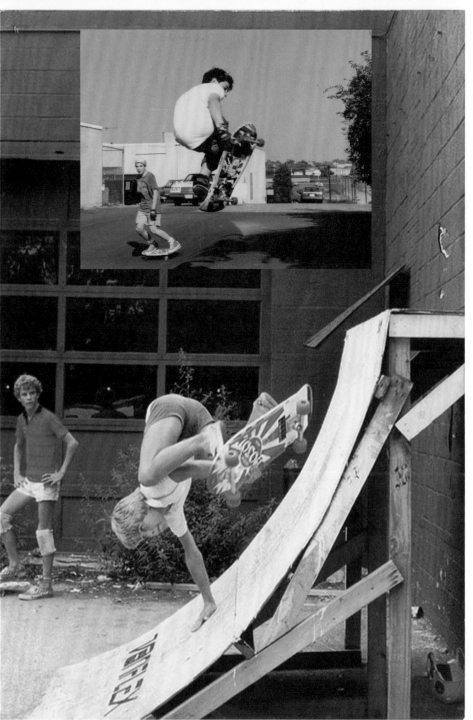

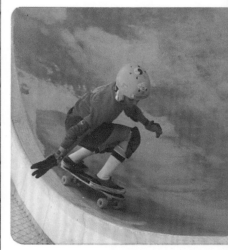

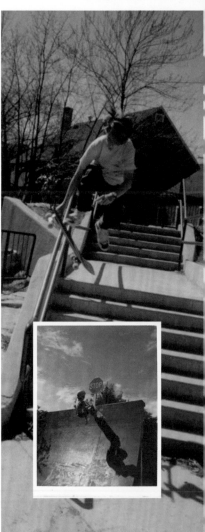

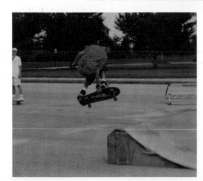

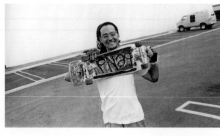

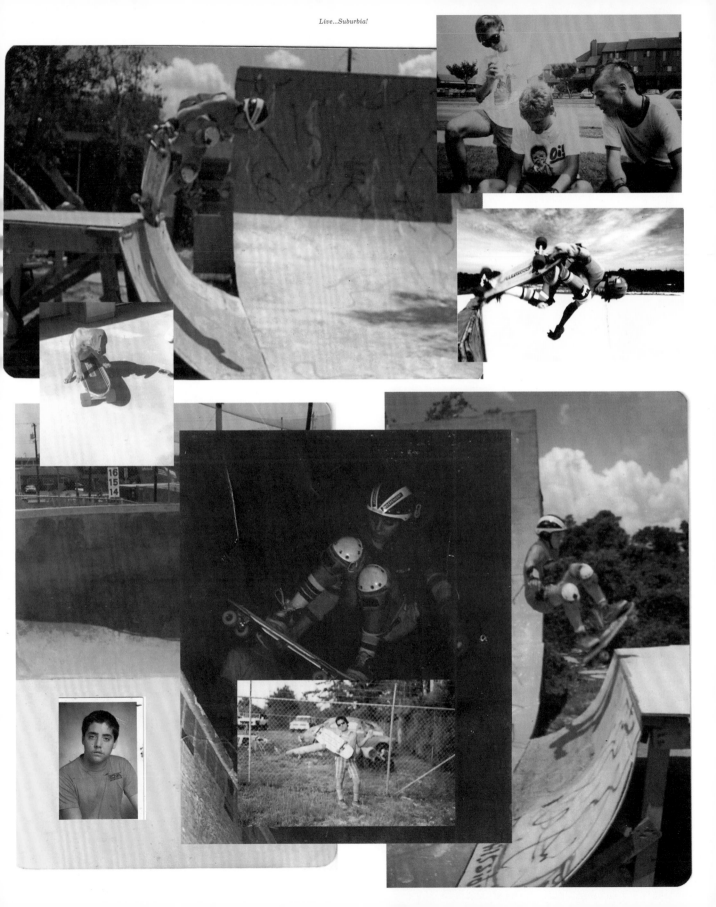

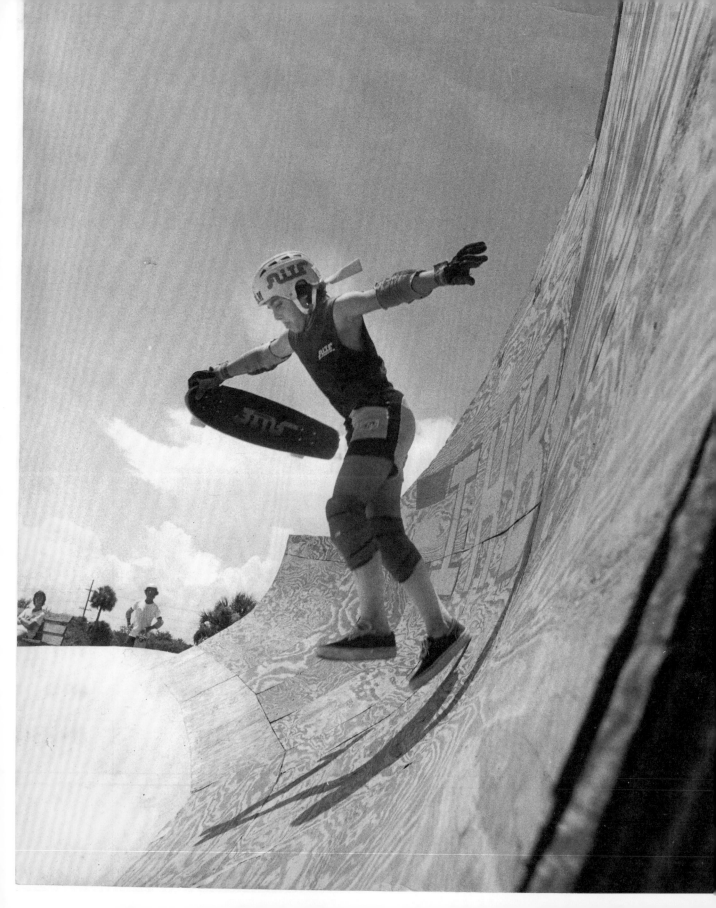

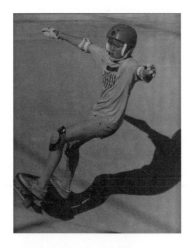

THEATRE OF PAIN

Anthony Pappalardo

Nothing ever came to fruition in Salem. It was a second-rate town, with second-rate chicks, a second-rate mall, and nowhere to hang out. The only thing going for it was a second-rate movie theater that showed movies no one else would bother screening. Or—you guessed it—second runs. Normally, this was just a cheap way to kill time on a rainy day or to hit on girls who didn't attend your high school but, in 1989, it was one of the few theaters showing *Gleaming the Cube*.

When I saw the words "GLEAMING THE CUBE" spelled out in the Sunday paper, my jaw dropped. An already slow school week would now creep by in anticipation of the Friday night debut of the movie. I had a week to rally together every friend I knew who rode a skateboard. Maybe there'd be other kids at the theatre who skateboarded, had halfpipes, and knew cool punk chicks who smoked cloves and who thought floppy hair and turquoise Vision Street Wear sneakers were cool. We'd find out in a few days.

Stacey Peralta, half of skateboard company Powell Peralta and skate video mastermind, was a consultant for the *Gleaming the Cube* and several pros appeared in the movie. Even Tony Hawk talked about the movie in *Thrasher*. Their credibility convinced me it wouldn't be a hokey novelty movie. I was sold. I spent the week preparing, which meant a trip to the Salvation Army in hopes of finding a surplus army jacket and drawing myself a Suicidal Tendencies t-shirt featuring a Vato Skull and the words "Pledge Your Allegiance" (which my mom helped me spell correctly) in faux Los Angeles gang graffiti.

Friday arrived and of course I declined a ride to the theater. My next door neighbor and I had a plan to be in the parking lot two hours before the movie. From there, we'd chug Big Gulps, ingest McDonald's burgers and different forms of sugar and, of course, skate! There was no way the theater would kick us out, as we were actual customers that night and the parking lot was huge. We pushed our way to the Salem Tri Cinema and heard the hum of Swiss Bearings as we got closer. About 15 kids were pushing across the parking lot. Someone had found a piece of plywood and propped it up on the curb with some rocks, creating a springy

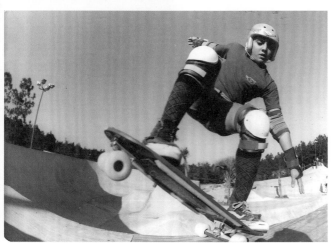

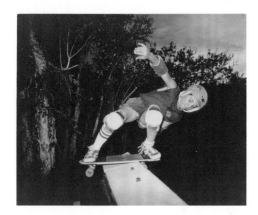

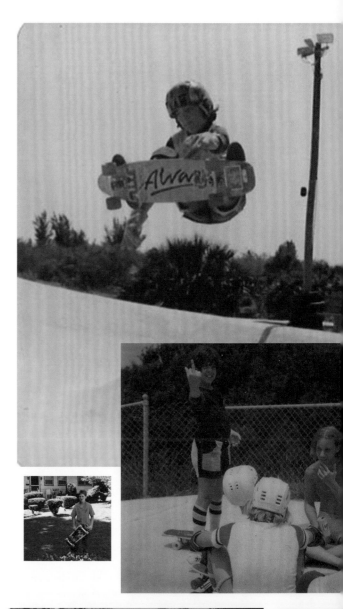

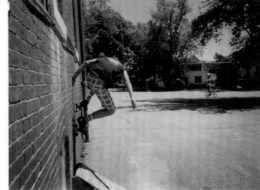

wedge ramp that wasn't really good for anything other than symbolically being a ramp.

As 7:15 p.m. approached, two things became apparent: Christian Slater's dashing looks weren't going to pack this theater, and that this movie wasn't a battle cry for every local skater to come together and make a statement. I knew everyone in the parking lot and the only girls who showed up were the same four awkward R.E.M. fans who sometimes wore Doc Martens and never had sex with us. The movie itself was equally uneventful and borderline depressing. The plot barely made sense right down to a fleet of police officers being scared off by Tony Hawk's pizza delivery truck, and the overall message was really disturbing. The movie started off with the obligatory skateboarding montage and introduction to the main characters including Yabbo who lived in a bomb shelter, but upon Christian's adopted brother being murdered, things took a turn that resonated with all of us. No one took Christian seriously because he was a skater, and if he was going to solve this murder mystery, he'd have to drop the board and his "edgy" look and be normal. Lastly, he'd need the help of a detective in order to sniff the right trail and bring the murderers to justice. The moral of the story was that skaters are fucking losers and you still need a cop to save the day... barf. If you want to get the girl and solve the mystery, you need to ditch your loser friends who live in underground tunnels and be a regular boy.

The soundtrack sucked, the skateboarding was forgettable, and there weren't even any hot chicks in the movie. We ended up sneaking into *Ghostbusters 2* afterwards to ensure that we'd have the worst night ever. Later in the year, Flea and Yabbo teamed up to skateboard and wear stuffed animal pants in Young MC's "Bust A Move" video, and most of my friends quit skateboarding to pursue a more stable existence. By the time *Gleaming the Cube* was being shown on cable television, I had a library of actual skate videos in my bedroom. For some reason they changed the name of the movie to *A Brother's Justice* and, later, *Skate or Die*, which was kind of funny for a murder mystery. I'm sure they could have easily remade this movie with pogo balls, snowboards, and probably rollerblades, too.

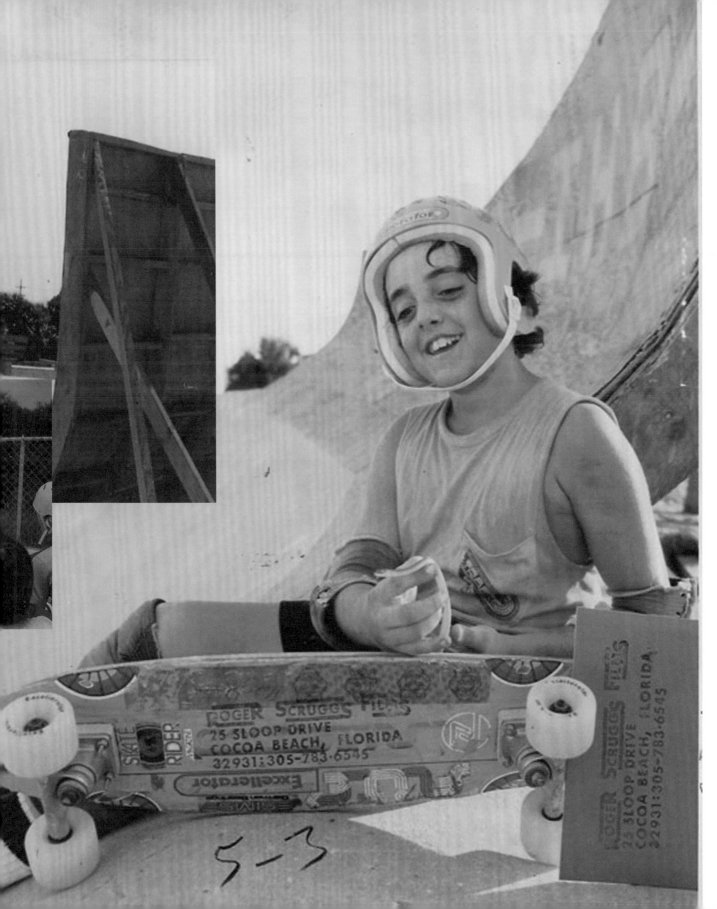

ROGER SCRUGGS FILMS
25 SLOOP DRIVE
COCOA BEACH, FLORIDA
32931:305-783-6545

SKATE
RIDER

Excellerator

ROGER SCRUGGS FILMS
25 SLOOP DRIVE
COCOA BEACH, FLORIDA
32931:305-783-6545

5-3

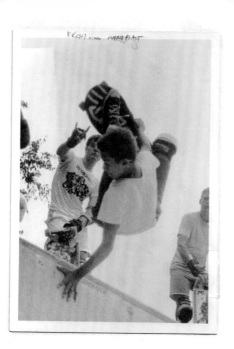

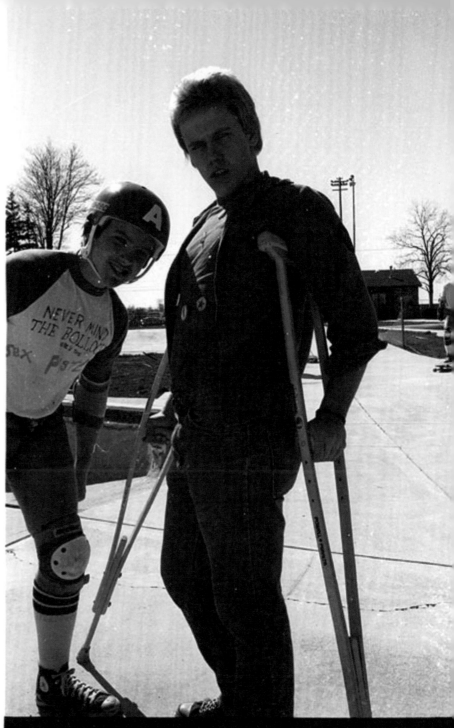

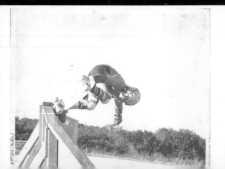

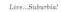

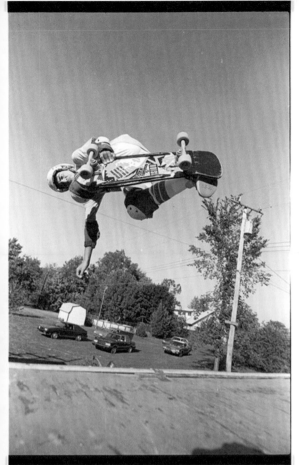

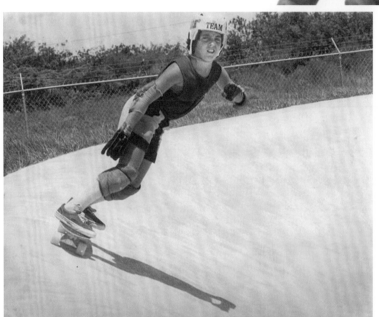

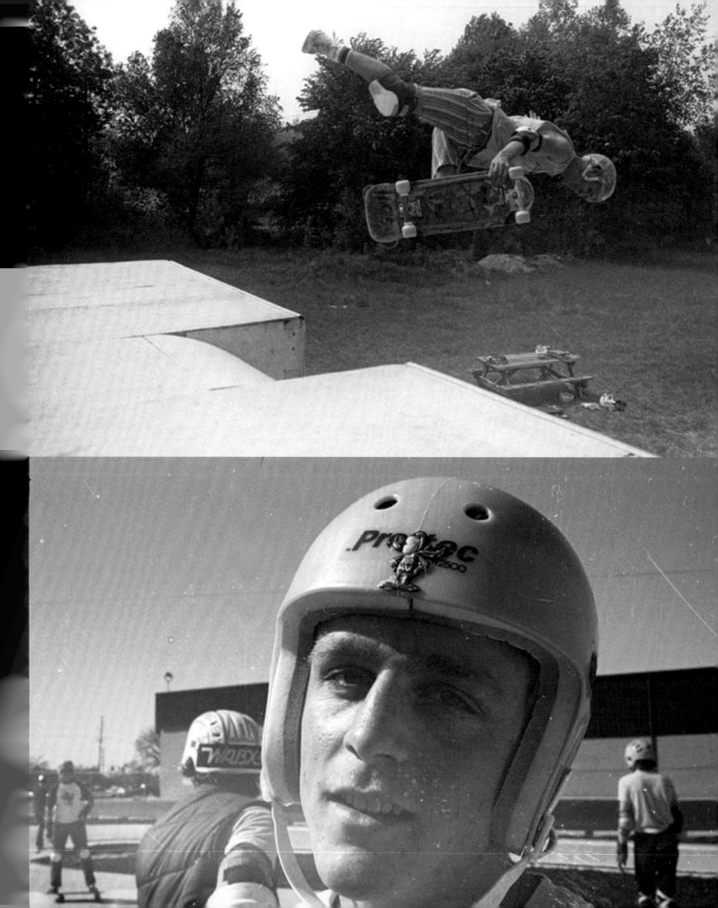

THE RAMP LOCALS

Anthony Pappalardo

In middle school, I graduated from a clunky Variflex skateboard with a clip-art snake to a Sims Kevin Staab deck bearing a Day-Glo pirate. When my Slime Ball wheels hit the rough pavement of Salem, New Hampshire, I was telepathically transported to Venice Beach. My Masshole accent faded and I spoke with a nasally tone and used words like "stoked" that my peers didn't understand. Maybe it was all mental, but suddenly I could grind further on yellow curbs. The department store board curse was lifted and I was baptized.

My board became the most important accoutrement of my teen years. It traveled with me to the mall, dentist, on family vacations and any taunt of "poser" was quickly answered with a boneless or some other maneuver I picked up from the pages of *Thrasher*. Sadly, it wasn't long before I learned that the valley landscape of my town wasn't engineered for my new passion. The curbs barely slid and the drainage ditches that lined every inch of southern California weren't a staple of New England architecture. Some kids I knew had half-finished halfpipes rotting in their yard but they chose tennis rackets and chasing girls in polo shirts over shin bruises and grip tape burns. Their ramps remained unfinished and off-limits. I'd have to steal some wood from the dozens of two-car garage prisons being erected around me and build my own structure to launch myself to California.

Ramps were referred to as "eyesores" at our dinner table, though somehow tacky landscaping and novelty mailboxes were perfectly acceptable. Any ramp I made would have to be hidden in the bushes, and every time I'd push off to retrieve it, I'd hope some stoner didn't light it on fire or that the rain hadn't waterlogged it beyond repair.

My town had a potluck crew of skateboarders, most of them wore B.U.M. Equipment and Bugle Boy jeans to school to avoid being labeled a "skate fag." I'd push over to the apartment complex where a few of these incognito shredders lived and they'd emerge wearing berets, fanny packs and bright clothing. We'd go to Marshalls and steal the tags off the odd-sized Gotcha and Jimmy'Z closeouts hanging on the racks. The hangtags would fold back to reveal stickers with which we'd mark our territory—usually parking blocks. Skateboarding wasn't on television;

there were no skateparks in the entire state and not one skate shop in Salem. *Thrasher* magazine, secondhand dubs of Powell Peralta videos, and imagination were all that kept it alive in my world.

The 1986 cinematic masterpiece, *Thrashin'*, was one exception. The movie's limited release didn't reach any of the nearby theaters, but it did show up at the Video Express where I'd make my weekend selections after picking up pizza and Cokes next door every Friday night. My routine was simple: run to the new release section and hope for an action movie or campy horror film, double over the martial arts section for another installment of *American Ninja,* and finally head to the sports section where *Psycho Skate* and other slightly out-of-date skateboarding titles occasionally appeared. Most skate videos were under and hour but cost as much as a movie, so I'd have to convince my parents that I would watch it at least three times, for maximum value.

Not only did *Thrashin'* reach my town, but it costarred Pamela Gidley, a resident of Salem, New Hampshire, and winner of Wilhemina Modeling Agency's "Most Beautiful Girl In The World" contest in 1985. Pamela's acting career began opposite Josh Brolin in *Thrashin'*, which featured several pro-skater cameos, the Red Hot Chili Peppers, and a half-decent/half-embarrassing soundtrack. Her performance may not have won her any awards, but it was a springboard for her film and television career, which included an episode of *MacGyver* and the punk train wreck of a movie *Dudes* (also featuring Flea). The fruits of her labor manifested in a DeLorean that never moved from the driveway of her parent's half-acre ranch home on one of Salem's main roads. Our budget skate crew would often skate down the street, saving our best ollie for the curb cut in front of her house. Though she probably lived in Los Angeles now, in our minds she was just waiting in the window, praying to see some "real" skateboarders ride by and sweep her away. I calculated our age difference and it could have been a little awkward until I could drive, but after that we'd be a perfect match. Pam never appeared in Salem or ran out to compliment the foot-high indy grab that I executed perfectly right in her front yard.

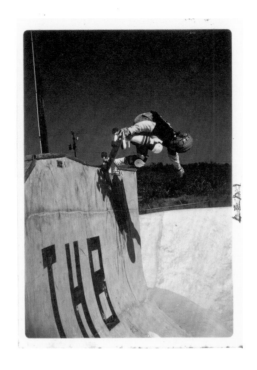

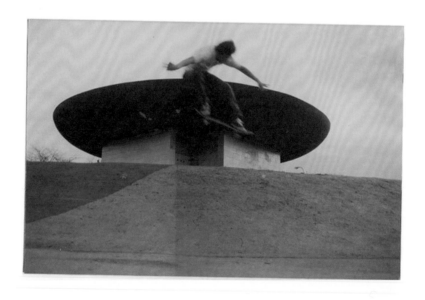

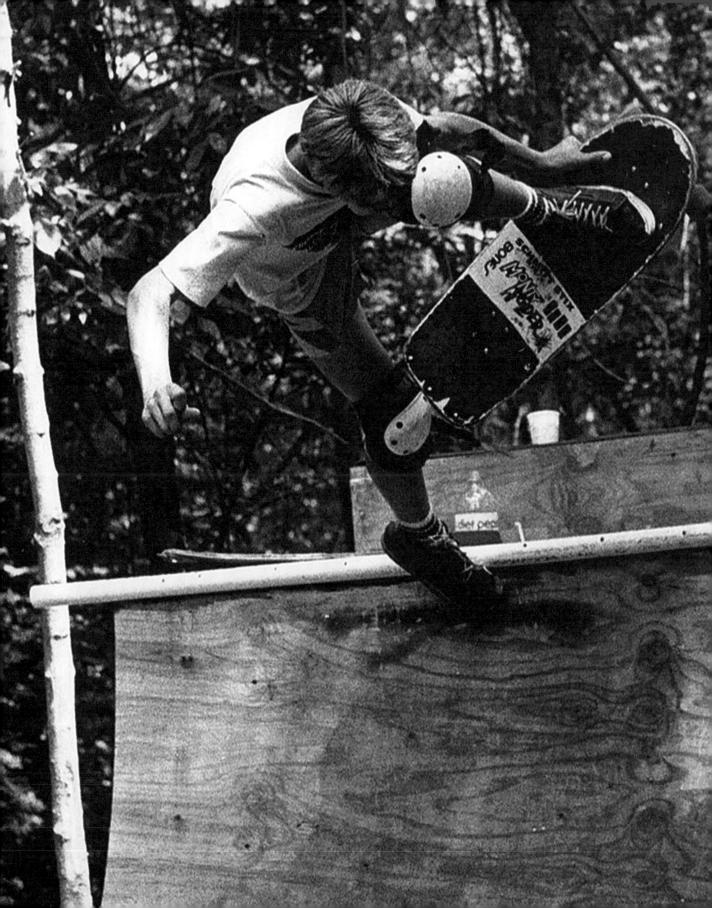

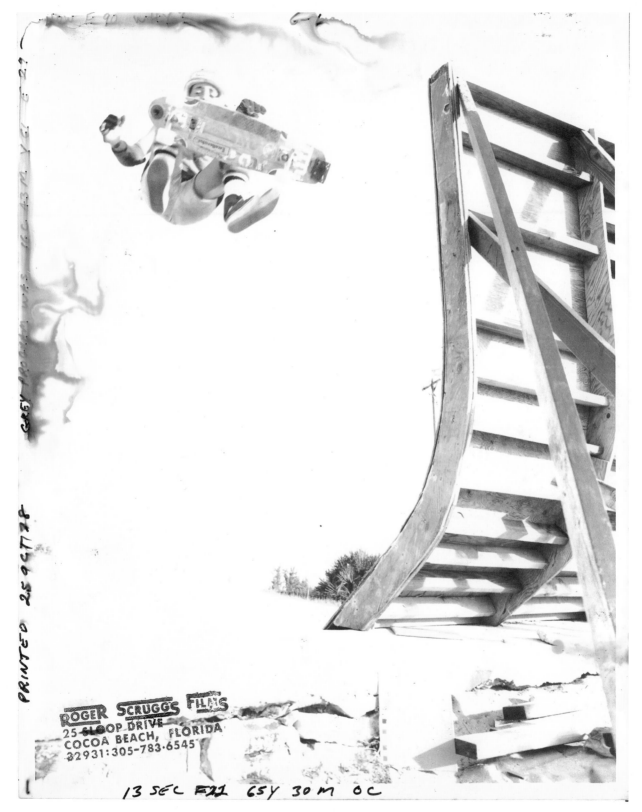

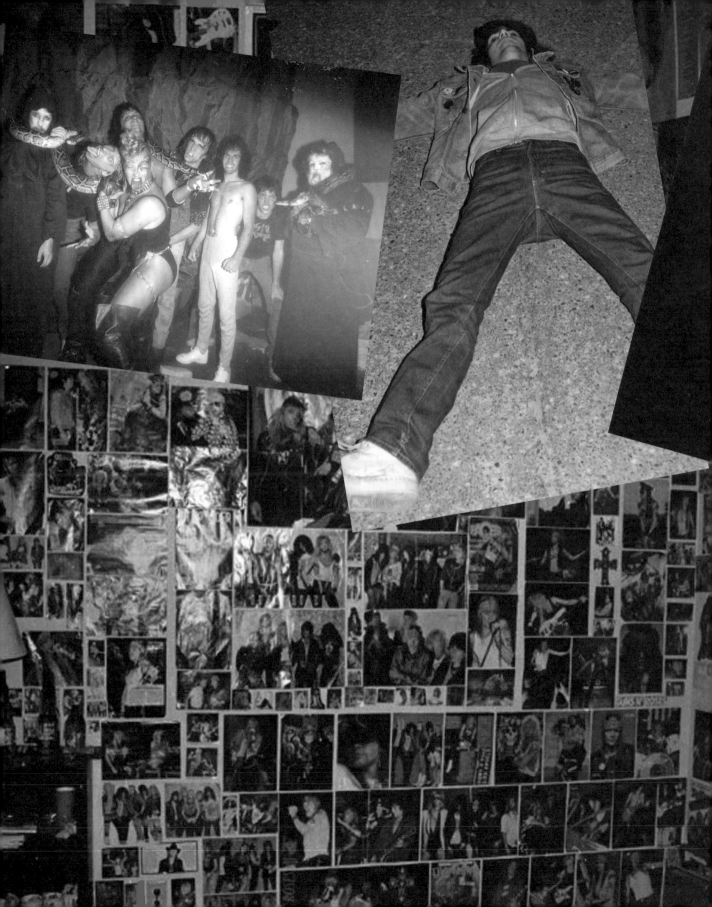

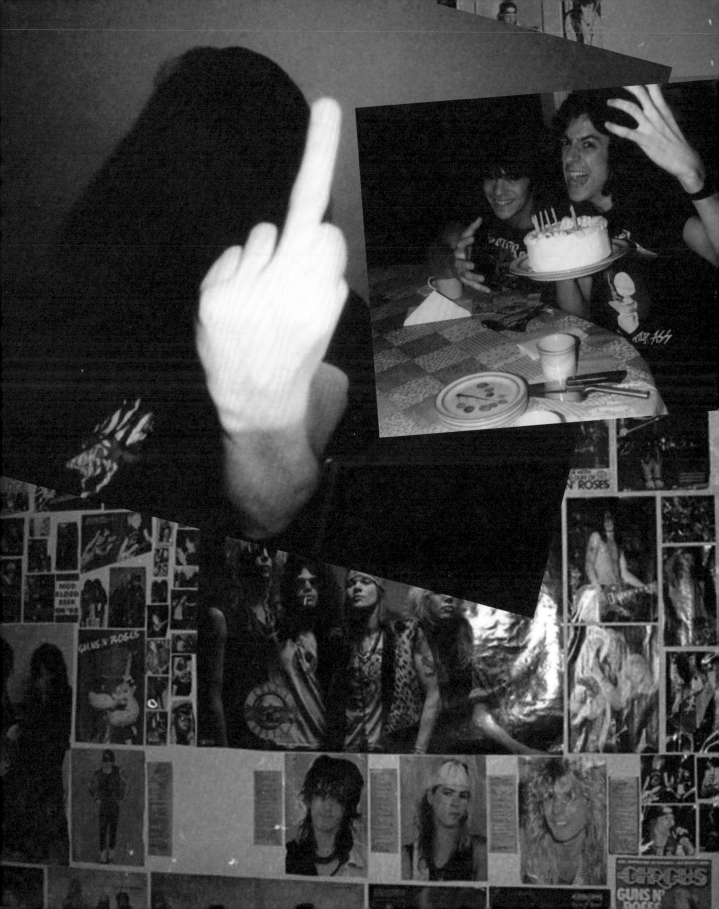

GET YOUR WINGS

Anthony Pappalardo

Moving from a city to a town meant access to the woods: a place without laws or supervision. My body was covered in denim on a brisk September afternoon. My new neighbor (and best friend by default) and I were sitting on a rock behind a scummy pond, deciding which mistake we'd make next. Like good New Englanders, we had worn out our Nice Price copy of Aerosmith's *Greatest Hits* and learned—or so we thought—from the lyrics to "Mama Kin," that you could smoke tea. Somehow, we knew more about making a pot pipe than we did about what to smoke out of it. After heating a penknife over a small open fire, we bore a hole through half of an empty plastic Easter egg. The shaft of a BIC pen was then inserted into the hole and some tin foil placed in the purple cradle. After punching a few holes in the foil, we were ready to pour the contents of one Lipton tea bag into the center and get higher than the Toxic Twins. The familiar scent of town fairs, concerts, and seedy bathrooms filled the fall air. It smelled like we were getting high, but with only a few stolen cigarettes under our belts, we didn't know what to expect other than a light head and hopefully hallucinations. It was apparent that the smoky taste of plastic wasn't going to result in anything but headaches and disappointments. We immediately vowed never to speak of our Lipton christening and opted to light things on fire instead.

The dry brush behind Bodwell Pond quickly ignited, but we weren't worried. At the very worst, we'd leave a burning monument to preteen ignorance behind a small body of water that would eventually fizzle out. Unfortunately, two idiots who had just finished smoking tea from a plastic egg aren't good judges of how flammable nature is, and the fire quickly took over a 30 square-foot region which Johnny Cash-ed us into a ring of fire. We decided it made more sense to abandon the mess and air drum to a dubbed copy of Dokken's *Under Lock and Key* in a friend's basement, hopefully getting a glimpse of the stirrup-pant-covered legs of his 16-year-old Bon Jovi-concert-video-worthy sister, Liz.

Despite my neighbor/new best friend living three suburban homes away, I always chose to travel through the woods to make the journey home that much more epic. There was a chance that I'd find a waterlogged porno mag or even some beer. This day, fate left a white plastic bag—or "DeMoulas Bag" as they were called in the Merrimack Valley—after a local supermarket chain, in my path. I poked the bag with a stick as if it were a dead cat, and some Polaroid instant photographs fell out face down like snowflakes. Unfortunately upon flipping them over with my oak scepter, I quickly saw the bottom halves of naked middle-aged uncircumcised men and ran, for fear of becoming "a gay."

I pushed open our red steel door, complete with gold-plated door knocker, and heard my parents conversing about "that idiot who lit the field behind the pond on fire." Apparently the fire department had gone out to extinguish the blaze. I wasn't sorry to break up Salem's Finest's poker game or that I ruined a forest, because I was fixated on those fucking Polaroids. Why couldn't they have been of hot chicks from Canada that I could lie about fucking, only to hide in the toolbox I made in metals class? I felt tricked and weird. Little did I know, tricked and weird were the hallmarks of suburbia.

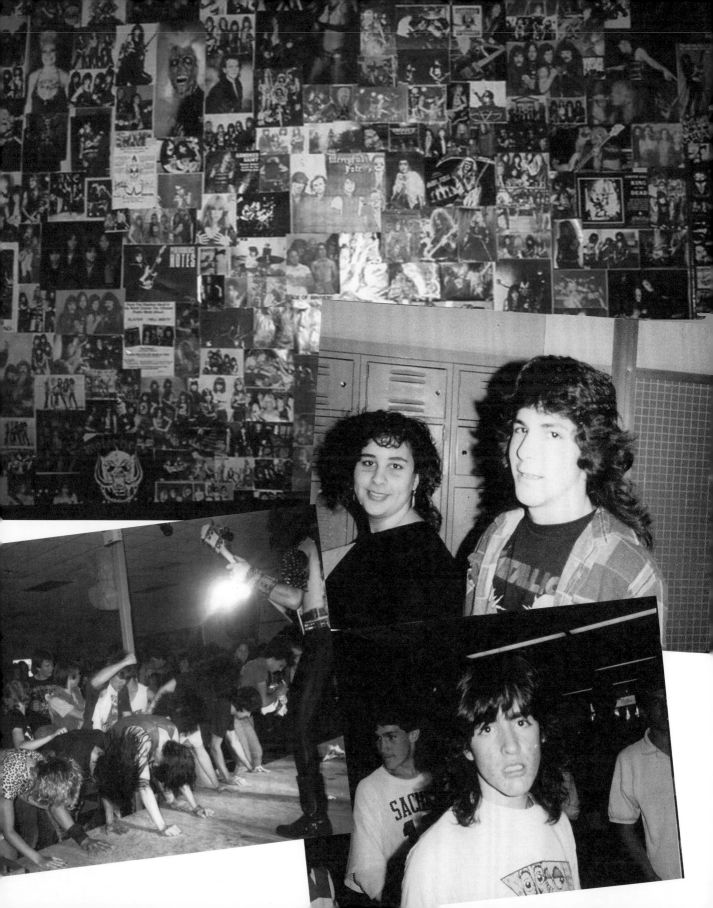

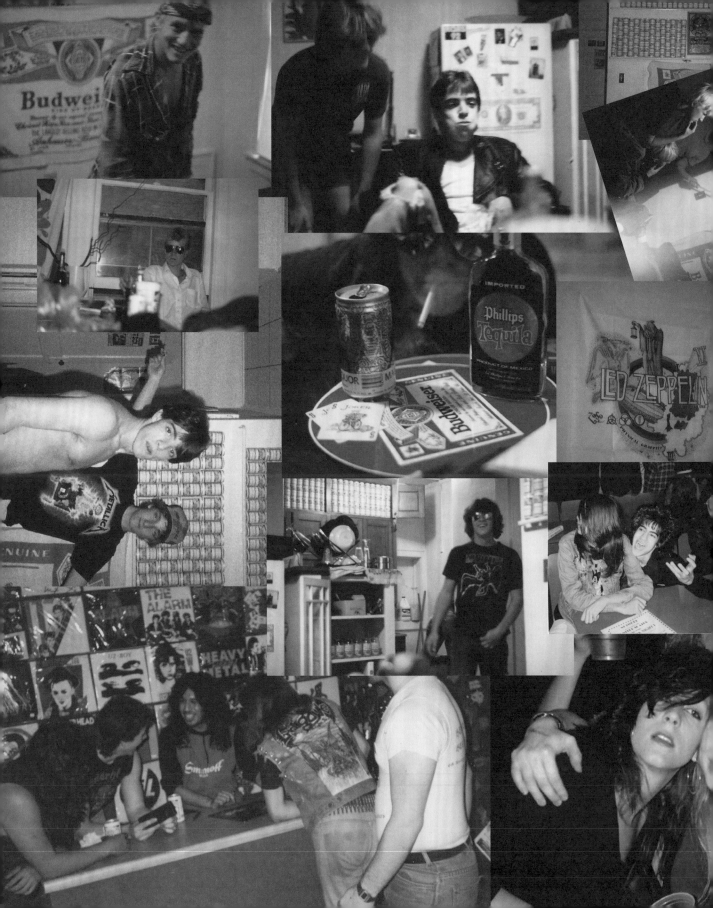

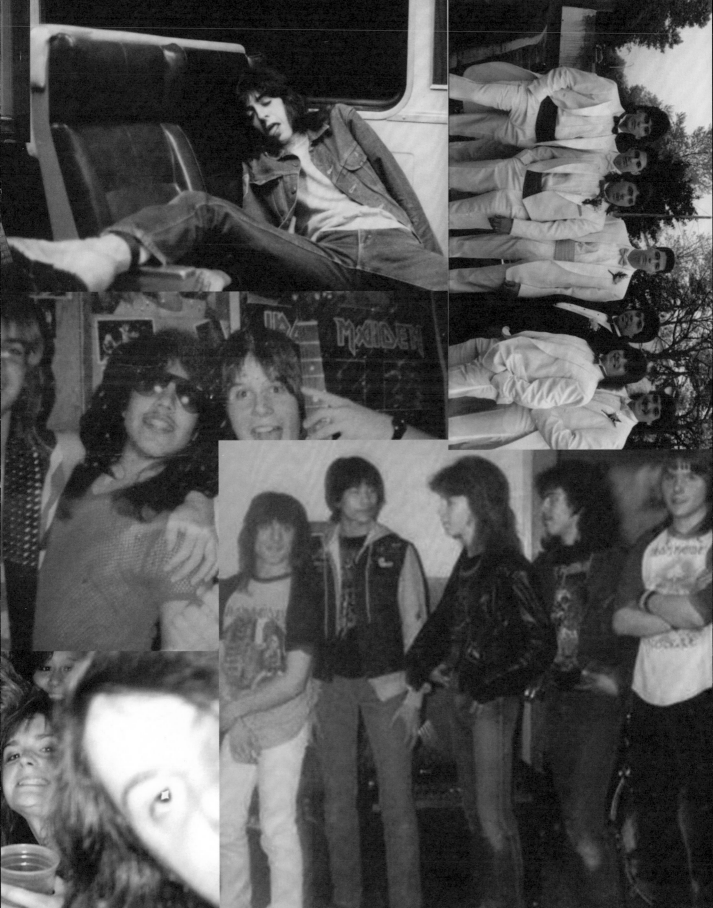

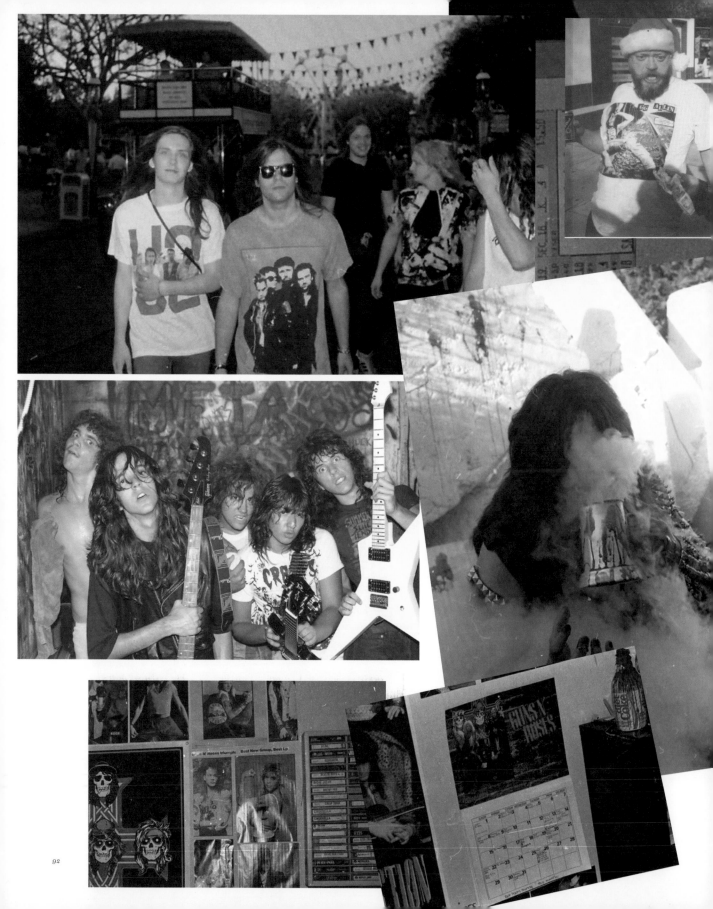

STAY HUNGRY

Max G. Morton

The motley half of my dojo went on a field trip. OD from Strong Island was treating us to see his hometown's legend, Twisted Sister. As always, I was the youngest and most inexperienced to be out past curfew. Mother felt that I would be safe with my sensei. Little did she know, the born-again, third-degree black belt had been born yet again, this time as his former, Detroit-wild-man self. His mustache was caked with cocaine and the previous night's blood adorned his snake skin boots. It was fitting that he howled along to the Ted Nugent tape he'd dusted off on the way there. I was caught sitting between OD's leathery vixen and Pat the punker from Miami who ate raw meat and sparred in a spiked dog collar. I guess you could have called me a heavy punker. They were both misfits who lusted after Wendy O. One liked uppers and the other dug downers. Sensei drove OD's yellow Mustang. A sick grim reaper with a banner reading "Masters of Reality" was airbrushed on the hood. Our dojo didn't fuck around.

The second we pulled into the parking lot and saw guys lifting up their girlfriends' tops and fighting in the backs of pick-up trucks, I knew I was about to cut my teeth on something rusty and most likely diseased. All the band logo stickers and shirts in the parking lot were new to me, not to mention all the fresh flesh. Sensei, Pat, and OD smuggled their drugs, brass knuckles, and a camera in the Tampax box of OD's foxy girlfriend. This was a time in suburbia when a box of tampons was so taboo that a security guard wouldn't dare put their hand inside of one. Once past the metallic gates, OD raided the merch for a new pink muscle tee and headband. Sensei and Pat went to piss while I watched the blonde witchery deep-throat a hotdog. They were all pros in this leather and spandex-clad arena and I was not. Metal was king and these hairy barbarians were charging through the venue shouting fist-banging obscenities.

I felt more alone and extremely smaller than normal as the first power chord of the night rang out and some gargantuan yelped, "Tampa, are you fucking ready to rock?" Separated from my karate buddies as the beer-soaked stampede charged, my stomach dropped and my head ran with 1001 what-ifs. How the fuck was I going to get home? In the midst of chaos, something else erupted. A standoff between a dude not much bigger than myself in a button-up shirt and a blob in a denim vest. This volcano of human flesh had apparently fondled the button-up's property.

Fed up with the commentary on his outerwear, the button-up fired off a round of front kicks to the groin region of his obese opponent. After the fifth solidified the reality of how fucked he was about to be, he backed off, abandoning his girlfriend. Reaching through the crowd, the beast grabbed his victim. Holding him right up to his mouth, he bit down on the front pocket of the button-up, tearing it clean off. He threw the wimp onto the floor and a pit of laughter rose to a climax of food and beverages being chucked at the guy.

OD put his hand on my shoulder and handed me a Twisted Sister shirt. "Dude, that guy ain't getting laid tonight." We laughed and took our places in the front row.

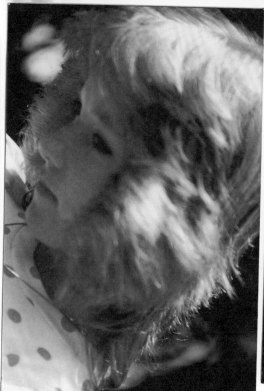
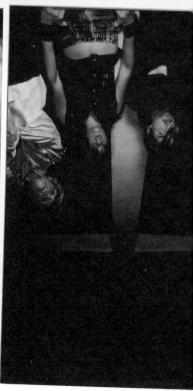
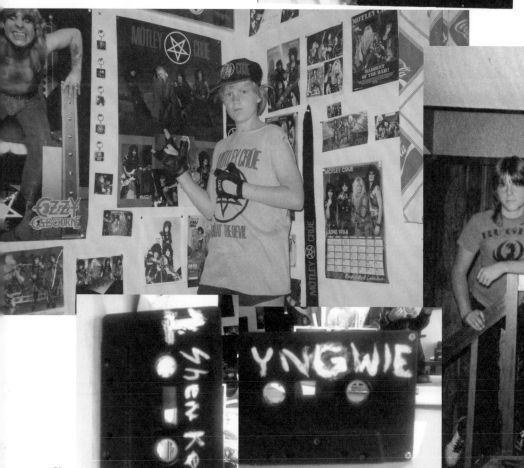
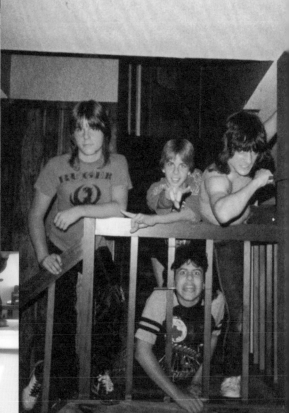

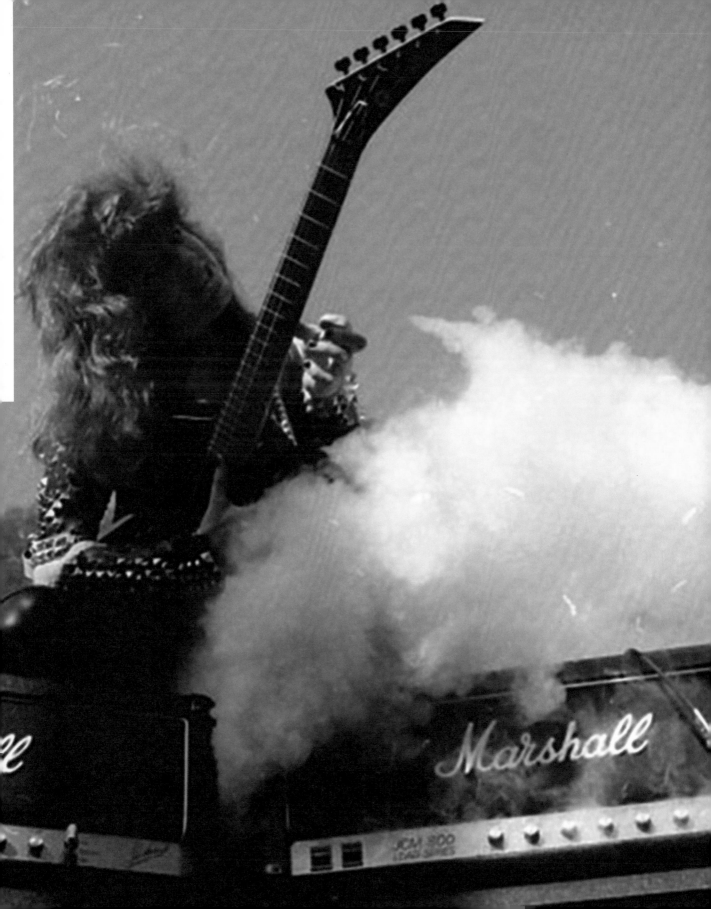

DONE WITH
MIRRORS

Anthony Pappalardo

It only took 40 minutes to get to the Topsfield Fair from my home in New Hampshire, but the ride felt like 40 years. Unlike other trips to the fair, this one came with expectations. Normally my parents would surprise us on a random sunny day and take us to the fair unannounced. This year they made it known exactly what weekend we'd be going. I suppose it was the same time each year and I could have figured this out on my own, but I didn't spend much time as a kid deductively reasoning as to when I'd be in a large field surrounded by fried food.

I battled backseat boredom with Travel Battleship, a few games of punch buggy with my sister, and a few *Avengers* comic books that made me car sick. A friend convinced his parents to take him to the fair too; I had known him since kindergarten, and now we were both 12 years old. Once we met at the entrance, we'd have roughly three hours to win prizes, buy heavy metal paraphernalia on a tight budget, sample different fair cuisine, and hopefully lose our virginities behind an unsafe ride.

Knowing what was waiting for me at the Topsfield Fair made it impossible to sleep the night before, so I stayed up trying to perfect my dart skills. Using a red pen and a scrap of white paper, I crafted a mock-carnival target from memory. I was fairly sure the target was a thin red star and that all you had to do was hit any part of the star, but if you got it in the center, you'd win a top-shelf prize. All I needed to do was to hit one of the prongs to score the mirror of my choice. I was hoping they'd have an Overkill *Fuck You* mirror, complete with middle finger—which I'd have to hide from my parents—but I knew that might be a stretch. I didn't know that you were supposed to be sniffing cocaine off these things, but I should have figured out that mirrors with heavy metal album covers printed on them aren't really great at their main purpose of reflecting people's faces.

My dart skills were now sharp and it was time for *Headbangers Ball*. Alice Cooper had found sobriety and resurrected his shock rock career. He and his curly-haired, beefcake guitar player Kane Roberts were hosting the show. Kane played an electric guitar shaped like a machine gun and was promoting his solo record. He stood before a wall of Laney amplifiers and announced his soon-to-be can't-miss single "Rock Doll." As usual, the beginning of the show was completely shitty and packed with hard rock, but if you suffered through White Lion and Kingdom Come, you'd eventually see some thrash videos. Normally, I would have tuned out Mr. Roberts, but he mentioned that if you wanted to learn how to pick up chicks, then you should pay attention to his video. Kane was often featured in *RIP* magazine with hot sluts, so I figured he was an expert—plus, I didn't have an older brother to mentor me. Kane's video began with him dry humping his guitar while his 'roided fingers played wimpy licks of compressed hard rock. I wouldn't be choosing Kane's album for a K-Tel penny. I also didn't learn shit about picking up girls.

A quick stop at a gas station convenience store netted me a Jolt soda which quickly cancelled out my *Headbangers Ball* hangover as we headed into the home stretch. While my dad parked the car, I pulled my sunglasses out of my pocket and set a meeting point with my parents. The clock started ticking on my digital watch, and I was ready to find my own rock doll at the Topsfield Fair. My friend was already waiting at the gate wearing a painter's cap and an AC/DC *Flick of the Switch* t-shirt. I was confident in a pair of Levi's and the Skyway bicycles shirt that I begged my mom to buy me despite not owning a Skyway bike. There was no way we weren't meeting chicks today.

My dart training paid off and I quickly had a Megadeth *Killing is My Business* mirror in less than six darts (they didn't have an Overkill one). Normally, it would have taken me a lot longer to hit the prize-winning target, but my quick win was economical and I now had some disposable income. Maybe it was time to head to the airbrush booth and customize a t-shirt. I always wanted to get a caricature of myself sprayed into a famous album cover. I was about the same height as the doughy future warrior on the cover of *Paranoid*—it could totally work.

Airbrushing was pricier than I thought, so that was quickly ruled out. We decided to hit the outdoor dirtbag mall and see if there were any weapons or bootleg t-shirts we could buy. There were rows and rows of black market heavy metal shirts lining about 30% of the field. We coasted past the *1984* baby smoking cigs, several Ozzys, Eddies, and Pink

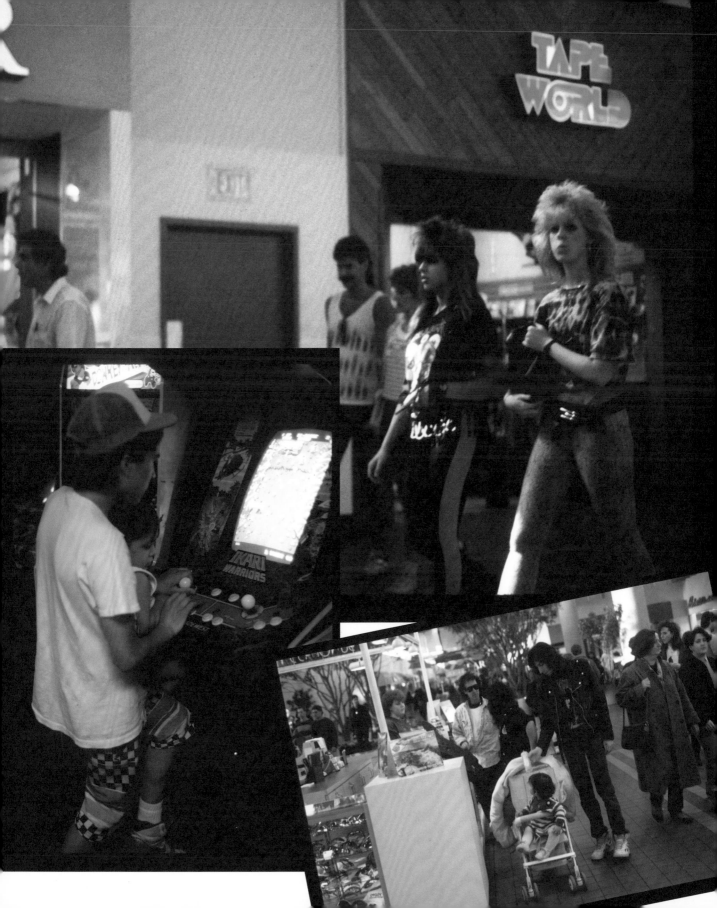

Floyd prisms until we found a rack with a *Ride the Lightning* shirt facing us. Pay dirt. We flipped through our new heroes, from S.O.D. to Helloween —they were all there waiting to find a home on our hairless chests—not a Stryper to be found. My heart was set on an Anthrax shirt that had the Not Man kind of riding a skateboard with Judge Dredd on the back; completely bootleg but a perfect marriage of mascot and ultraviolent comic book heroism. My friend's parents had a strict "no devils, no pentagram" policy, so his choices were limited. He pleaded with me to let him get the Anthrax shirt or he'd be stuck with a generic Metallica design. As soon as I saw King Diamond's face poking out of the next rack, Anthrax was his. The only King Diamond album I owned was the *No Presents for Christmas* EP because it was $3.99, but at least I wasn't a total poser.

It felt great to be official dirtbags now, but we needed snacks. We rounded the corner and spotted my sister moonwalking wearing a sequined glove as my parents paid for some cotton candy, and we immediately spun around. Beyond the ring toss, water gun races, and pop-tent smoke shops was a fried dough stand with a line of girls our age. Girl #1 wore a black-and-white zebra print shirt bunched together on the side with a pink ring, and her friend had on an oversized Europe concert shirt with acid-washed jeans. They were cute and we had never actually seen a girl who liked thrash metal and skateboarding, so Europe was good enough. One Tom-Cruise-sunglassed nod later, we were face to face with these retainer-ready girls, only to be quickly rebuffed when my friend nervously squeaked, "Ladies..." The *Night Ranger* soundtrack in the background stopped and the fairground went silent, only to be pierced by the giggles of the two girls. They were young, but old enough to have heard better opening lines.

We lost at love and fried dough but had a good chance at Ikari Warriors and nachos, so we quickly headed to the arcade with a little less pride. Europe sucked anyway and girls who liked them didn't really like metal—they liked feminine guys.

"*Ladies!*" I said in a mocking Ron Jeremy voice to my friend. "Where did you hear that, on *Happy Days*?"

"Fuck off," he responded. "You're the one who pushed down his sunglasses and glanced at them like the Karate Kid. Get a life, man!"

Controlling two shirtless war heroes with big guns was the bonding experience we needed to boost morale. The *Ikari Warriors* machine stood there blinking and beckoning. I placed a quarter on the rim of the screen to call next game as my friend got tokens.

"Anthony!" I heard from behind. "How's it hangin' dude?" It was the catcher of the Royals, my little league team.

"Whoa!" I responded in astonishment. "Nice Siouxsie and the Banshees shirt, Kev! Did you get that at Wild Tops?"

Kevin blinked through his thick glasses several times and tugged on the rat tail resting on his shoulder. "Huh, what? This shirt...it's

Nikki Sixx and it was only eight bucks because it doesn't even say Mötley Crüe!"

I knew from *120 Minutes* and the t-shirt section of the *Sessions* catalog that Kev was definitely wearing the portrait of a gothic woman on his chest, but you know what, no one else knew, and fuck...yeah, it was Nikki Sixx, sure. Who cared anyway? Kev was a fucking goofball who still built muscle car models and was sent home last year for shitting his pants. He asked if we wanted to race him at Pole Position and pointed over to the giant racing machine, but we were set on Ikari Warriors until we saw the KISS pinball machine adjacent to the driving game.

KISS didn't wear makeup anymore and had a rotating cast of guitarists who weren't Ace Frehley, but who could actually play guitar. No one cared about them or their pinball machine, no one except for a lanky guy we'd soon know as Gas or Gas Man.

Gas was surrounded by female backup singers shouting, "Here's your change, Gas!" "Nice shot, Gas!" or just "Gas!" He was either the one guy who ordered a penis enlarger from a porno mag and it worked, or he sold drugs. We were too much in awe to just peg him as a drug dealer. I scanned Gas up and down like Robocop and knew everything about him. His Converse Weapon high-tops had a hole from the grip tape of the skateboard leaned up against the pinball machine—he actually skated. He smoked Newports, liked Exodus, had one earring, a mustache, and 20 girlfriends. His belt was made of bullets and his tooth was chipped. The girls around him were wearing tight leggings and looked like X-Men characters. They barely had features, just little button noses and eyes that followed Gas like the *Mona Lisa*. Their names were Brandy, Candy, Sandy, and Mandy and most of them had feathered roach clips hanging from their hair. Gas gripped each side of the machine and thrusted like he was fucking Ace, Paul, Gene, and Peter in the ass. This was the closest to sex we'd ever seen besides walking in on our parents.

Occasionally, we'd check in on Kev and say, "Nice score," or something to show that we weren't gawking at Gas and his entourage, but our staring was obvious and soon we were approached by one of the girls whose name ended with a Y.

"You guys party?" she asked. Our party experience was limited to Beastie Boys videos and warm beer in the woods. We partied, but not hard. I didn't want my friend to blow it again, so I stepped up and simply said, "Yeah," while trying not to make eye contact.

"Two for ten, and if you got more, we got more. OK, Chachi?" she asked. "Just shake me the money in a few and I'll take care of you, OK? And don't be fucking obvious," she threatened.

Two what? Joints, pills, blow jobs? This immediately cut Kev out and we didn't have time to do much, as we'd be in leather-back seats with stomachaches in about 15 minutes. We needed an exit strategy, so we slapped the Pole Position machine, said bye to Kev and kicked rocks

outside of the arcade. I faintly heard Candy say something like "fucking narcs" as we walked out. My ears were ringing with the bells of falls, chimes of extra guys, and high–score cheers as Ozzy sang "Shot in the Dark." Next year, I passed on the Topsfield Fair. Like the mall years before, there was nothing there I wanted anymore. I'd spent that weekend behind a supermarket grinding a curb on my skateboard while my friend smoked Newports—an homage to Gas.

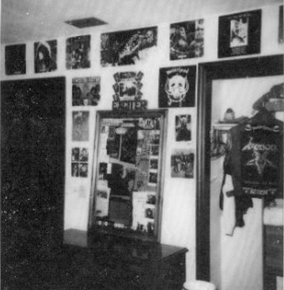

For suburbanites everywhere, stickers were a big part of pre-internet communication. If you were a metalhead, everyone knew by the concert shirt and patch-infested denim jacket you were wearing. If you were a metalhead at the mall, everyone knew you were doing some shopping due to the glob of stickers coated on the shittiest car in the parking lot. Some cars are subtler than others. Perhaps a classy lone Smiths sticker let fellow motoring vehicles in on your melancholy. Stickers gave hope and let us know that we were not alone, that we were not the only vegetarian or headbanger on board. Seeing a car in the parking lot covered in hardcore stickers was all the hope you needed to survive another lonely school year. Once you liked a band, you plastered the world in pride, not unlike mothers humiliating all the honor students on the highway as kids zoomed by giving the middle finger from the backseat.

When I was younger, I got a sticker everywhere I went. When I got home I'd place them on my bedroom door, never thinking we would one day move or I would grow out of AC/DC or Harley Davidson. When it was time to go, the door was filled up on both sides. I pleaded to take the door with me, but it was not an option. My collection was left for the next kid who inherited our haunted home.

– Max G. Morton

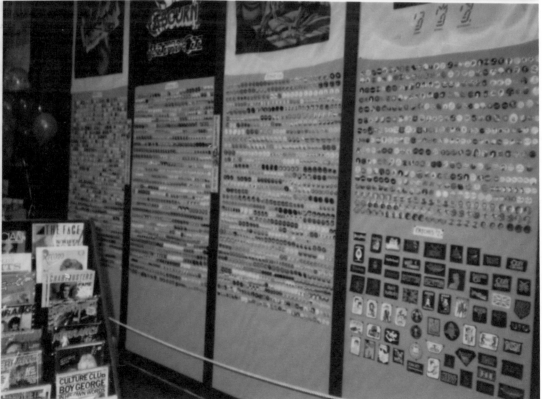

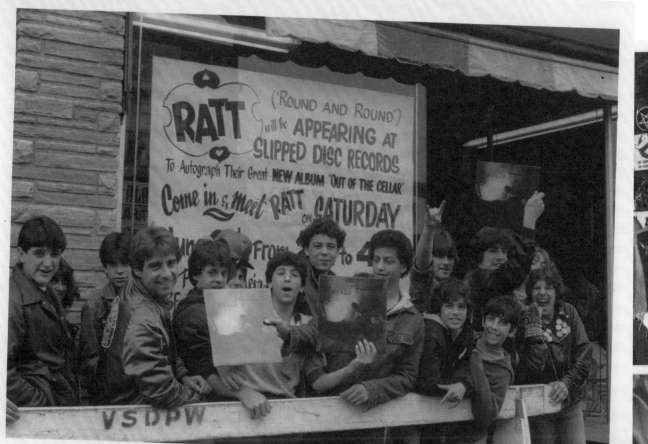

RATT ('ROUND AND ROUND') will be APPEARING AT SLIPPED DISC RECORDS To Autograph Their Great NEW ALBUM 'OUT OF THE CELLAR' Come in & Meet RATT on SATURDAY

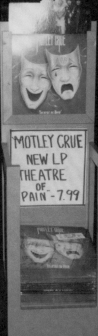

MOTLEY CRUE NEW LP THEATRE OF PAIN - 7.99

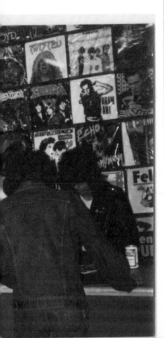

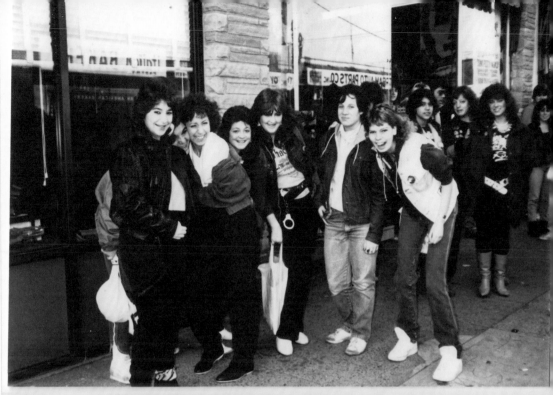

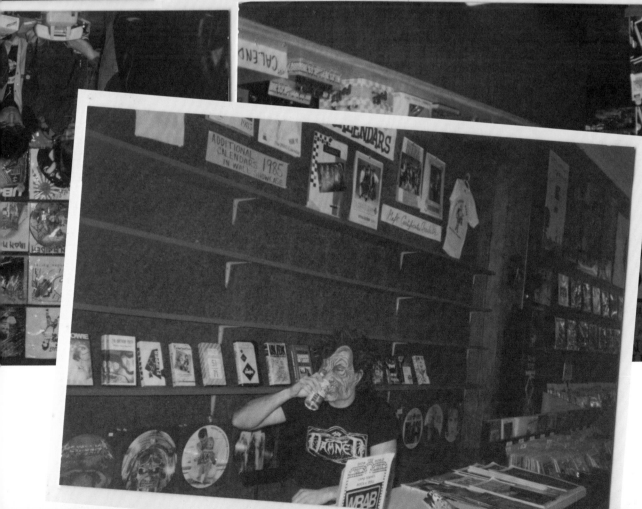

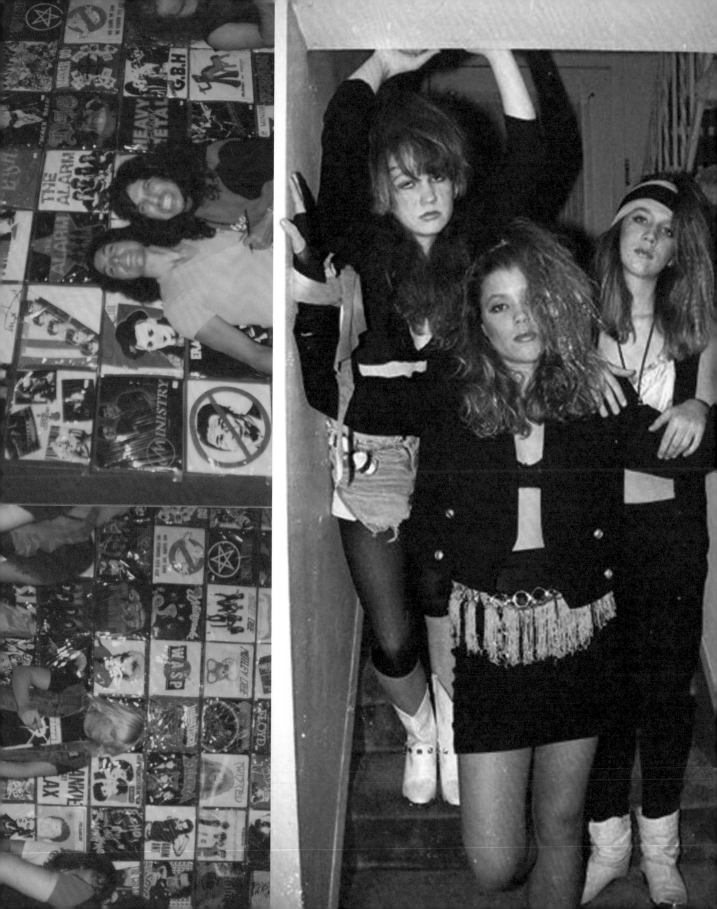

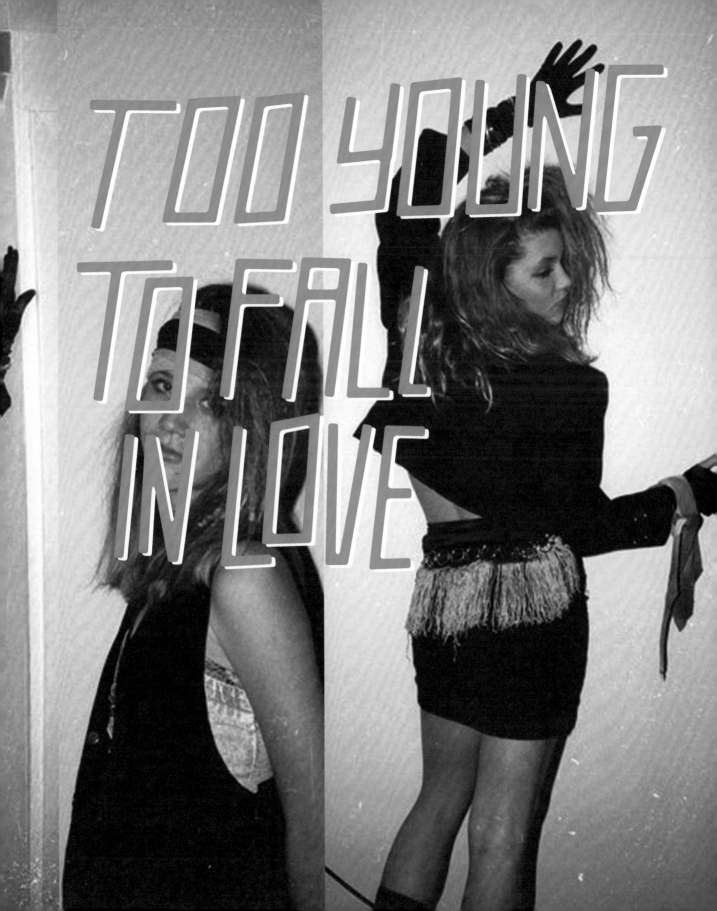

A COIN OPERATED RIDE THROUGH A HEAVY METAL SCHOOLGIRL'S FAVORITE PINBALL MACHINE

Max G. Morton

There are many reasons to never go back. That's why time machines aren't marketed to the masses. Girls that were once beautiful like Traci, Shannon, and Kelly are a prime example. Clearly 23 years later they don't have being 16 on their side.

Kelly looked like an eagle. Pushing seven feet tall, her acid wash camel-toe could have devoured a small rodeo town. Like most dominant birds of prey, she was the president of their group. The more dicks one made disappear, the more power they owned, I suppose. She was all-knowing. In math class she'd explain the facts of life. "Grow out your hair and get a BC Rich. Punk will never get you laid." Her hair was feathered via spray adhesive. Hail, snow, sleet, rain; it never budged. Note: the same carrier that coined that motto adorns an eagle as their logo. Girls that tall seemed untouchable. I didn't know what to do with a five-foot girl, how was I expected to handle two more feet? Her stern looks of disapproval whenever anyone even spoke to her were enough to instill the fear of ever entertaining the thought of masturbating to her feathered glory.

Shannon had a flat face. Rumors circling this bizarre facial construction ranged from a horny Pit Bull to a freebasing malfunction with Mick Mars. Somehow it all seemed believable. This was Florida, girls got face-lifts all the time from junkyard dogs. Shannon wasn't up to caliber for Nikki, Vince, or Tommy and, despite the most popular rumor, I am quite sure she never got hit in the face with a frying pan. She was the weakest link of the crüe. She never had much to say, but left for lunch daily and went to every club and arena with Kelly and Traci. Kelly probably kept her around for vanity's sake.

Traci was my favorite. The best. Boys were scared of never coming out of Kelly's denim-coated nest and took wages on who would fuck Shannon for a pool of money or weed. Shannon and Kelly wore their backstage passes to school the next morning. People knew their stories, but Traci kept it classy. Never said anything. She gave me a few rides home from school and we even went swimming a few times together (nothing happened). Her car smelled like hot bubblegum and melted cassette tapes. She was generous and gave me flashes of skin here and there.

It was surreal, an honor in itself that she would sit on my bed in her wet animal print bikini bottoms and see-thru concert jersey, humoring me with a game of Super Mario Brothers.

Post-dropout I saw Shannon working the town. Cosmetic counter in the mall, a spandex shop in the mall, the supermarket near the mall, and finally the Blockbuster video that was in the parking lot of the supermarket near the mall. Her vagina had its memories and that was that. I saw Kelly at a stoplight, sitting shotgun in a jacked-up truck. She was with a nameless redneck who went to our school and dipped in the smoking area. He owned a stained, cancerous, pregnant lower lip and a liking for Judas Priest. Sometimes you get that lonely. If I'd stayed around I'm sure I would have seen Traci somewhere, if she really was human. From my own research on bottomless nights, I knew she never went straight to video nor was she ever employed by the Peek-A-Boo Lounge. I never heard any parking lot reunion briefings on what rock star she married, so I knew she was around. In 1987, she was total sex. In the future, most likely not. One night I saw her car parked behind a 7-11. It had collected a few new dents and stickers. There was noise coming out of the Street Fighter machine. Four feet. A stoned female laugh was followed by the token "bogus dude!" from a town wasteoid who never did anything past that one tour. It could have been her, it could have been anyone from Main Street USA. I grabbed my Kools and pressed on.

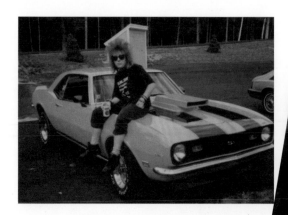

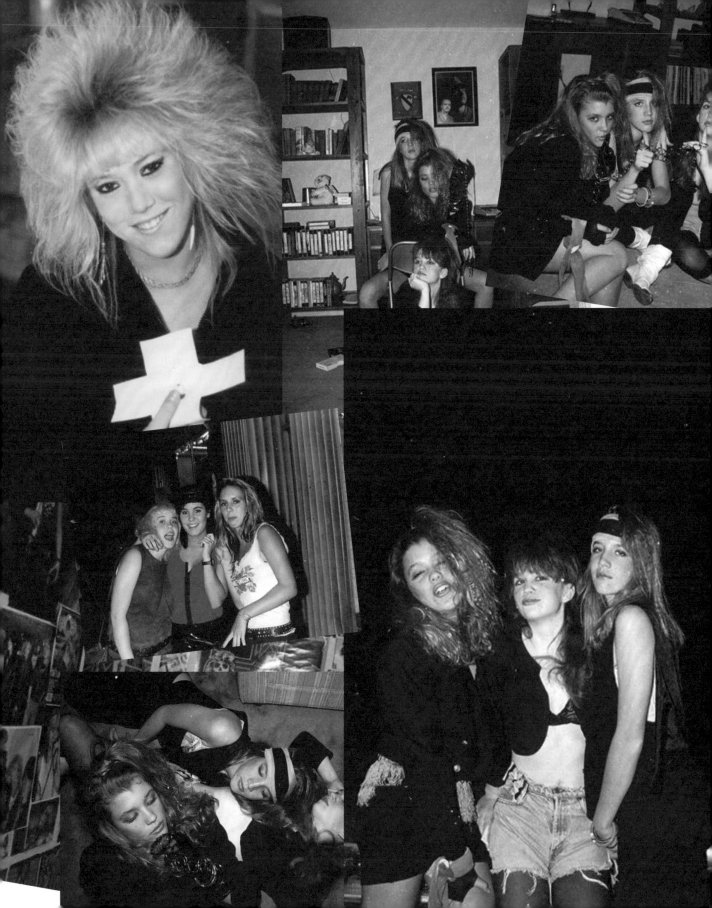

S.A.L.A.D.

Anthony Pappalardo

We were deseeding brick weed in the tollbooth green house of the future. Four interlocked fiberglass orbs were stacked on the lawn of the Salem Flea Market, forming a spec house built in the 1970s that would usher in the modern world.

The structure resembled a lunar landing probe with three main pods forming a triangle at the bottom and one master orb majestically resting on top. No one was quite sure of the history behind this anomaly, but its space-age appearance probably symbolized a new age in America 15 years prior. In this world of pill-form meals and automatic grooming units, Salem, New Hampshire residents could reside in a modular world of comfort and cutting-edge technology. This world still didn't exist, and the house of the future was now just a prop discarded to the left of the Salem Flea Market—otherwise known as the place where kids went to buy butterfly knives, porno tapes, and bootleg Judas Priest three-quarter-sleeve shirts.

My nerves were already shot as the sun was setting and we'd soon be high, and I was trying to ascend the modernist ladder that led to the top orb where we rolled the world's worst joint. We fled to this weed haven after a trip to the House of S.A.L.A.D., the former home of our area's own alleged satanic cult. My 13-year-old brain was already hazy from warm Schlitz beer that the kid sitting across from me had supplied and the bad weed was just giving me a headache. My cohort was Steve Costa and hours ago we were finishing up the 30-minute detention we were given for saying that we hated retards, homos, and Ethiopians. I was gagging on smoke and the stench of piss and shit, because apparently people didn't require bathrooms in the future, so the present-day stoners, lovers, and squatters who visited just used the kitchen area to relieve themselves.

Our English teacher, Mr. Capuano—or "Mr. Cap" as he liked to be called—had revved up the room on the first day of English class by asking us all to state our names and prejudices. This icebreaker resulted in complete mayhem and landed Steve and I in detention that afternoon. Most students simply answered with their name and stated that they

didn't have any prejudices. Mr. Cap would then take a few jabs at them, trying to get them to admit that they were in fact bigots before moving onto the next student. As he approached the back of the classroom, the hyena snickering began. The back wall of the cement-blocked room was lined with leather and denim. A boy with Bruce Dickinson bangs proudly responded, "I'm Steve Costa and I don't like homos, Mr. Cap."

Bruce Jr. was immediately high-fived by the denim coat next to him. Mr. Cap's thick nicotine-stained fingers slowly rubbed his brow as he glanced at the checkered floor of Room 315.

"You don't like homosexuals, do you, Mr. Costa? Would you care to explain what bothers you about them?" asked Mr. Cap.

"Uhmmm, I don't like homos because they're gay and one of them screwed a monkey and made AIDS, and that's fucking gross. The end," the trooper responded.

Once again, Mr. Cap kneaded the thick waves of wrinkles on his forehead, this time more deliberately. "Well Steven, thank you for being honest. You see, most of you aren't honest," he said sternly. "Picture this: The bell rings and we all get up to leave class. As we're filing out, we notice one of the Special Education students limping over to the stairs. The kid misses the first step, falls down, and slides on his back down the stairs. The kid gets up and says, 'I meant to do that guys.' Who in this room isn't going to laugh? I'm laughing, that's for sure. Any person falling is pretty funny to me. We shouldn't have to hold back our laughter just because someone has a handicap, so thank you, Steven. Thank you again for having some gusto and saying what you're prejudiced against."

"Oh yeah I forgot, I don't like retards either, Mr. Cap. Thanks for reminding me. I don't see why they get to be in the lunch line before anyone else. Half the time they drop their food or play with it. Let the people who can eat without a bib go first," Steve Costa added. The high-fives continued and the other metalheads agreed with Steven and announced that they too didn't like homos or retards. After a girl with braces and a crunchy perm sheepishly answered, "I don't have any prejudices," it was my turn to answer.

"Mr. Pappalardo... Mr. Pappalardo... That's a great name. Are you Greek?" asked Mr. Cap.

"No," I replied. "I'm Italian. Both sides of my family are from Sicily."

"OK. Did you know that the Sicilians are considered low class in Italy?" Mr. Cap asked. "You're an islander, and you have darker skin than the Northerners there, Tony... So let's hear it, do you hate Northern Italians?"

"Uhmmm, no," I answered swiftly. "I don't really care about being Italian, I was just answering you. *The Godfather* is really boring too... but yeah, anyway, well...I mean I don't like homos and retards really. Actually, I mean I don't hate retards, I just get annoyed by them I guess,

but…" I knew I had to make a splash here. The easy choice was to say I hated old people or teachers and I contemplated firing back with that, especially after the weird Italian comment, but my brain took over and I blurted out, "I really hate Ethiopians—they are the worst. Their commercials are the longest. It's like, you're watching something you like, and then you gotta hear how ten cents a day is all it will take to save these people with flies all around them who don't have food. It's all a scam and I hate them for it."

The room went silent, no nervous laughter just quiet. A snicker belonging to Steve Costa cut through the room suddenly. "Ethiopians are fucking gay!" he exclaimed, sending the entire room into hysterics. Mr. Cap loudly clapped the giant paws protruding from his wrists together to gain control of the monster he created.

"That's enough! Settle down!" he exclaimed before shifting his piercing black eyes at me.

Mr. Cap then wrote "Anthony" and "Steve" on the blackboard in yellow chalk and told us that he would be speaking to us after class. We weren't really sure what we had done wrong since we were encouraged to be ignorant, but we'd soon learn that we had gone too far and that we would serve detention later that day for 30 minutes.

During detention that afternoon, Steve decided it was a good idea to rifle through Mr. Cap's desk when he momentarily left the room, finding his wallet and pocketing 40 dollars before safely returning to his desk in time to continue to doodle the blocky Rush logo that was never really Rush's logo on his notebook.

A few minutes later we were free. It was 3 p.m. as we made our way out to the rack where our BMX bikes were chained.

"We got 40 bucks to spend, man. Let's go buy ganja," Steve shouted victoriously while tilting his head back. He opened his bag to proudly reveal a few dented beer cans as I unlocked my bike. My parents wouldn't get home for hours and I had nothing better to do.

Steve lived in an apartment complex adjacent to a tattoo shop that operated out of a trailer, where a friend of mine once got what I thought was a clown eating an ice cream cone, but was actually supposed to be a skull biting a snake. I didn't know anything about Steve Costa prior to this day, but I was now pedaling around with him and his quilted denim jacket in search of drugs, presumably a reward for my loyalty.

As we pulled into this complex, Steve coasted toward a stoop where a manly looking teenager was sitting, aggressively smoking Marlboro Reds. His red bangs fell almost to the bridge of his nose, making it impossible to make eye contact with him. He and Steve quickly locked hands in a green-for-brown exchange. I immediately noticed the blue cross inked in the web of this mystery man's hand. I tried to fix my eyes on where our dealer's eyes were supposed to be and kept my eyes off the large burn on his neck in order to play things cool. Any guy who sold drugs off

a stoop and was covered in a giant burn would probably kill me. I couldn't risk it.

A few minutes later, I was zipping down Route 28—the giant strip mall that ran the entire length of our town—following Steve to our next destination, the House of S.A.L.A.D. Two things scared the shit out of regular people in the 1980s: skinheads and satanists. S.A.L.A.D. was an acronym for Satan Always Lives After Death. While they could have chosen any title for their LaVey-worshipping sect, they were married to one that evoked a secretary's lunch, rather than inverted crosses, disemboweled bodies, or the Prince of Darkness. It was poetic that a cult that existed in the non-witch town named Salem would have such a non-threatening name.

What I knew about the cult of S.A.L.A.D. was culled from an exposé written up in the town paper where they interviewed several luminaries of the local mall food court and a number of suburban folklore whisperers. Each of them denied allegiance to the cult and even clarified that while several heavy metal bands used satanic imagery, that they were not actually satanists. One known, yellow-cocaine-dealing hessian cleverly mentioned that Metallica had even penned a song describing the evils of narcotics titled "Master of Puppets" and quoted the lyric, "Chomp your breakfast on a mirror."

S.A.L.A.D. was accused of several sexual assaults, B&Es, and of selling drugs to fund their cult, but nothing had ever been proven other than late rent payments on a subsidized home, resulting in eviction. As the world ticked closer to the 1990s, the cult seemed to fizzle. Hair was getting shorter, metal was losing its potency, and being intimidated by skinny men in tight jeans and puffy, high-top sneakers became less threatening. As the economy got better and things became less scary, even skinheads weren't threatening and white people started listening to EMF and Jesus Jones. S.A.L.A.D. didn't have an unholy prayer of survival.

Prior to meeting Steve, I thought the actual House of S.A.L.A.D. was a myth, but he was pedaling with an urgency that suggested otherwise. As my mag wheels spun down the pitted pavement, every story and fear I had about satanic cults shot through my brain. I thought about the hazy nights I spent in a black-walled basement bedroom a year prior. My best friend at the time spent his summers with his father in the true metal capital of the United States: Florida. He'd return each fall with the latest and greatest from his fucked-up, sticky summers, from Bathory to Deicide, as well as a slew of crossover punk and hardcore cassettes and records. His sister was wired into the local metal scene in Boston and would often have longhairs over, ranging from Aqua-Netted power metallers to legit, candle-burning ritualists.

My friend had converted a walk-in closet in his basement into a heavy metal haven, complete with pitch-black walls, candles, blacklight posters, and a record player that resembled a death metal

altar. The claustrophobic coffin room was where I heard the first notes of Merciful Fate and Venom. One night, his sister returned home jacked on some form of speed with a man who lacked the feminine features and garb of her normal one-night stands. His greasy black hair was parted in the middle and he smelled like menthol cigarettes and musty oil. They commandeered the closet and lit a single candle. Eddie and Vic Rattlehead looked on as they assumed an occult pose on the floor. The unnamed, un-announced dirt removed a tape from his back pocket that sweet soul sister immediately clicked into a cassette deck that rested beneath the turntable and above the glowing glass of the Marantz tube receiver.

I was waiting for the most extreme note to ring out or the rusti-est power chord on earth, but instead the hiss of the tape was followed by a backwards-speaking voice. Both of them were now trancing out, sharing a joint that reeked of burning plastic and sitting with their legs folded on the floor. My friend and I quickly realized that this wasn't going to lead anywhere beneficial to us and we slowly left the closet and decided to re-watch the last half hour of a *Headbangers Ball* that we had taped earlier.

I didn't know one fucking thing about Steve Costa. He was just some fucking dude who didn't talk to me directly and spoke in movie quotes and staggered hessian slang. I started to wonder if he was coherent at all or even knew where he was going. He took a sharp left-hand turn down Hunter Road and started chanting "Salad, salad...eyyyyyyahhhhh-hhhhh!!!!! SALAD!" His wavy hair was bouncing off his denim shoulders and I was fixated on the crude, misspelled "JUDAS PREIST" logo that it rhythmically touched. Judas Priest and the S.A.L.A.D. chant were turning this into a comedy. My head was playing Suicidal's "Institutionalized" video, which I had watched a thousand times that summer. I wanted to be there, not with some BMX bandit pedaling toward the former home of a herbivorous cult.

Steve power slid in front of a typical two-bedroom house with an overgrown lawn. There was nothing particularly creepy, sketchy, or cool about the house other than a few broken windows and S.A.L.A.D. etched into the mailbox.

"SALAD!!!!!!!!!!!!" He again shouted towards the sky as we ditched our bikes and walked toward the front door. We cupped our hands and peered into the living room window and saw...a dirty house. I ran toward the kitchen and looked in to see another empty dirty room. There were no signs of sacrifice tables, stolen surgical instruments, or black candles; just a few pots, pans, and cardboard boxes. I bolted around to the backyard to peer into the basement, obviously a perfect facade for a cult would be to appear mundane, but their cellar had to be filled with sacrificial poles, black cloaks, and Latin words scrawled in blood.

The only thing hanging in the basement was a red Everlast punching bag. It was apparent to me that the House of S.A.L.A.D. was just as fucking boring as the gearheads who prided themselves on spinning

donuts in parking lots and blasting the same hard rock soundtrack that their older brothers left behind before they went to juvy or jail. I was staring through this house through the indigo sky's last flecks of light and wishing I had met someone with a floppy skater haircut and a quarter pipe instead of another Kerry King-worshipping, aspiring mechanic.

I asked Steve if he wanted to go in as a last ditch effort to make the mission worthwhile, but he just looked confused. "Mal Tallon was in here one night with his brother and they were looking at records in the mirror and shit, like you know that you can see the word "devil" when you put a Dio record in the mirror, man? It's fucked up shit! They heard a voice say, 'Evil, evil,' when they were doing it! They listened to *Number of the Beast* later too and shit, real loud..." Steve rambled on, his voice sounded like a Cheech and Chong skit dubbed on a Kmart blank cassette —the kind that doesn't even come with a cover. I asked if we were going to smoke the pot that he bought off the dude with the cross tattoo on his hand. I had to salvage this boring afternoon somehow. Then Steve's eyes lit up.

"Let's go to the House of the Future man, there's a round room at the top that we can hot box and get high high high high, after that we'll see who's drinking at Captain's Pond, maybe Danielle will be there and will give us a little rub-rub tug-tug—she's a fucking SKANK!!... Run to the hills, run for your liiiiiiifffffffeeeeeee..." Steve kept barking, cranking and snickering as I followed him down the back roads of suburbia. We had cheap drugs, warm beer, and the House of the Future, but it just sounded like classic rock static. Black magic, cults, backwards messages, and suicide solutions were as kitschy as Randy Rhoads' polka-dotted Flying V, and I wanted to be back in my boring bedroom looking at the pages of *Thrasher* and wondering what the bands reviewed in Puszone sounded like. RIP Satan.

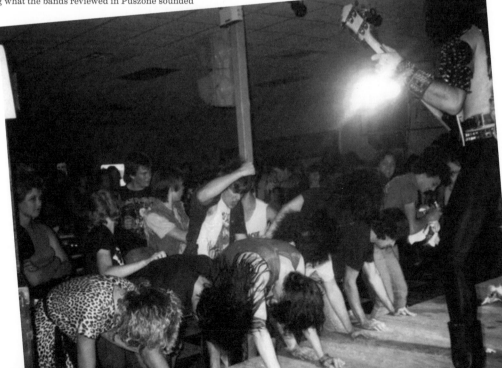

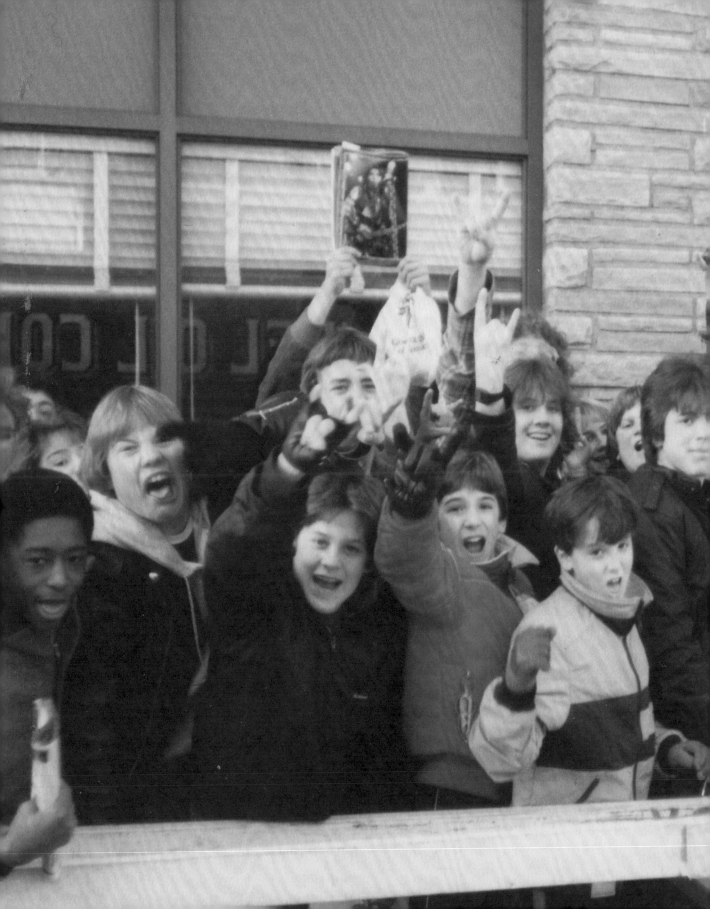

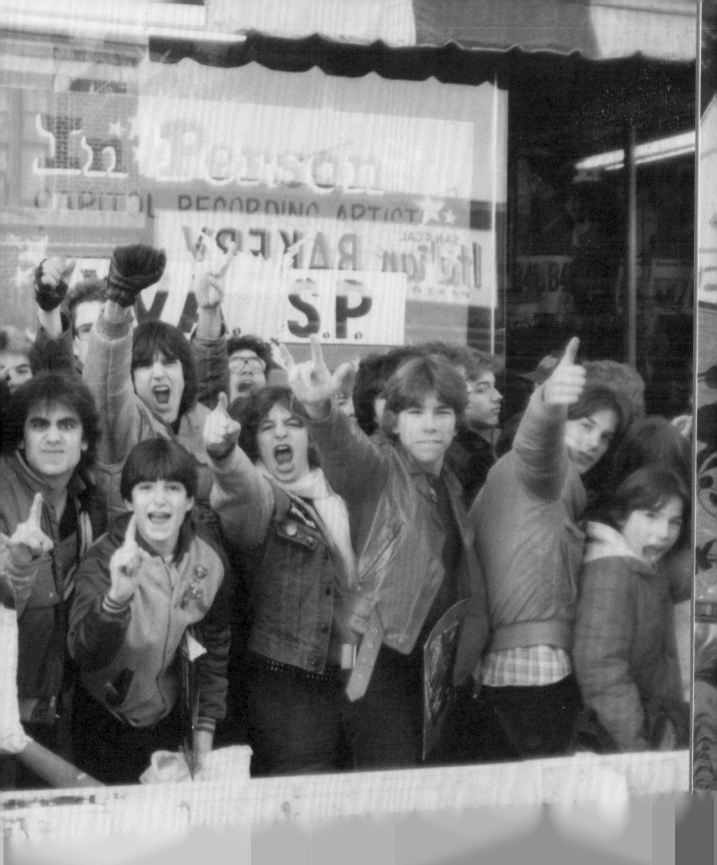

CUM ON FEEL
THE NOIZE

Anthony Pappalardo

Birthdays meant feeling tense all day, waiting for that trip to the mall
at 7:45 p.m. once my dad got home from work. Two Kools later, we'd be
there and I'd sprint to the tobacco shop. This store had everything I could
ever want except for music, though right across the hall stood both a Tape
World and Record Town. I lived for that small stretch of suburban brick
and mortar. The smoke shop was my armory: I felt like Rambo gearing up
before the drop into Vietnam every time I stepped inside.

 The tobacco shop sold baseball cards, candy, comic books,
weapons, magazines, rock posters, devices for smoking drugs, and, most
importantly, t-shirts. To celebrate my entrance into the world, I was
allowed to pick out any design I wanted from a book of iron-on decals and
have it grafted onto a three-quarter-sleeve baseball shirt. If my parents
were in a particularly good mood, I'd be able to personalize it with fuzzy,
iron-on letters.

 The back left pocket of my Lee jeans held a yellow banana
comb, my high-top Reebok sneakers had just enough slack hanging from
the second to last eyelet and I wore the Led Zeppelin pin my friend Brian
had given me that didn't actually say "Led Zeppelin"—it just had the image
of the naked Swan Song angel dude—kind of creepy for a 10-year-old boy
to be wearing, but whatever. I had spent the time between 2:45 p.m. and
7:45 p.m. making sure my mall entrance would make a splash.

 My plan was to get the *Aces High* Iron Maiden graphic this year
and the words "Aces High" on the back to clarify that I knew where the
image came from. Unfortunately, the wasteoid behind the counter had
bad news for me: It was sold out and I would have to pick something else.
In a panic move, I flipped to the next page and settled for the cover of the
recently released and hyped Quiet Riot album *Metal Health*. What a
fucking joke. The singer had balding curly hair, Rudy Sarzo licked his
bass, and their best bad songs were originally done by Slade. Worst of all,
I'd have a full year to think about this mistake. Perhaps the caterpillar-
mustached stoner behind the counter was just lying so the last Maiden
iron-on could go to a friend who could score him 'ludes.

 My mother's knack for washing clothing at the highest heat
setting made the *Metal Health* shirt crack and fray within a few washes,
so I was pardoned from wearing it. Shortly after my birthday that year, a
hockey trip to Montreal led my father and I to a head shop off Saint
Catherine Street where I chose a replacement: a bootleg Ozzy t-shirt
featuring a rendering of the *Diary of a Madman* artwork, drawn
completely out of perspective. It was still better than "feeling the noize."

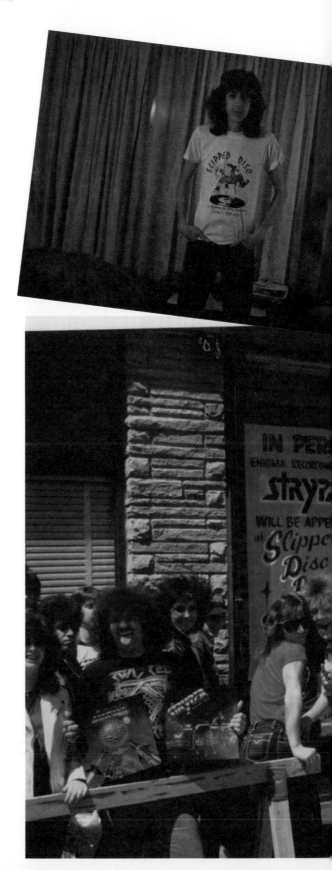

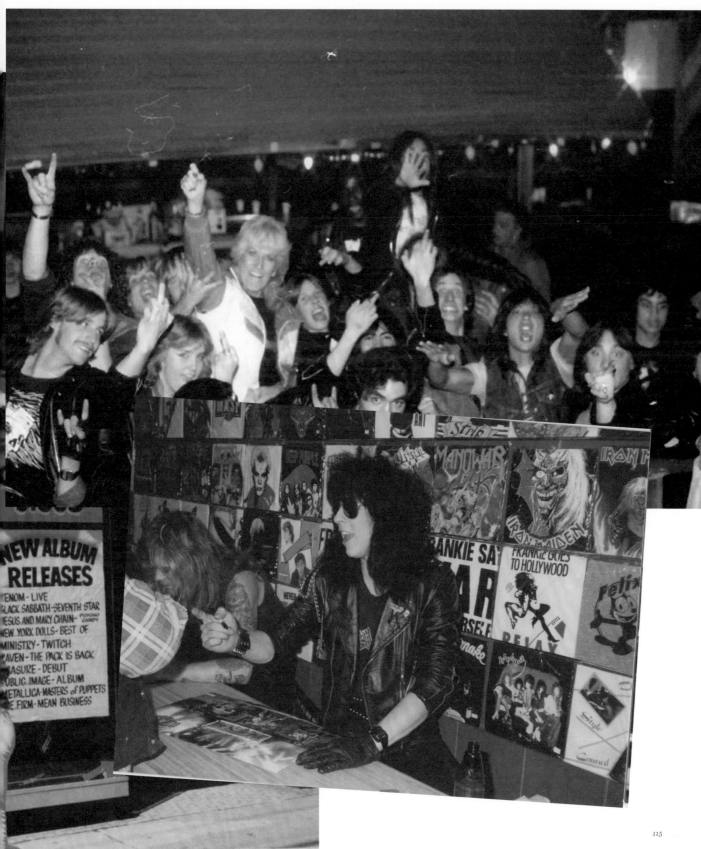

NEW ALBUM
RELEASES
VENOM - LIVE
BLACK SABBATH-SEVENTH STAR
JESUS AND MARY CHAIN- PSYCHO CANDY
NEW YORK DOLLS- BEST OF
MINISTRY- TWITCH
RAVEN- THE PACK IS BACK
ERASURE- DEBUT
PUBLIC IMAGE- ALBUM
METALLICA- MASTERS of PUPPETS
THE FIRM- MEAN BUSINESS

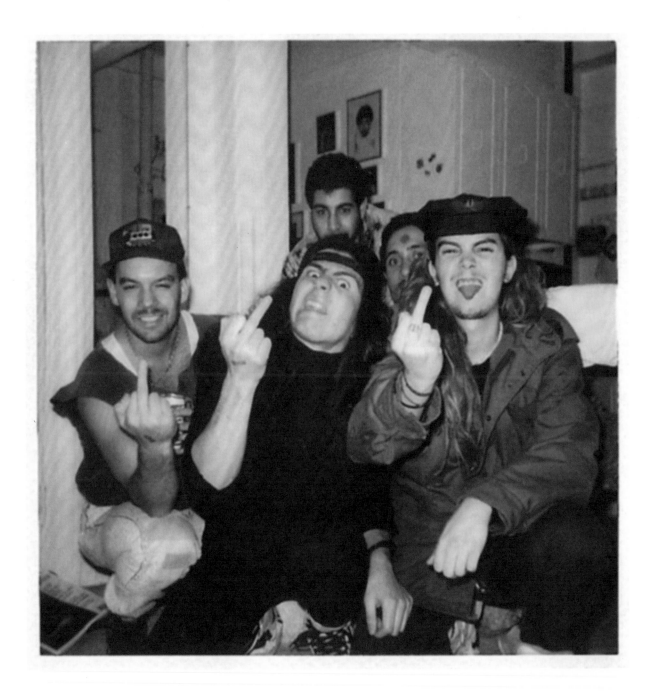

I AM IRON MAN

Anthony Pappalardo

James Regan was a boy by age but not by stature. He stood well over six feet with broad shoulders and cold, blue eyes. When he gripped his ruddy fingers together they looked like brick wrecking balls that could easily smash through walls or at least flatten the noses of young boys with one swing. The neighborhood was terrified of James Regan. From age 13, James rode his yellow dirt bike around town without a helmet, license, or care. He was above the law.

No matter what the thermometers said, he wore a sherpa-lined denim coat which housed a weapons armory: butterfly knives, Chinese stars, butane lighters, pre-rolled joints, and a switchblade comb were always by his side. Normally, young burnouts decorated their jackets with patches and pins of their favorite metal bands, but James' jacket was bare. He didn't have time to be a seamstress—he was focused on mayhem and destruction. I learned quickly that the more patches, the less threatening a kid was. This theory was proven later in my life when I saw crusty punks lying in their own filth with pregnant dogs begging for change in Harvard Square. There was nothing scary about junkies resembling shit-stained rag dolls asking for beer money.

James was a loner who didn't need backup. He was a one-man army...or at least capable of keeping a gang of preteens in check. None of the kids on my block had older brothers willing to challenge him to a fight, so when he roared through, we were pretty much at his mercy.

Normally, it was easy to avoid James, as he was always busy fixing something, building something, smoking something, or fucking something, but things changed when we found an abandoned ski slope near our neighborhood that was full of paths perfect for racing BMX bikes. There wasn't a black diamond trail, just amateur inclines descending the "mountain" that just needed a little grooming before they'd became our private raceway. We heard that a homeless guy lived in the woods there and hung himself but that only added to the danger and excitement. We spent the winter sledding there, one friend even snapped a wing, but we convinced him to tell his parents he did it playing football to make sure we wouldn't be banned from the mountain. Our plan was simple: after the

winter thaw, we'd grab shovels and build jumps along the trails and we'd have the only true racing track and stunt zone in a 30-mile radius.

Spring came and we swapped our winter work boots for sneakers and set off to the mountain to begin construction. No sooner had ground been broken did we hear the menacing roar of James' dirt bike. We were fucked. James had a method to his torture: he'd single out one boy and then force the others to make decisions. For example, you might be asked to punch your friend or absorb a blow from James himself. He'd make you jump off things, eat things, and one time he even buried poor Joey Belisle in a mock funeral only to piss on his grave. James wasn't nice.

He power slid into our construction site and covered us in dirt and rocks before dismounting his yellow steed. "Gaying off in the woods, faggots?" he asked rhetorically. Despite his golden shower, Joey hadn't learned anything and actually responded.

"No man, we're building some jumps..." he stopped and gulped emphatically, realizing his mistake and trying to save himself. "...We...we figured you'd wanna use the jumps so we're gonna build them really high!"

"Why the fuck would I wanna jump off a mound of dirt while you homos watch me? Do you think I'm a fag too?" James responded. This wasn't going well. The mountain was sandwiched between two growing housing developments, one construction site directly bordered the first trail where we were now standing. Building had slowed down and the site was merely a sea of discarded cinder blocks, lumber, nails, and mortar. James kicked around the piles of raw materials briefly before picking up a piece of plywood about three feet square.

"OK Joey, go stand over there and hide behind this piece of wood," James ordered. Joey grabbed the wood sulking and walked off about 20 feet in a grass clearing. "The rest of you, come over here now!" he demanded in between drags of a Marlboro Red.

James directed us to a pile of rocks and chipped bricks. "OK, Joey is gonna hide behind his piece of wood for the next 10 minutes while you guys throw shit at him. Don't fucking stop or you have to join him and there ain't much room back there. OK, start NOW!" James said as his soulless eyes pierced all of us. It was a minor relief to not be behind the wooden shield, but this seemed too simple. There was no way it was this easy.

We pelted Joey for what felt like an hour, he'd occasionally have to readjust the wood and James would chuck a rock right at his fingers. This was the only time he joined in. On James' command, Joey emerged from his foxhole, ears ringing and fingers swollen.

"Hey, I'm hungry," James said. "Who lives the closest to here?" Apparently, watching the stoning piqued his appetite. Once again, Joey was the victim as his house was a five-minute walk through the woods. We followed James single file like an adolescent chain gang before arriving at Joey's house. He was instructed to go inside and fetch some chips and

soda in five minutes or less or else he'd be back behind the wooden shield
or maybe thrown off his tree house. As soon as his door opened, we heard
a familiar sound: Buddy Mailloux's dinner bell. Each night when it was
time for supper, Buddy's mother rang a bell which was his cue to scamper
home like a puppy before eating something overcooked and fattening.
"Buddy...Buddy, dinner time!!!!!!!" sang his mother and her brittle bleached
hair.

 Buddy thought he was off the hook, but as he took a step
toward his home, he was quickly stopped by James. In one motion, he was
body slammed to the ground and pinned. James' voice was suddenly two
octaves higher as he screamed, "Fuck you, mom! I'm not going to eat your
meatloaf anymore. GO FUCK YOURSELF, BITCH!" Buddy was tearing
up as James' mammoth hand covered his mouth. His mother kept calling
and James kept responding with more curses until things went silent for
a moment and we heard a door slam. With a spin and a kick, James' cycle
was roaring and he was gone. Buddy's mom ran over and saw him spitting
dirt as the dust settled from James' escape. She knew Buddy hadn't cursed
her out and silently escorted him home to dinner.

 The rest of us headed off to our fort which was really just a
plywood shanty that overlooked our neighborhood. Two pieces of plywood
were configured around some rocks creating a shelter from the elements
and a perfect place to read stolen porno mags and light small contained
fires. No parents or cops could get close to the fort without us having ample
time to scatter and flee back to the woods.

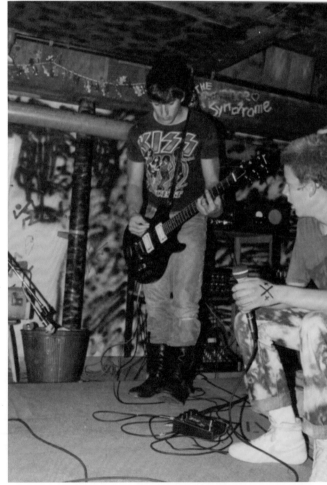

 The second-oldest kid in our neighborhood, Kenny LeFevere,
was there smoking Winston cigarettes stolen from his dad and drinking
something he stole out of a flask. Despite being older than us, Kenny was
relatively cool. He might turn on you if someone cool and closer to his
age was around, but he generally didn't give a fuck. He'd offer us cigs and
swigs, and occasionally would give us old bike parts and metal magazines
that he had read cover to cover. We told him about the wooden shield game
and the meatloaf beat down and he laughed.

 "If you guys are sick of James fucking with you, why don't you
all just fight him? He's beating the shit out of you every day. You'll proba-
bly lose, but there's five of you. You can probably take him, and if not, he'll
probably just find someone else to fuck with," Kenny reasoned. We stared
at him blankly. I think we all wanted to just ask him to fight James for us,
but we knew that would never happen. Five-on-one started to make sense
to me. We asked a few combat-related questions before Kenny pedaled off.
James didn't have any friends who would torment us in school as retribu-
tion if we did beat him up, and he couldn't really do much worse than beat
us up more. At the worst, we'd be confined to the safety of our yards for a
while and avoid the usual secluded fishing spots, and at best we'd have the
hairy, beastly monkey of James Regan off our backs. Suddenly we realized
we were playing with house money.

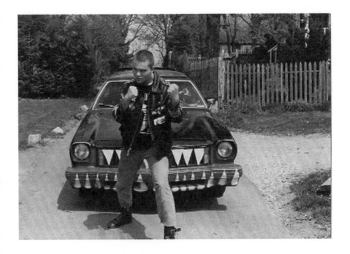

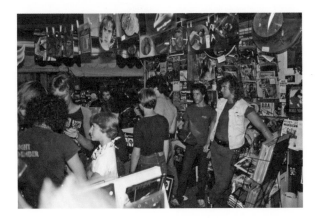

My potluck crew sat in our clubhouse planning our attack. "We should form an official gang," I said. I think I was just excited about writing a gang name on walls or maybe even putting mailbox decals on my bike's number plate proclaiming the newfound gang. Everyone agreed and it was time to vote on a name. The Lions, Demons, Black Snakes, and Titans were quickly shot down. We went through a few more suggestions including the Salem Swords and Salem Samurais, but alliteration didn't sound tough enough.

"Scorpions have those big stingers," said Rick Hannigan. "They're small, but they can really fuck you up. What about the Scorpions?" Balding German rock bands and women in cages were not on our minds—we completely forgot about the band the Scorpions as no one fucking liked them. The Scorpions was now our gang and we started training that second, without Buddy—he was a total pussy anyway. First order of business was to gather up our collective weapons. We had nunchakus made of sawed-down broomsticks and clothesline rope, sheet metal shanks carved in shop class, and Rick even had a pair of brass knuckles he stole from his uncle. Well...they weren't actually brass, they were some kind of silver alloy, but they looked cool.

Our arsenal was set, we headed off to Rick's basement to sharpen our hand-to-hand battle skills before having to go home for dinner. There was a wrestling mat lining his basement floor that served as our battle arena. In a few minutes we were confident that the Scorpions could take James or any bully—fuck, we could probably fare better against the damn Russians than the fags in *Red Dawn*. Years of recreating the WWF, NWA, and AWA wrestling moves in Rick's basement boosted our confidence more. I was daydreaming of my finishing move—a variation on the Iron Sheik's Camel Clutch—when Rick was called to dinner. We needed a good meal and some rest. Tomorrow wasn't just Wednesday, it marked the beginning of a war.

We hashed out our strategy on the bus ride to school. The trick was to play dumb, head off to the woods with our shovels (which could come in handy in case we needed to bury James' corpse) and our weapons and wait. At the least, we'd make progress on our dirt jumps and build some muscle. The day crawled by but eventually the bell rang at 3 p.m. and we were free to fight. My Walkman was blasting "Shout at the Devil" and James was fucked.

I was the first one to the clubhouse armed with my weapons and a bulldog mentality. One by one, the Scorpions arrived, each bringing his own expertise to the table. This was one of those *Dirty Dozen* movie moments when the team is assembled. Rick was the calm, good-looking one; I had the most weapons; Joey and Buddy had taken the most licks and were hungry for revenge; and our wildcard was Greg Derosa, or Rosie, as we called him. Unlike the rest of us, Rosie actually stuck with his karate classes. He even had a satin jacket with a dragon on the back, his name

on the sleeve and the dojo's name written in gold thread. He had recently learned how to chop through thin pieces of wood and was flexible enough to kick higher than his head. Rosie's skills were our secret weapon: if things got sketchy, he could always deliver a Spot-Bilt sneaker to the jaw and give us time to regroup. We believed in the sting of the Scorpion.

Off we were to dig and wait. We marched on like the random excavation crew that Indiana Jones employed to find the Lost Ark. We set up camp and anticipated the roaring grind of James' dirt bike. We were ready.

Burning gasoline and the familiar growl of James' bike manifested about 30 minutes into our dig, he was so fucking predictable. The Scorpions exchanged stone-faced nods, each of our heads playing a victory soundtrack. Our minds were punching Drago, blowing up the Death Star, and throwing that weird spiky thing from Krull at our enemy. Again, James slid his bike at us, creating a dust cloud as he pushed his kickstand down. As his loose tan work boot slid off during the motion, our window had arrived. Someone yelled "SCORPIONSSSSSSSSSS!!!!!!" as we surrounded him and unsheathed our weapons. James sat on his bike unfazed and laughed loudly, tilting his head back like Goliath, looking towards the sky. "I'm gonna fucking wreck you guys!" he yelled. A bolt of lightning struck him and he grew to 30-feet tall, his bike now a Clydesdale breathing fire. I was frozen, afraid to flinch, but the rest of the Scorpions were already half a football field away. James jumped to his feet, his eyes fixed on me the entire time. My nunchakus lay limp in my hand, they were just parts of a broomstick and would probably just shatter on his thick skull if I even had a chance to swing them. I was screwed. I spotted a small piece of two-by-four laying to my left, I threw my homemade weapon far into the woods and picked up the lumber.

"What are you gonna do with that, Jim Duggan?" James shouted. Not only was he going to fucking kill me, but he was also witty for the first time in his life. I reared back and emulated Roger Clemens' windup and flung the wood at him, hoping it would hit his face and blind him, or perhaps knock the wind out of him. The small piece of pine spiraled at James and fell well short of his face or sternum, it actually just hit his bare foot. Before I could even feel a touch of disappointment James was screaming like a stuck pig, gripping his foot. "I'm gonna fucking kill youuuuuuuuuu!!!!!!!!!!" he exclaimed. It didn't matter now—I had plenty of time to get the fuck out of there. My feet didn't touch the ground on my way home. It took me half a second to flee to my bedroom, blast Diamond Dave and air guitar to "Unchained." As the adrenaline wore off, I debated penning my will on loose-leaf paper and asking my parents if they had thought about moving to another town, preferably tomorrow. My mom knocked on the door and told me I had a phone call. It was probably Rick checking to see if I was still alive. I told her I'd call him back and she asked if I was her secretary before agreeing. I lied about a book report I

had to finish and shut my door. I'd be safe at school the next day, but expected to see James waiting for me when I got home. Both of my parents worked until 5 p.m., giving him a two-hour window to beat me to a pulp.

I finished dinner quickly and asked to be excused. There was nothing on television so I fished around in my closet and found a handheld electronic football game that I hadn't played in years. I swapped out the batteries from my Walkman, and suddenly the flickering red lights on the screen had me distracted. I was the New England Patriots squaring off against the Chicago Bears for a rematch, and I wasn't going to lose this time. Rick had taped a bunch of his brother's records and lent me the cassette so I could copy it. I was today's Tom Sawyer and briefly forgot that I'd be dead in less than 24 hours.

There was a knock on my door, I sprung up and answered it. My dad was standing there looking a little annoyed and confused. "One of your friends is here, Anthony," he said. "Why don't you guys hang out here while your mother and I talk to Mrs. Regan."

My whole body went numb. Why the fuck had my dad sold me out? There was now one flight of stairs between me and death... I couldn't even fucking move. A large silhouette lurched up the stairs with a noticeable limp. The familiar scent of "stinky kid" permeated the air. It certainly was James, but he wasn't rushing to kill me. Perhaps he was building suspense. When he reached the top of the stairs, I noticed that his foot was mummified in white bandages and he was gripping his stomach.

He entered my room and immediately sat on my bed and stared at me, only this time there was no venom in his gaze. "I had to get a fucking tetanus shot and a bunch of stitches, asshole," he said. "I didn't give a shit, but my mom fucking freaked out because I tracked blood in the house, then she made me go to the hospital."

Apparently, the piece of wood I chose to bludgeon James' foot with had a rusty nail protruding from it that pierced his thin-socked foot. No one had ever seen James' parents: we assumed he just lived on his own like one of the Outsiders, but he did actually have a mother, albeit one who smelled like boxed wine and cigarettes, according to my dad. Before I could even think of how to respond, James was mimicking the garbled beginning of Black Sabbath's "Iron Man" playing on my stereo. "I am iron man!" he gurgled with his eyes closed, while Tony Iommi bent guitar notes that bounced around my skull as I envisioned my own funeral procession. I glanced up and saw my parents standing with a rail-thin woman with a maroon leather jacket and poodle perm.

"Yous guys is friends now right?" she asked in a thick New England accent. It was obvious she had been crying and her face was so wrinkled and pursed that it looked like she was permanently taking a drag of a Virginia Slim. Three...two...one... The waterworks began and my

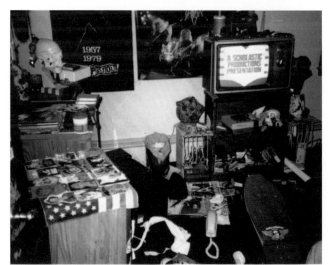

parents looked completely shocked. My mother actually curled her lips in and held back a smirk.

"I know James is wicked big and can be rough, but he ain't a bad boy and he likes yous guys," she said between sobs. "He won't push yous around anymore, OK. But my baby really got hurt today. He got stitches and everythin'," she said, leaving the "-g" off everything as most in suburban Massachusetts did. James shot her a glare, presumably for the baby comment and letting everyone know that he was mortal. My dad realized this was his time to be the alpha male and resolve this so he could get back to watching VHS tapes of *Sherlock Holmes* and *The Three Stooges*.

"OK boys, so let's see you shake hands, and Anthony, you apologize for hitting James. Only fairies use weapons in a fight, you know that," he said while giving me a slight wink. His tone and gestures confirmed that he wasn't mad at me, and fuck, James was taller than him, so I think he knew exactly why I had to throw shit at him. I almost died!

We shook hands and for about five seconds and I thought the cycle was over. "Hey can I borrow this tape? I'll copy it tonight and bring it by tomorrow," James asked.

"Oh, this tape? You can just have it," I replied, quickly lying through my teeth: "I have all the records anyway, so I can just tape them again." There was no way in hell I wanted to see James again. There was a chance that he'd be off his dirt bike for a while and we could finish our jump, but I wasn't really interested in going to the mountain again.

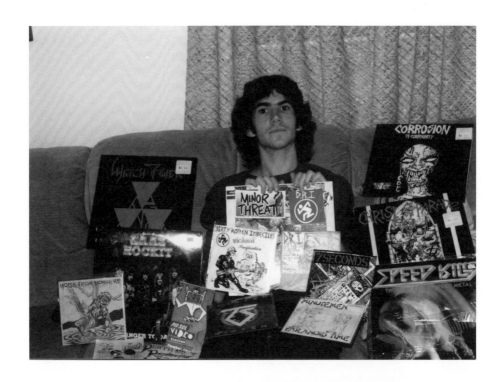

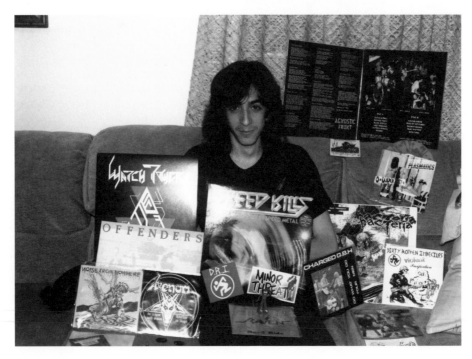

DON'T

BREAK THE

OATH

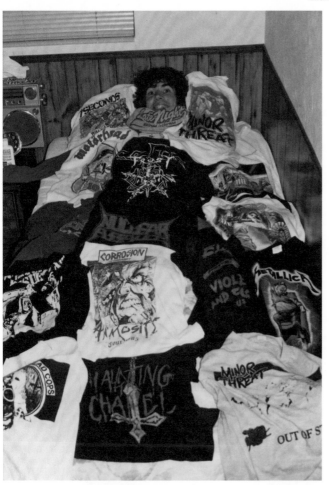

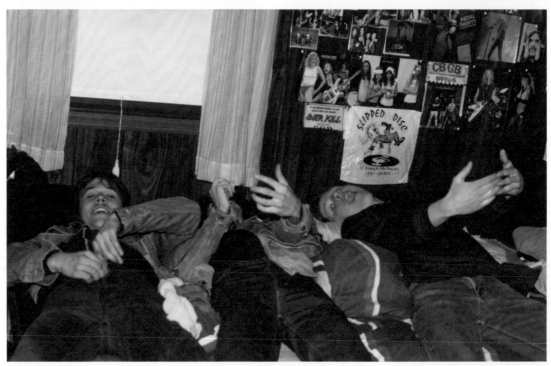

RESTLESS AND WILD

Max G. Morton

"You like metal?" was a strange question coming from a bald teen with a swastika armband. I wasn't a fan of Accept, but then again I had never listened to them. Al inserted the tape and smiled. I thought we were supposed to be listening to Oi! or Skrewdriver. Ah, to be among the simple-minded. Al was giggling as the "fake out" intro started with the German Hi-De-Hi-Ho bit. Within a minute, the nice German song got scratched, evil screaming prevailed and the ultimate rivet-fest began. "Fast as a Shark" was more brutal and thematic than most of my hardcore records combined. I was ready to kill. *Restless and Wild* could have easily been the theme to any *Over the Edge*-driven, 80s-themed waste-landscape. By the time "Neon Nights" came on, we were passing a bottle of Rush around, blacking out to the dismal lawns of suburbia. I was horny for violence, and a little German with a shaved head and fatigues belted out my new anthem.

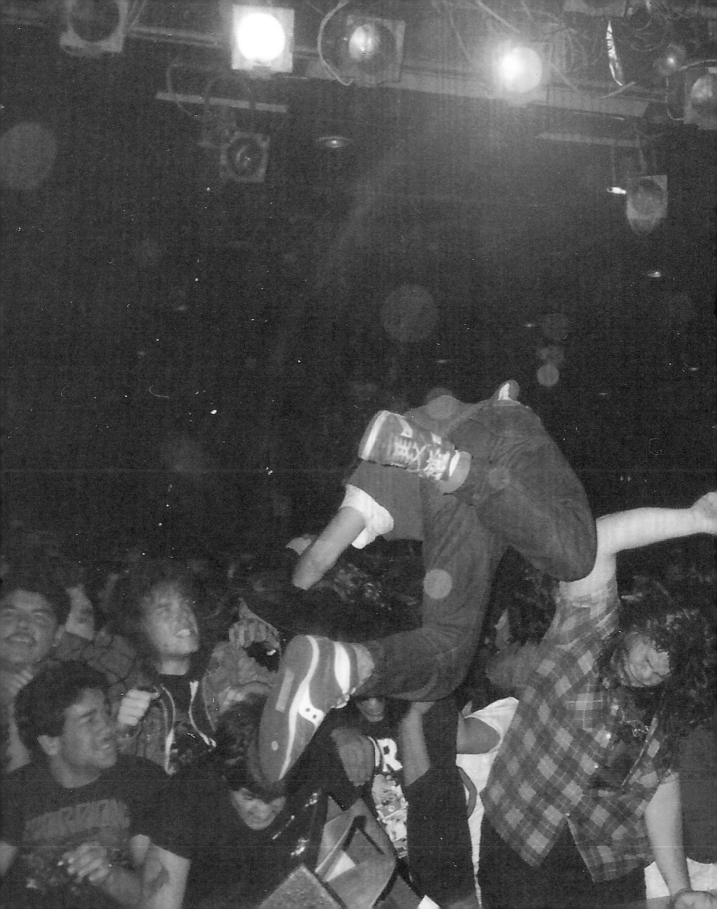

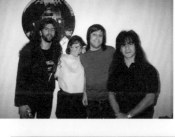

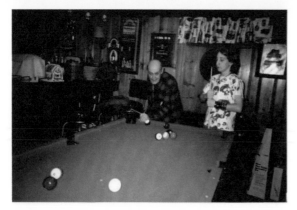

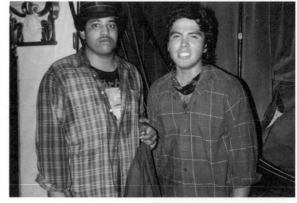

INSTITUTIONALIZED

Max G. Morton

It was the first middle school field trip I was not denied access to. It seemed quite heavenly and vaguely peculiar that all of my long-haired hallway allies and I were getting on a bus and traveling in the general direction of the water. There was even a rumor of McDonald's for lunch. I hated school so much that I would do anything to get my mom to sign a permission slip granting me an afternoon away from the numbers. I didn't bother to ask where we were going because anywhere is always better than here. Finally, all the kids who were never allowed in public were getting to sniff some wind.

The night before, I was at a birthday party. It was punishment for fighting at school. I hated the newly-crowned teen but he was the son of a woman in my mother's suburban coven. Her husband made deliveries with my father and once a year I would have to make the best out of this moron's Heather Thomas poster. Farts, Pac Man shot glasses of Dr. Pepper, stupid jokes, being frogged in the leg multiple times, and watching him and the sister air guitar to Journey made it clear I did not belong.

As the bus pulled in, the other junior hooligans and I started to cramp up in the stomach. The welcoming ulcers told us our parents had signed us away to rehab. A medical fortress protected by a massive electrical fence was a far cry from feeding apples to the oldest living manatee in captivity. Motley Mike started swinging on the PE coach while a few other kids broke open the fire exit. It was a free-for-all that ended abruptly. We were not armed and had to surrender to the abundance of armed guards. "Fuck" was our new mantra. After being shown to our new rooms we were left in silence under artificial lighting while a few kids were restrained by a force dubbed "Mr. Armstrong." After an hour that felt longer than any school day, we were summoned to a room with some staunch Republicans, more armed guards, the principal, a few mothers, and some older, heavily medicated outlaws. Under the same roof we all viewed a psycho-delic PSA version of *Alice in Wonderland* as warning for our crimes and misdemeanors.

In the middle of the film, a guy with spiderweb tattoos leaned over. Making stern contact with his wild eyes, he introduced himself. Not allowing me any space to answer, he started blasting me with a series of questions and statements. "Hey I'm Joe. It's not so bad here. You'll get used to it. What's your favorite band? You like Agnostic Front? You bring any pills or weed? We are going to be great friends."

He had chosen me out of all the little Frankensteins to befriend. What exactly was I radiating to give off the signals that we'd soon meet again?

I'd been around punks before but they all told me to get lost. Whether it was as simple as "Get lost!" or hurling a brick at my mom's boyfriend, there was never any sort of invitation for me to be a kid united. This was the first time I felt as if I could be part of a scene. A few months later when Joe was "released" we started hanging out, skating, listening to records, and going to shows. Through the mess that a little anger can make and the no-tolerance policies of the public school system in Reagan Country, I had been placed in the path of someone who embodied all of my solitary late night creative visualization rituals. And through this one person, a whole scene of other youth not of this earth, who held similar ideas and thoughts and came from equally broken homes. All of those photos on the backs of record covers and all those scene reports were real. Confirmed.

Pg. 1

THROWN INTO ~~THE~~ SWAMP WHEN
I WAS 6 VIA NYC. CULTURE DIDN'T
COME EASY. WE HAD TO FIND ANOTHER
DUMPSTER TO DIVE ANOTHER CAT TO COOK CAJUN STYLE
ANOTHER..... FAITH OR FIX.
TRUTH WAS A OPEN WOUND ON THE WHEELS
OF EXCESS. DEATH WAS SUCCESS. LIVE NOW
OR FOREVER REST. THERE WAS NO CHOICE
IN BECOMING ONE OF THEM. NO RADIO
TO TRANSMIT THE GOSPEL. NO PRESS
OR MEDIA EITHER. WE HAD TO SEEK
AND FIND OUR OWN PROOF. THAT TRUTH
WAS THE ONLY DEFENSE ~~AND~~
OTHERWISE WE WOULD BE BURNT ~~FOR~~
~~US~~ AT THE STAKE. WE WERE OUTSIDERS
THE UNCHOSEN ONES. THE FREAKS
PUNKS THE FAGGOTS. IN A AGE WHEN
YOU ~~MET~~ YOUR BEST FRIEND AT THE
RECORD STORE BUYING THE LATEST BLACK
FLAG, ADVERTS, SUBHUMANS OR DISCHARD
RELEASE. OR AT LEAST SOME CHICK INTO
FUCK

PG 2

GOTH, SKA, EVEN A RANDOM Oi OR SKINHEADED ~~LADY~~. THE LINES WERE DRAWN.

TALENTLESS BUT PISSED THE BOREDOM WAS ENOUGH ~~to~~ FUEL IGNITE

A 1000 PUNKROCK SUICIDE BOMBERS, RATHER ~~THAN~~ LIVE PARALIZED. WE SKATED ON CONCOCTIONS + HOME MADE REMEDIES WE MIXED OURSELVES. LEADING US TO SHUT DOWN SKATE PARKS, COLLEGE GIRL WINDOWS, AND RANDOM SHOWS ~~ALL~~ THROUGH THE NIGHT.

FUNNY HOW 30 YEARS LATER, THE VERY FIRST RECORDS I BOUGHT THAT INSPIRED ME ARE NOW MY COMRADES. TOO MANY TO LIST BUT DUE TO THEIR TENACITY TRUE INSPIRATION ON THIS LATCH KEY CHILD AT SUCH A EARLY AGE. I'VE BEEN ABLE TO ~~SEE~~ THE WORLD ON MY OWN LIVE TERMS AND SURVIVE. AND WOULD NEVER TRADE IT FOR ALL DONALD TRUMPS BORING CAPITALIST ~~~~ RICHES

BECAUSE HE IS THE KING OF THEM!

PG 3
30 YEARS IS Just A DROP IN THE FUCK IT.

BLACK FUCKING METAL! PUNK ROCK SCUM! AMEN

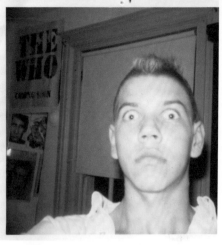

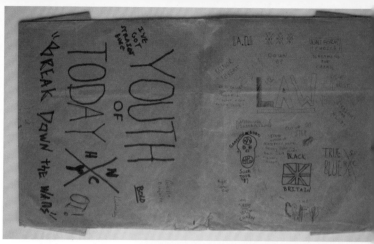

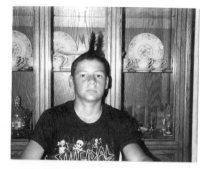

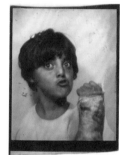

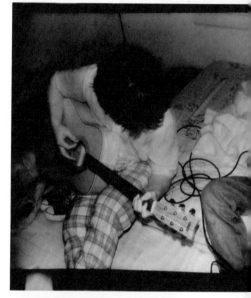

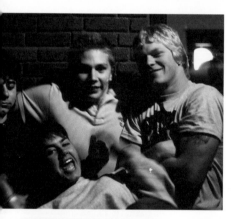

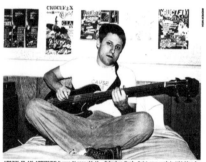

"PUNK IS AN ATTITUDE," says 24-year-old Al Quint, a Swampscott native and local banker who publishes a fanzine — a Xeroxed newsletter — called Suburban Punk. Quint says punk is "thinking for yourself rather than just going along with what society dictates — the whole American dream thing."

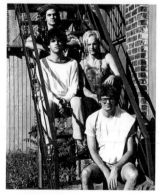

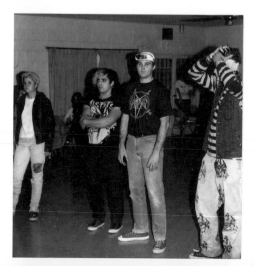

YOUNG
LOUD
&
SNOTTY

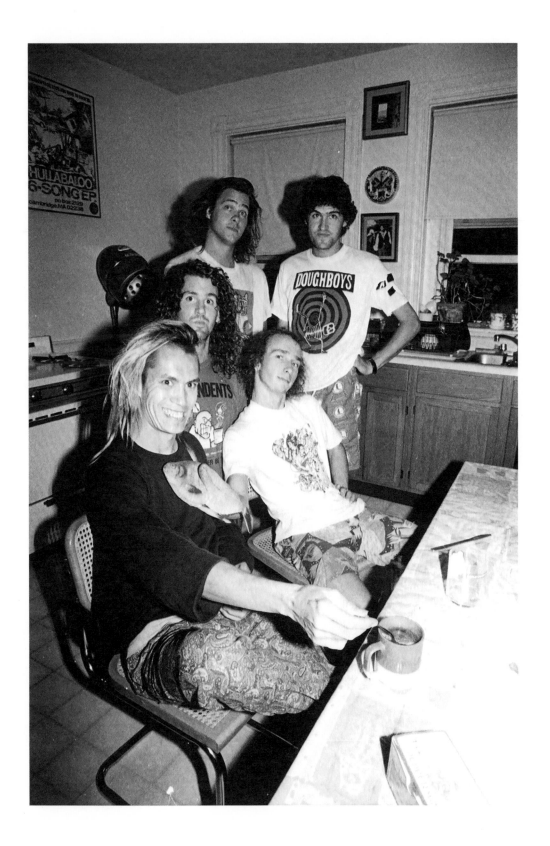

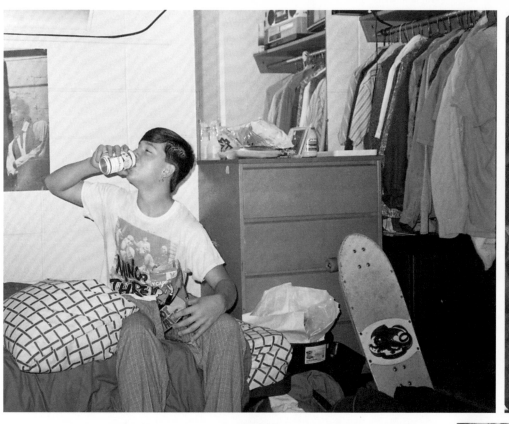

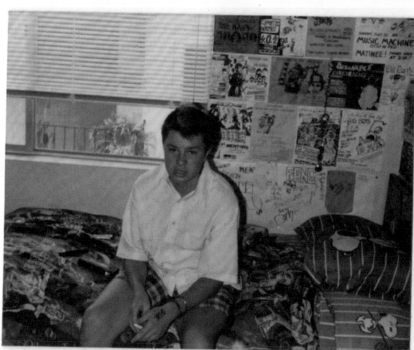

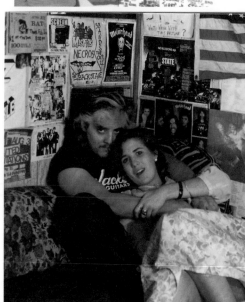

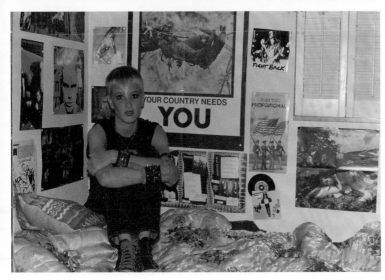

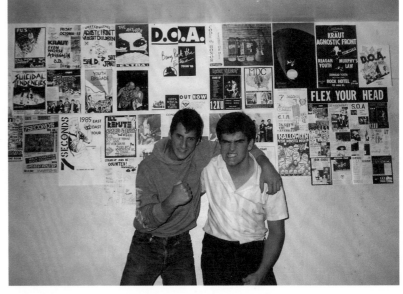

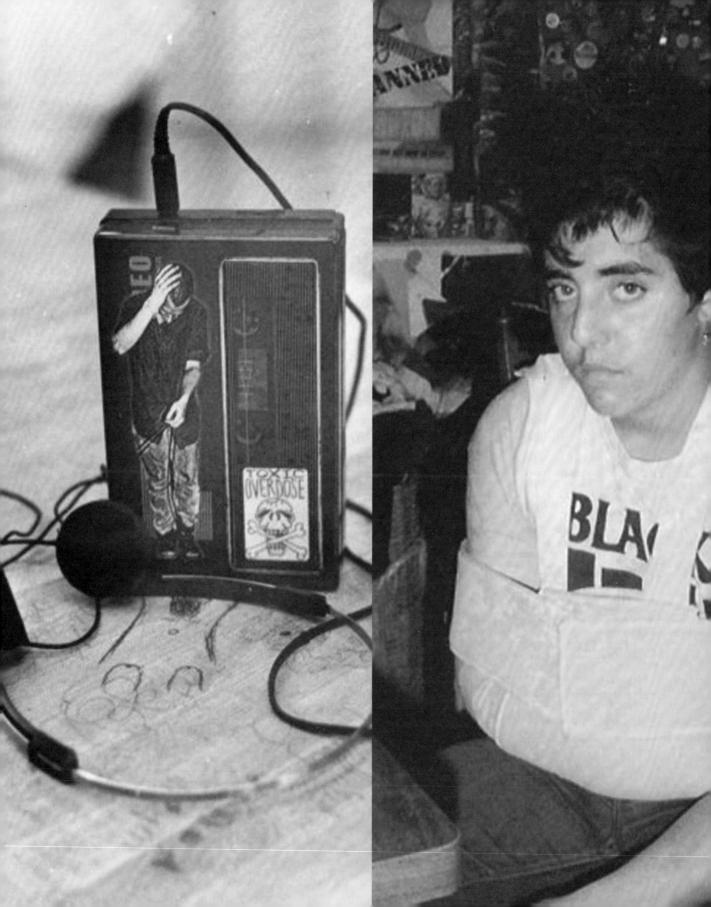

BLACK COFFEE

Anthony Pappalardo

My suburban umbilical cord was cut the day I first rode bitch in a sticker-covered Jetta. Prior to that day, my teenage mistakes were made in basements, sheds, and the woods. Suddenly, I was given a brand new way to say fuck you; a method of transportation in which to execute all my bad ideas. Because 14-year-old boys aren't cool to anyone over 14, being invited to squeeze into a backseat of some beater, provided I coughed up gas money, made me feel like a god. The car of an older punk, skin, skater, or burnout wasn't just an escape from the wood paneling of my depressing, stucco-ceilinged room, it was church. The backseat was the pew, the same backseat where bar chord-gripping fingers guitar-soloed on virgin pussy, where yellow coke was chopped, where weed was inhaled between phlegmy coughs, where sweaty heads rested and blood coagulated after a crusade. Good altar boys didn't speak, they listened and absorbed. Long drives meant 90-minute Maxell sermons that could expand your world from the Ramones, Metallica, and Zeppelin to the SSD, Rudimentary Peni, and Abrasive Wheels. Cassettes were the voice of the suburbs. You needed a soundtrack everywhere you went and the analog hiss of tape was the only way to make this happen—because every shitty car had a shitty tape deck in the 1980s.

My phone rang early on a Saturday morning in February of 1989. A friend of mine informed me that there was room in Keith Galloway's car if I wanted to head into Boston to go skating and buy records. I'd been carted around the suburbs by rat-tailed drivers to barren parking lots with rough pavement before: it wasn't much more than a faster way to do something boring. Typically, the dudes we knew wore Champion sweatshirts and Reebok high-tops to school to avoid ridicule, but secretly had a skateboard in their trunk. They'd find the most desolate places to skateboard to avoid being called a skater fag and they'd never dream of driving 28 miles to Boston to actually have fun. Guys like this had names like Greg or Alan and would disappear if they had the attention of a pimply, fringed cheerleader girl who conveniently didn't have her driver's license. Keith, on the other hand, was a legend, with a car and a flirty girlfriend named Greta whose real name was probably something normal. She had a smoky

voice, wore too much makeup, drew her eyebrows on, smelled like musty thrift store clothes and some type of mystical oil. She'd sit on the curb reading books on the occult, chain-smoking while we rolled around, and would always address us by our full names. I was convinced that she did this because the more syllables she was able to pronounce, the more she could tease your teenaged cock. "Where do you live An-tho-ny Pa-ppa-lar-do?" or "Can I borrow your lighter Ev-an La-Rue?" sounded better than anything you'd hear on a 900 number. A trip to Boston meant she'd be riding shotgun, arguing with Keith about something for the entire drive.

We piled into the car and kept our eyes fixated on the stickers and marker scrawls on the backs of the seats ahead of us like good soldiers. It was freezing outside and the heat in the car barely worked, but no one would dare ask Keith Galloway to turn the heat up —that was suicide. Along with being old enough to buy beer and having a car, Keith had seen every punk and metal show you could dream of, hit people with brass knuckles, had random scars from things people had done to him, and owned some poorly covered-up white power tattoos including a swastika on his arm turned into what looked like a child's rendition of a window. He also had a "Nazi shark" on his calf, masked by interlocking triangles which I guess were supposed to be either the Budweiser logo or the markings on a black widow. Provided you didn't get on his bad side, Keith was friendly and engaging. Finding yourself on his bad side could result in being kicked out of the car, beaten up, or—the absolute worst—being given a really demeaning nickname. You'd actually be kept around after being nicknamed just so you could be called this shitty moniker in front of everyone. Despite being introduced to Keith several times he would alternate between calling me Anthony and Andy. I didn't bother to correct him when he said, "Andy, grab me a tape from that DeMoulas bag on the floor."

Picking a tape for everyone to listen to—my trial by fire. It shouldn't have been that big of a deal, since they were all his fucking tapes, but I still felt like this was a more important decision than deciding where I was

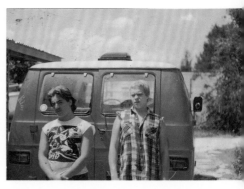

going to college. I fished around for a second and passed over the
Punk and Disorderly comp and a blank tape that said "The Vandals" on it in
fifth-grade printing. Then I noticed a red cover peeking out, Black Flag's
Slip It In. After a lifetime of parochial grade school, there was nothing
cooler to me than an album cover featuring a nun giving me the shit-eye,
gripping a dude's hairy leg. It was the perfect blend of sketchy and funny.
When I transitioned out of metal in middle school and converted to
hardcore, I was saved. Black Flag was my gateway drug. I wasn't a crusty
"remember-when" punk who cringed when people said Rollins was the
best Black Flag singer; I had a whole catalog to devour without guidance
or discretion and I honestly dug Rollins. I was also too young to say
"remember when." Henry Rollins was the perfect blend of drill sergeant
and father figure. He yelled out motivational phrases, was physically
fit, and catered to every rebellious need I had. Punk rock was cool and
lawless, but at the end of the day, punk rockers were the skinny junkie
dudes begging for change in Harvard Square—they had a snappy answer
for everything but came off as fucking pathetic. Henry Rollins was the
manifestation of everything I thought was simple, cool, and tough. A plain
t-shirt, blue jeans, Vans, and a shaved head was the perfect uniform to
me since I didn't know how you could even skate in bondage pants and I
thought mohawks were too much fucking work. I had a look, an attitude,
and "Annihilate This Week" as my motto, but I needed fuel. In order to
really be impatient and overly self-aware, I looked to "Black Coffee" as my
anthem and became strung out on coffee—black coffee, specifically—24/7.
At 14, I wasn't going to be let into any bars and I wasn't ready for any dan-
gerous habits, so coffee was a safe and practical rebellion. It's fucking cold
in New England and coffee warms you up. I needed to be alert and hyper,
and being jacked on caffeine gave me the perfect edge. Not to mention, for
99 cents I could sit as long as I wanted in a Denny's to plot and plan. Black
coffee was not only Rollins-approved, the Descendents worshiped it as
well. I could graduate to other beverages later.

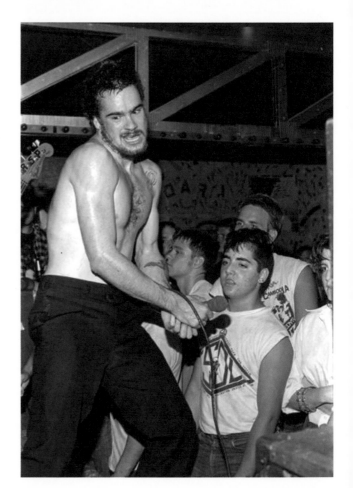

"Thanks Ant," was the reply after handing over the tape and
I was relieved that I had transitioned back to my birth name. The click

of the tape into the deck was followed by the last strains of the title track "Slip It In," which was actually a relief because that song is over six minutes long and kind of boring. I didn't really have any ire toward any women yet either. Seconds later, the Sabbath-y grind of "Black Coffee" was blasting as we cruised up the on-ramp headed south to Boston. Everything felt official, until my whole world stopped. I heard Mr. Ginn's guitar sped up to hyper speed and a loud buzzing hum. Greta had reached over to fast-forward "Black Coffee" because she wanted to hear "Wound Up." "What the fuck are you doing!? What the fuck are you doing, you fucking bitch!? Jesus fucking Christ, we were listening to that!" Keith screamed over to Greta. His right hand was open and raised and his eyes were bugging out of his skull like one of those gag toys being squeezed too hard. I was reminded at this point of another chapter in Keith Galloway's folklore: he was really into coke, speed, or any substance that made him more intense. As they shouted back and forth and the poorly aligned car carved a jagged path on the highway, I was fixated on the buzz of the tape fast-forwarding. You could faintly hear the music speeding past, mixed with a hazy frequency that cut through the cursing and screaming in the front seat. I wasn't focused on it to achieve some zen-like escape, I was fixated because I knew at any moment there would be a mechanical "clack!" and then Side B would be cranked at maximum volume, causing these two maniacs to yell louder or start beating the shit out of each other in a methamphetamine-fueled rage that would ultimately result in a ten-car pileup. We undergraduates just sat there paralyzed, afraid to move or speak, wondering if our last moments were going to be spent in a stinking Jetta whose floor was covered in fast food refuse and sweat-soaked t-shirts.

The snap of the stereo's gears was followed by the angular dirge of "Obliteration," a confusing sound that made the bitching of these two dusted-out maniacs even more claustrophobic and unbearable. Keith was now leaning over the steering wheel and had advanced to the stage of rage where you just mutter things and channel your inner douche bag. He progressed past yelling at Greta and was now showing the signs of a

true maniac by cursing out people who weren't even there. "Fuck you, you fucking piece of shit, don't-you-fucking-tell-me-what-the-fuck-I-should-do, don't you fucking talk to my mother that way you fucking spook, I-don't-need-this-fucking-shit..." he ranted in an unnerving staccato cadence. I was pretty sure he was bitching out his black stepdad, followed by a teacher maybe, and then onto Greta again. We whipped off the highway and pulled into a strip mall parking lot where Greta was instructed to get the fuck out of the fucking car, which she did, without much resistance. Her pale face was covered in drippy makeup and she was gripping her head, which caused one of her drawn-on eyebrows to smear. Really disturbing. Like all true psychopaths, Keith flipped his switch back to that of a levelheaded, regular human and asked one of us to jump in the front. Luckily, I was riding bitch, so it was between Evan and Bucco the Skin. Evan jumped into the front seat as Keith calmly talked about what a fucking bitch his bitch girlfriend was and how she could go die behind a dumpster because he didn't care. His voice never rose above the music or showed any signs of aggression, just a calm venting about his "bitch-cunt-liar-whore" better half. Our stride was broken, but not our spirits. Greta's flirting had been semi-exciting, but our mission was to buy records and skate.

The pew had one less body, the tension was gone, Keith's ranting was manageable, and in 20 minutes we'd be rolling over smooth brick and budgeting out which 7" singles we could afford while still leaving a few bucks for coffee and french fries.

Keith jolted himself back into normal driving posture, cracked his neck and lowered the music. Then he tilted his head back and proclaimed "Fuck it man, it's cold as hell out and Boston's fucking freezing anyway, let's just go skate the ramp in my garage, it's only five minutes away."

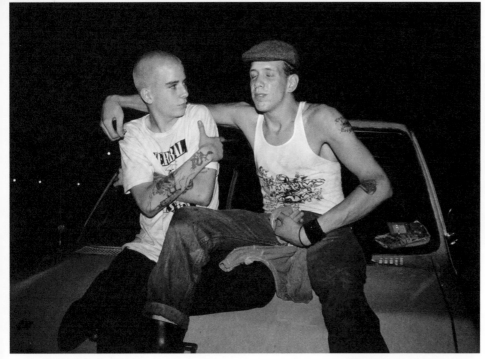

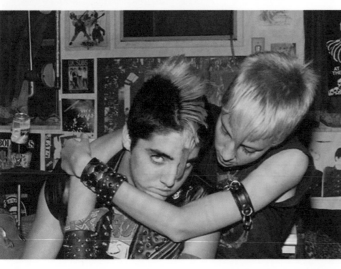

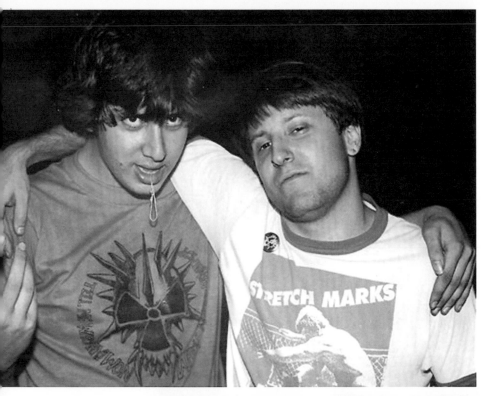

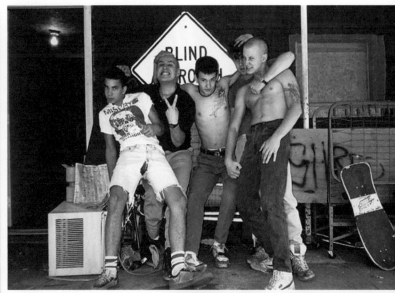

CASEY, YOU FIEND,

GET ON THE BALL AND SEND THOSE SKULLS TO US!! THE MONEY YOU SENT FOR "WHO KILLED MARILYN?" + "3 HITS FROM HELL" 45's WAS THE PRICE FOR T-SHIRTS __OT RECORDS, SO WE SENT YOU BOTH. PLUS BUTTONS, __ LIKE ALL THIS STUFF.
__E OF T-SHIRTS SOON — L.P. COVER, __OSTER ART T-SHIRT, AND A JERRY __ NEW FIEND CLUB T-SHIRT.
__' IS ON "3 HITS FROM HELL" (LOGO + __OUR SINGLES ARE DISTRIBUTED __C + ROUGH TRADE. BULLET + __ ARE LONG OUT OF PRINT.
__DOES'

GLENN DANZIG

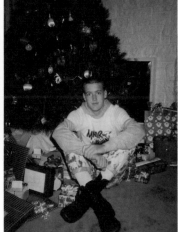

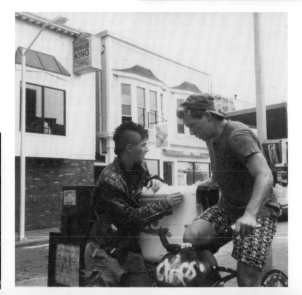

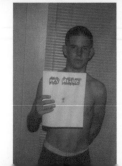

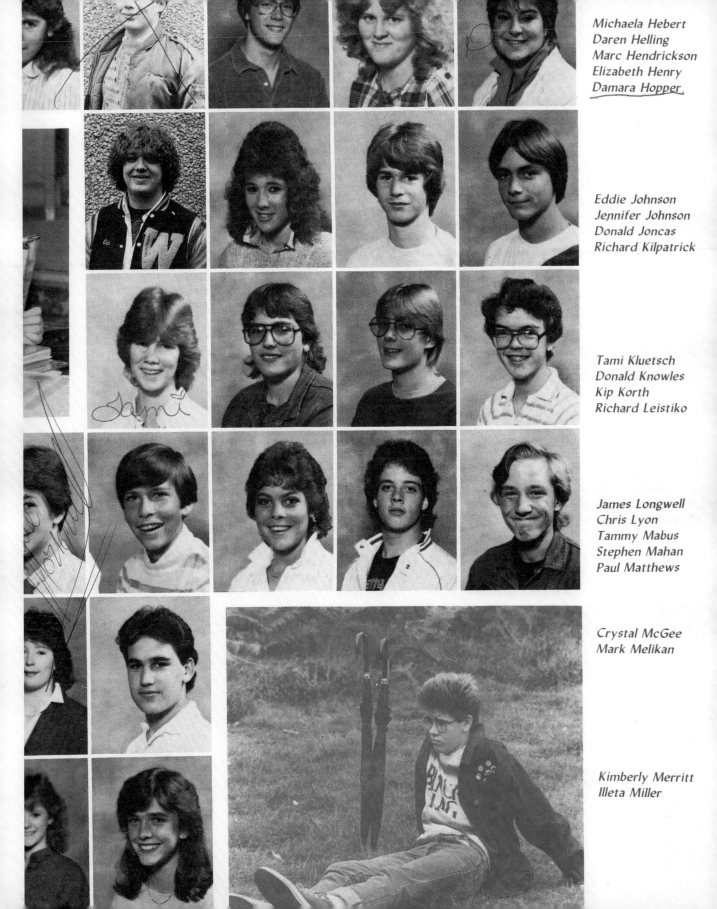

Michaela Hebert
Daren Helling
Marc Hendrickson
Elizabeth Henry
Damara Hopper

Eddie Johnson
Jennifer Johnson
Donald Joncas
Richard Kilpatrick

Tami Kluetsch
Donald Knowles
Kip Korth
Richard Leistiko

James Longwell
Chris Lyon
Tammy Mabus
Stephen Mahan
Paul Matthews

Crystal McGee
Mark Melikan

Kimberly Merritt
Illeta Miller

AMERICAN HARDCORE PARKING LOT

Max G. Morton

My mother was a poster child for her generation. Once wild and free, she soon surrendered her dreams to the nine-to-five world and enjoyed a glass of wine before bed with a man half her age. Not unlike what she'd done to her parents, I put my mother through the ringer. She was hip to the definition of her favorite word, "karma." All aspects of radical counterculture that her parents just didn't understand were back tenfold with me.

She was a prime candidate to grasp the art of growing pains and my questioning of everything. While most of the hippies got straight after The Family creepy crawled around the canyon, Mother never quite grew out of it. Hippies are snobby and can't see anything past their nude sit-ins and whale-saving causes and conveniently she forgot what it was like to be young. When it was her turn to raise a kid she could no longer relate to getting her hands dirty with experience.

I had to feel everything. I absolutely needed to run my fingers through the most matted, Aqua Net-sprayed, spandex-wearing hair. Mother didn't understand. After dropping the humiliated leopard-printed beast home, moments after discovering her surfing me on my water bed, Mother kept repeating how the boys in my tribe were so much more attractive than the girls. She couldn't just be silent or sing along to Stevie Nicks, she had to critique the only trout I could catch on hot suburban concrete (in the bowling alley parking lot, to be exact). Mother loved *I Am Curious* but thought Showtime late-night programming was juvenile. I was a horny teen wolf. I had no time for meaning in another language.

The woman who had once smoked banana peels and eaten bugs that were supposed to bring her closer to the spirit world was now puzzled that I wanted to burn occult symbols (from her books) and band logos onto walls with adhesive and fire. Blue Cheer was one of her favorite bands but she didn't understand Black Flag. "Feedback was different in the 60s."

There was a unique ground rule in her house: No Ozzy. When I was into metal I could conjure demons, wear an inverted cross, and "Fuck Like a Beast," but the Prince of Darkness was out. To her it was simple: he ate a bird and made an entire audience stomp on a bag full of puppies. Not

having a Sabbath shirt kind of made me a queer in the heavy metal section of the locker room. When Randy Rhoads died I was granted permission to move on. After that phase she repeatedly told me how "not evil" Venom and Celtic Frost were, to the point where I had to find something really evil—bald monsters. Yes, American skinheads. She was way more supportive than most, but she liked what she liked and expected me to forever follow her lead as I did when I was six. Unfortunately, acid wash is not the same as bleach splattered *Spirit Of Oi!* inspired Levis. Reebok high tops are not cooler than steel-toe oxbloods and just because we went to see Van Halen together once doesn't mean that years later I'd want to go see them with a new singer.

Mother had done all the same things but much better, with much more meaning. There was a "message" at her concerts. I am not sure where the message in the Exploited was lost upon her, possibly between me trying a mouthful of Red Man at a dirt bike race and huffing Rush in the back of homeroom with a bleached troll.

The parties my mother went to were in houses. Now that the kids who attended those parties were grown up, they never left town, knowing what would happen if they did. Because of this, we were forced to loiter elsewhere. Every weekend, Mother would say, "You were in the parking lot of Kmart until 2 a.m.? Doing what? I can't drag you there when it's open! What is so special about that parking lot in the middle of the night?"

Loud, fast music coming out of multiple vehicles, unfed hearts sharing about the enemies (teachers, parents, and jocks) and experiences of the past week, a few fights, and by the end of the night, drunk, sloppy girls with no other place to pee but behind dumpsters, much to the delight of the voyeurs. Cops would eventually come, but the beauty of suburbia is that the next night you could go to the next parking lot over and do the same thing. We may have run out of beer but we would never run out of parking lots in which to rot the night away. Trading tapes, buying acid, getting chased by someone's unhinged older brother who just got out of jail and was on a mission to do exactly what was done to him in a parking

lot by the elders of suburbia... The torch was passed and we lit our men-
thols with it. Shopping cart jousting, Big-Gulp-induced wet t-shirt contests,
impromptu slam-dancing, and whatever was under the manufactured
moon of disposable wastelandscapes. We cut our teeth and partied in the
parking lots of Anywhere USA.

 I remember Mother picking me up in her rust-red Toyota truck
one night when my ride got arrested. There was usually at least one proud
casualty shuffling off in cuffs for yelling "pig" to a pig. Like true strip-mall
fugitives, another friend and I ran to the next parking lot. The girls there
were a little older and hotter and the guys were a little more stoned and
dangerous. After being treated like we were invisible, turf war vibes led
us to the pay phone where we called upon my mother for a ride home.
Looking around at all the restless youth on the hoods of their cars, high-
fiving and staring at the stars, Mother asked us what we did that night, for
the first time with actual interest. Minus the dabbling in Night Train, dirt
weed, and running from the law, I told her the truth. "Oh, nothing." Not
like she would have gotten it anyway.

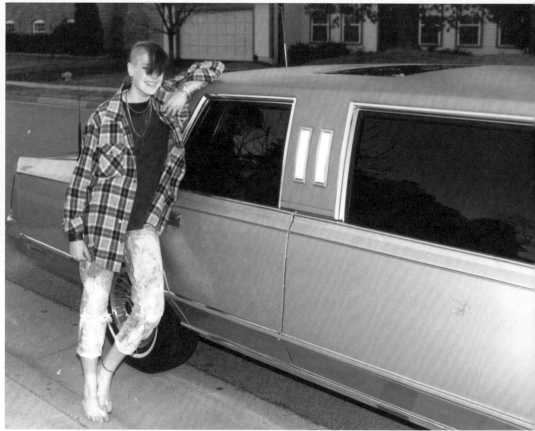

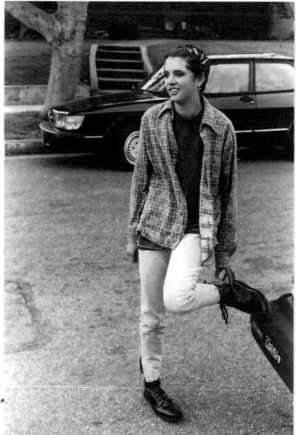

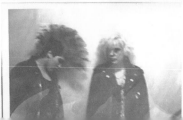

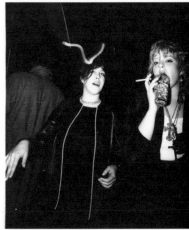

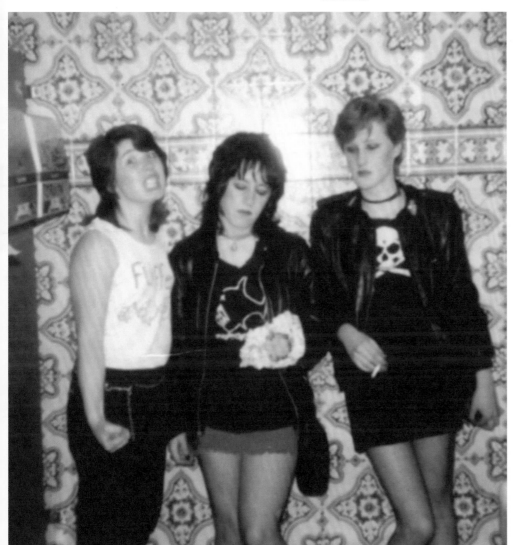

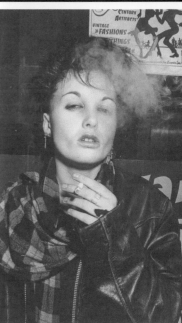

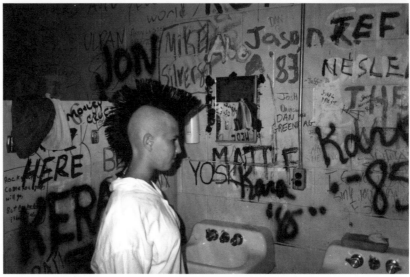

153

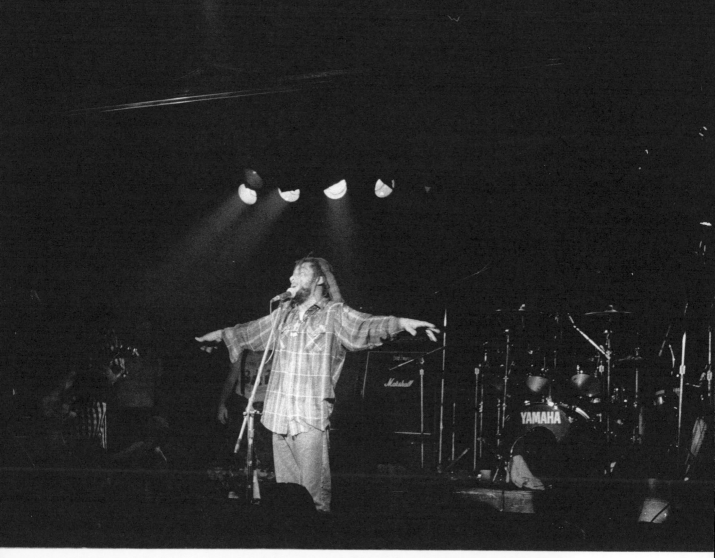

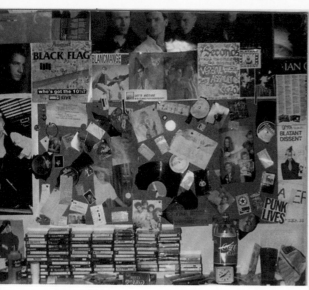

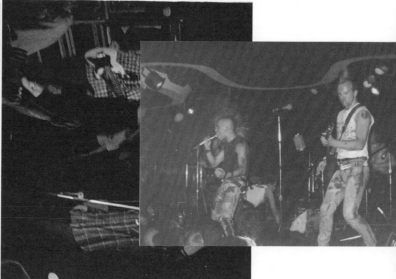

SCREAMING SKULL

Max G. Morton

Records granted me a pulse. As with my drugged-up coping rituals, I had a similar taste for new music. I did what was needed and explored the places necessary to obtain such highs. One day I stole a cassette from my mom's boyfriend. Upon liberation, I damaged it and returned it to the mall. After a stern inspection, I was granted an exchange at the same value. Success. Soon I would have to get creative with my scams. There were only so many stores in Florida.

When the clerks caught on that I was the only kid with defective Queen tapes, I began ordering subscriptions from Columbia House under my favorite serial killer names to the empty homes in my neighborhood. When my thirteen brand new, sealed tapes arrived I would exchange them, one by one, explaining that my grandmother had the best intentions, but she just didn't understand my taste in music.

Records were more important than food, so I'd starve to save my lunch money. Weekly, I placed orders from Raunch and Toxic Shock. I would anxiously await my mother's return from work, hand her my cash in exchange for her Visa, and place a call. They knew my name and would recommend accordingly. Five to seven business days later, UPS would ring our door with a box or sometimes two of records. Knife in hand I'd storm my room, gut the box wide open and throw on the first record. A seven-inch would last no more than a few minutes on each side and a good LP always ended under the 20 minute mark.

By the time the initial high would come to a close 24 hours later, Mother would be pulling into the driveway again. Rushing out to greet her—cash in hand—I got my fix, and the ritual repeated.

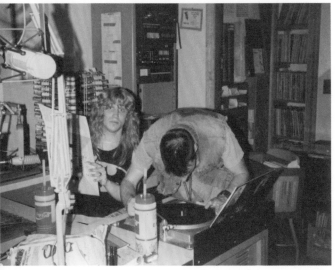

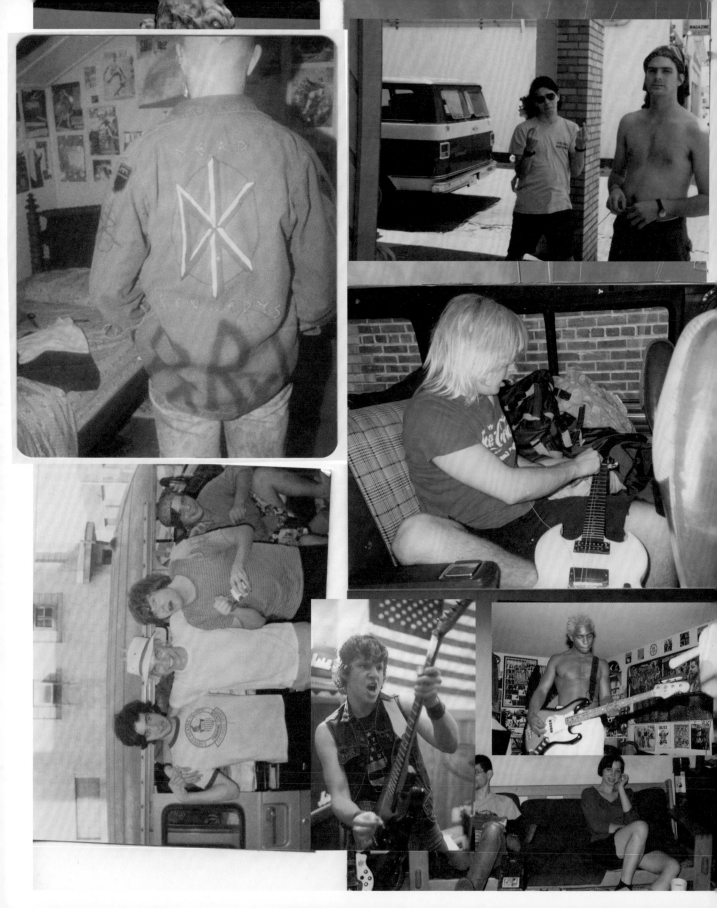

"WAKE UP, AND LIVE!"

X

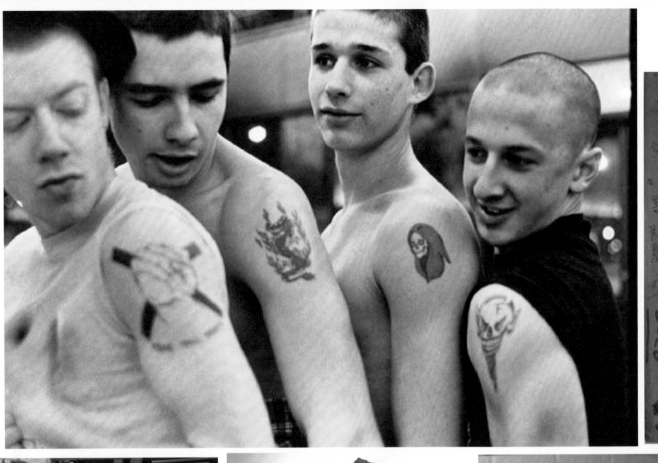

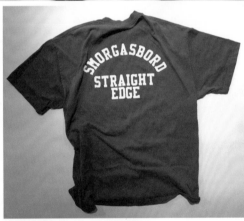

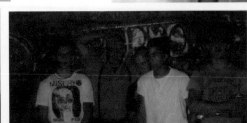

ME, YOU, YOUTH CREW

Anthony Pappalardo

Before settling in Salem, my family lived about 25 miles north of Boston in a city called Lawrence, Massachusetts, or "Law-Town," as any white dude with a goatee and House of Pain cassette called it. Despite the nickname, Lawrence lacked laws, or at least no one gave a fuck about them. The city became famous in the 1980s for having the second-highest car theft rate in the U.S. It was also the birthplace of Robert Goulet, and had some insane race wars in the mid 80s which resulted in houses being burned down.

My family was always into music, especially my uncle, who would rip blues solos complete with "guitar face" through a Fender amplifier with an "on" button that glowed ruby red. My dad, aunts, and uncles had record collections and would play me all their favorite bands. I'd look at every record and digest every panel of each gatefold or sleeve, from the cartoons on *Cheap Thrills* to the die-cut spinning wheel on *Led Zeppelin III*. I'd also read every page of every faintly pot-scented copy of *Rolling Stone* lying around.

In my family, listening to records wasn't just an activity: it was an education. Uncle Charlie had seen every band. I never got tired of him telling the story of watching Ginger Baker nail his kit to the stage, or seeing Hendrix play to 20 people in a small club outside of Boston.

My uncle and dad both shared one hated musical act: Led Zeppelin. The first two albums were great but they had turned into a "chick band" that my aunt worshipped. Later in life, I realized that was the same reason I fucking hated Guns N' Roses. My aunt got me into the Beatles, KISS, Led Zeppelin, and Aerosmith and also confused the fuck out of me when she bought *Double Fantasy* and kept playing the track "KISS, KISS, KISS." That song still terrifies me and makes me feel like I have just woken up from a dream about paper bags or something else creepy and mundane.

There was a VFW hall not too far from my parents' place. I remember waiting at a light in the back of their metallic green station wagon and seeing a bunch of kids in front of the hall. They looked a lot like the punks I saw in a copy of *Rolling Stone*. I thought punk rockers only existed in the UK, or on episodes of *Chips* and *Quincy*. A few weeks later,

I was walking through Kenmore Square with my dad on our way to a Red Sox game, when I saw a similar gang standing out in front of the Rathskeller. These dudes looked tough—less about mohawks and more about bald heads. They resembled soldiers more than artsy junkies. I stopped to tie my shoe just so I could soak it all in. I didn't recognize any of the acronyms written on their jackets and shirts—it was all some insane mystery to me. It didn't even dawn on me that there was a show going on in that club; I just thought these dudes were hanging out looking cool and angry.

When I was ten, we moved eight miles north to tax-free Salem, New Hampshire, with a giant strip mall lining Route 28, running through the entire town. It had bad concrete, nothing cool going on, and no public space. Just Kmart, tattoo parlors in trailers, and a hundred places to buy shit to improve your shitty three-bedroom, one-and-a-half bath home that looked like everyone else's suburban bunker. It's not shocking that a state with nothing to do, the largest KKK presence in the Northeast, and bad legal tattoos spawned someone like GG Allin.

I was about to start middle school, was completely into metal and BMX, and starting to get interested in skateboarding. I got a copy of *Thrasher* on a family trip and convinced my mom to write a check for $9.99 so I could subscribe. There was now a new world being sent to me every month, a world in which the drips in my neighborhood weren't interested. These douches were too busy watching monster movies, feathering their dry, stringy hair, or bragging about fights that never happened. They didn't get "playing skateboards" and reading Puszone.

My best friend growing up lived in a close-by town called Bradford, in a renovated farmhouse with his dad, who always wore sunglasses and smoked cigars. His pop was a paranoid maniac who feared that his son would be a fuck-up, so he sent him to Catholic school. Everything changed when he met this upperclassman named Mike D. Mike D—the "D" was always included—had a car, did a zine, knew where all these ramps were, and, to top it off, wasn't a dick. He would pick us up and take us skating, play us new bands, and just fill in the blanks for us. And we

fucking loved tapes. You could jam them in a boom box while you skated and you could copy them easily. Every suburban car had a tape deck and, while they might have sounded like shit, they were the perfect way to experience music when hyper and on the go. Records were for winding down and really listening—if we loved something, we'd get it on vinyl so it was more precious. You could throw a tape at the dude riding shotgun and no one really gave a fuck.

Mike D would quiz us to see what bands we knew about. His jaw dropped when we said we had heard Minor Threat, but not his favorite band at the time, Youth of Today. He proudly pulled out a blank tape with *Break Down the Walls* on it and played it for us. We hadn't heard anything like it.

He explained that they were from Connecticut and that their record cover photo was taken at the Rat in Boston. They were the second wave of straight edge, hardcore-influenced Boston bands, like SSD and DYS, but they took it to a new level. SSD and DYS were bands we knew, but at that time—with SSD's best stuff being out of print—we mainly knew to avoid both bands' bad metal records that plugged up every used bin. The biggest thing Mike D did was make us realize that, only 25 miles away, all this shit was going on. It sparked our interests in the older bands and made us love Youth of Today more. He promised to tape us the good SSD and DYS stuff and demanded that we revisit the *This Is Boston, Not L.A.* compilation immediately.

Even though Youth of Today was from Connecticut, they had relocated to New York City. The bands we knew from New York were rugged thugs who wore chains for belts, were covered in tattoos, and sounded like wrecking balls smashing through tenement buildings. The Cro-Mags were a band we loved, but Youth of Today was a band we connected with. It just seemed like what they were doing was more tangible to us. I knew guys who looked like this: Ray of Today wore one of those shell necklaces you'd buy at the beach to feel cool and try to attract girls, they rode skateboards, and wore Air Jordans, not boots. It was everything I thought of as cool in one place.

I couldn't stand hard on the LES—I didn't even really know what the fuck that was—but I could pose in my living room or fake a show in my bedroom with choreographed stage dives. It just made sense and things were starting to really click. What I liked about hardcore more than metal was that the dudes in the bands and in the pictures looked like me. No British accents yelling at me about the Queen, no biblical references or tales of great wars or demons. They weren't sporting mohawks and spikes and shit; they had the clothes I had. Being a punk was actually fucking expensive: Doc Martens, Manic Panic hair dye, and a leather jacket would run you at least 300 dollars, which wasn't in my universe. If I had that money, it was going towards some shitbox car that I'd later destroy by not changing the oil. I loved the idea of heavy music and heavy morals.

Hardcore was a perfect fit for my brain then. Maybe it was my Catholic background or strict parents that made a dude barking orders at me sound totally normal and actually cool.

The Boston crew that Youth of Today were referencing looked simple and cool with their high-tops and jeans. Their brand of punk was almost conservative, which was confusing. They were straight edge, but they hated Ronald and Nancy Reagan who were telling us to "Just Say No." The mantra was "no rules," but they had a code to which they adhered...well, maybe not Springa. On the surface, the idea of a sober army of fucked-up kids sounded completely scrambled, but plant this crew in the largest college town on earth, run by drunk pledges puking yellow beer nine months out of the year, and it's no surprise that this movement happened as a response to pretentious art school kids, under-read junior liberals, and loud frat boys.

The only difference between the Boston crew and Youth of Today was that the Boston crew still had a rugged vibe that is synonymous with Boston. They all looked like they worked hard jobs and were into hockey. Youth of Today looked younger, more athletic and less menacing. They rode skateboards, they looked cool—not cold—and they could probably get laid by someone other than a random, fat skinhead chick. Cappo, Porcelly, Ferraro, Setari, and Drew Beat (he looked Italian to me, and when I learned his real last name, I had confirmation). It seemed like every dude in Youth of Today was a suburban Italian. We all had similar profiles, strong Roman features and dark hair. I even asked my parents who we were related to in Connecticut, hoping to hear about a Cousin Ray, but it ended up being some fucking D'Benedettos and other Pappalardos.

Later that week, I biked to a record store to buy Youth of Today records and *The Way It Is*, a New York City hardcore compilation that they were on. I ended up getting a copy of *Can't Close My Eyes* on cassette. Everything about this tape resonated and had me taking the oath. Even the fact that the people on the cover were at eye level with the singer Ray Cappo—there was no rock star shit. Where was this band even playing? The image was so blown-out that it was mysterious.

I ripped the cellophane off the tape in the parking lot and began reading the lyrics. Everything spoke directly to me. "If the world was flat/I'd grind the edge." My town was fucking flat and dull, so instead of bitching, I started grinding anything I could there. "I Have Faith," "Positive Outlook," "Take a Stand"—the titles were simple and strong. When I finally got to the last track and its "Me, You, Youth Crew!" chant, I was ready to bike to New York City and take a shit on Salem, New Hampshire. Lucky for me, I had already learned through their lyrics that running away isn't too positive and that I should probably graduate high school instead.

I wanted to know everything about this band now. I went back through my old issues of *Thrasher* to find any blurbs about them. My friend

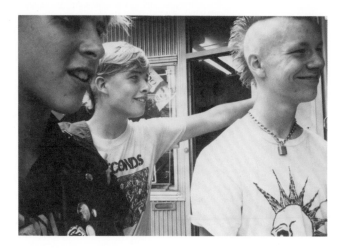

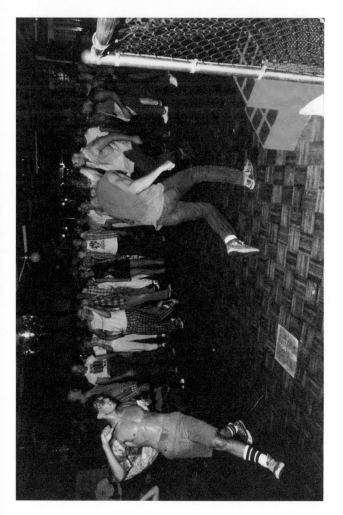

came over the following weekend with a copy of *We're Not in This Alone* and our lofty expectations were topped again, even if the mix of the record sounded like one giant guitar and a dude yelling. It just didn't fucking matter.

From the first shout of "We're back," the album had us focused and sucked-in by the intense energy that filled the room through my plastic speakers. The actual photograph on the cover was cropped to obscure Ray's head making us feel like we could project ourselves right into that pose. We needed to see Youth of Today now. They had played Boston several times before but there were rumors of them breaking up, and we were only 14 anyway—the lowest on the totem pole to catch a ride to gigs. There was a good chance it wasn't going to happen for us.

The space in my brain once delegated to KISS, Def Leppard, Metallica, and, more recently at the time, Suicidal Tendencies, had been given to Youth of Today. Even their logo was the perfect icon to me. The X-ed up fist was like a sports team logo; it showed power and strength. Unfortunately, my fist spent more time beating up candy bar wrappers, joysticks, and porno mags instead of Nazis, drugged-out threats, and walls.

I started high school in 1989, so I had one foot in the 80s, but by the end of my freshman year a lot had changed. Most of my peers were still stuck in hair spray, banana combs, and denim jackets while I was trekking around to punk and hardcore shows, mail-ordering records, and taking trips to Boston to buy records and skateboard all day. Getting to Newbury Comics and actually seeing Youth of Today's last 7" was epic and sad at the same time. We knew it was over, and the record seemed to visually mimic the also-posthumously released Minor Threat *Salad Days* 7". It was a somber artifact. The record had no type, just a picture of the band with Ray doing a jump that seemed impossible. The whole pose cemented in me that he was larger than life and could do anything.

Weekends in high school were exclusively about skateboarding and going to shows. This forced me into many tough choices. Would I hang around coffee shops and town squares hunting for alternative girls who had crushes on Robert Smith or Perry Farrell (but never both) or hang

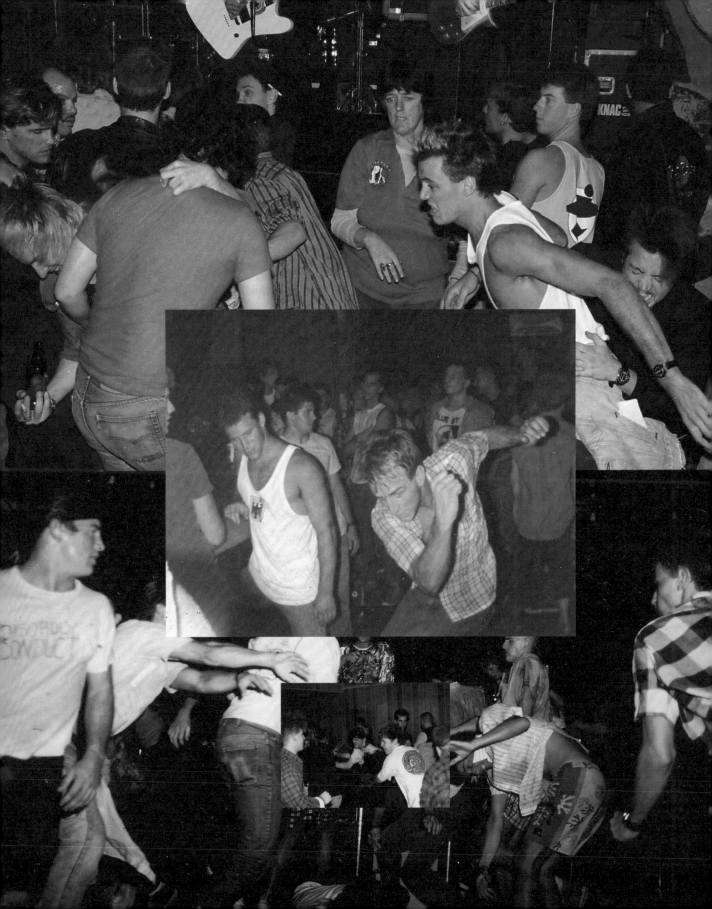

out with sweaty dudes in clubs with no air conditioning and dusty parking lots? To make getting laid the hardest thing possible, I chose shows, skating, and ultimately "brotherhood." Suffering through the *Rocky Horror Picture Show* or *Harold and Maude* to try to get a hand job was not an option.

Instead of worrying about touchdowns, acid, or awkward sex, my brain was consumed with what the Youth Crew was doing... Where did they hang out? What did they do for their birthdays? Who the fuck were these crucial dudes?

Soon enough, there were flyers circulating, saying that Ray from Youth of Today's new band Shelter would be playing in Boston. Shelter was the vehicle for Ray's new spiritual journey, as he was now steeped in Krishna consciousness. Rumors were swirling about him living in a Hare Krishna temple, traveling to India, and not masturbating. His spirituality seemed like the next step of straight edge and some kids I knew started getting into the philosophy. The images in the Bhagavad Gita were stunning and stories about war are always cool, but I had just put metal and great wars behind me. I loved Shelter and just wanted to see this band, plus we heard they covered "Disengage," so I knew it was going to be epic.

Shelter played. They were incredible and totally fucking weird too. Ray was wearing a drug rug and thrift store clothes, totally shaved up with the lone ponytail thing remaining (which I never learned the proper name for). Some of the guys in the band looked like lurkers from the temple where he lived, who were just given instruments. One of the clues was that they wore their pants really high and tucked their shirts in. Some of them even had their faces painted. It was disturbing, in a good way. Religion isn't welcomed in punk, and that seemed to prove as a motivation for Shelter. It was every bit as intense as anything I had seen and Ray was bringing some new ideas to the stage. Who cared if they worshipped a deity and didn't swear? Their merch table sold the obligatory t-shirts right next to chanting beads and Krishna literature, and they even had some ancient yogi with them.

The only shock for me was actually seeing Ray Cappo in person. On the records, he looked like a human G.I. Joe, but he was actually much shorter than me and quite small in stature. This was a total mind-fuck and I wanted to take Ray home in my pocket and show him off in school the next day or something.

After the show, Ray was swarmed by kids in the parking lot, fielding all the questions being thrown at him. I had never seen a man attacked like that at a show. They weren't asking for autographs or photo ops, everyone just wanted answers. This was the perfect time for him to simply state that they could find all the answers at Boston's own Hare Krishna temple, while enjoying a free vegetarian feast. He conveniently left out the fact that beforehand, you'd have to endure a shoeless lecture. Before setting foot in the temple, I had already made up my mind that a new life of not sleeping, not jerking off, not buying things, and not swearing wasn't for me, but I was happy to meet new people and talk about life. What the fuck else did I have to do? I wasn't about to forsake everything I actually enjoyed about being a teenager, and I think Shelter was OK with that too.

It was the 90s, I was about to go to college and I was excited about so many styles of music, my world expanding in so many directions. I wasn't interested in being a monk; I wanted to wear Girbaud Jeans and striped shirts and hang out for too long at bad pizza parlors talking about girls, records, and clothes.

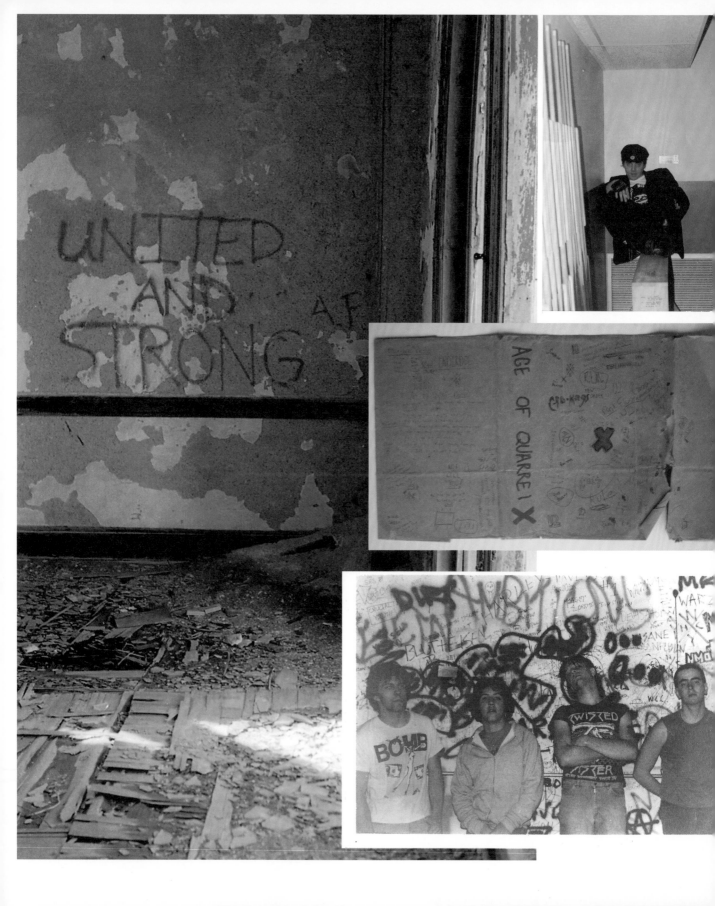

SCREAMING AT A WALL

Max G. Morton

Graffiti let the town know. I've tagged everything from band names to girls' names. Crüe, Maiden, Venom, Cro-Mags, skinhead, straight edge, Traci, Seka, whatever. It was a spell cast out to other lost souls of the unknown, seeking like-minded warriors in the teenage war. We've all marked names in a more negative tradition too. These statements were left for the next traveler to fall upon. Girls you never slept with but wish you did. A lesser karate team, bands that betrayed you, teachers that flunked you, even a jock who kicked your ass now magically sucks a million dicks and a million people know about it. If it weren't for the markings of the suburban astronomers, we would have all been without a compass.

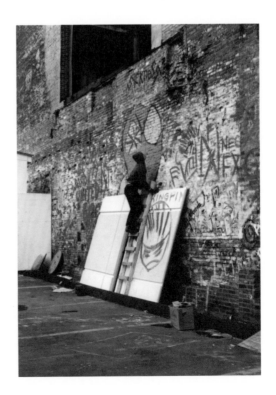

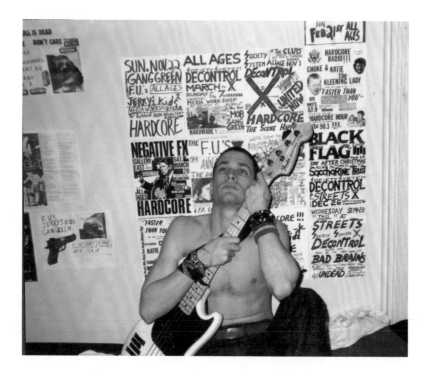

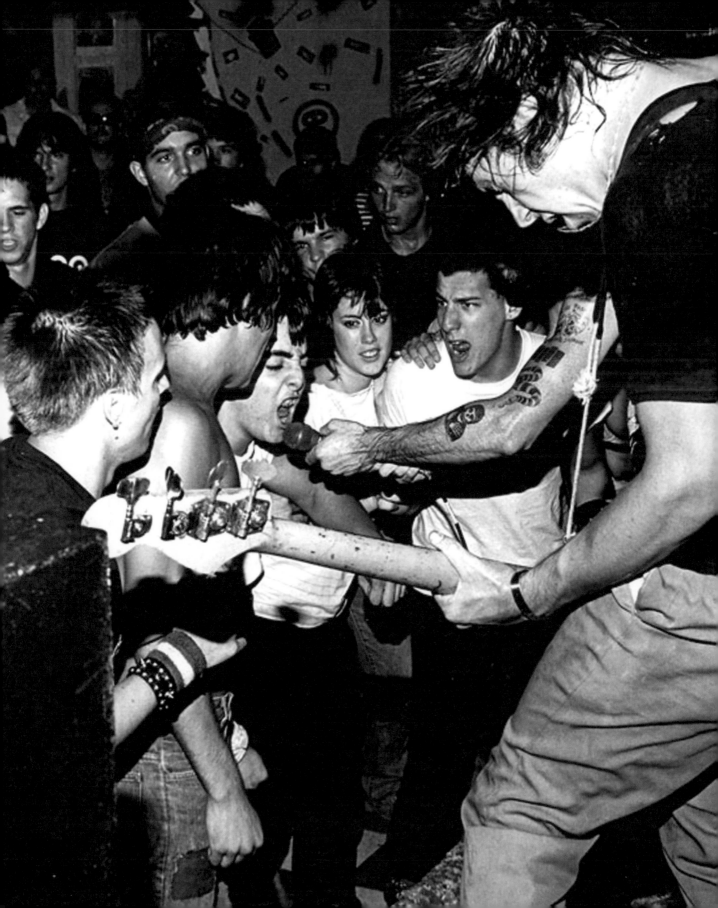

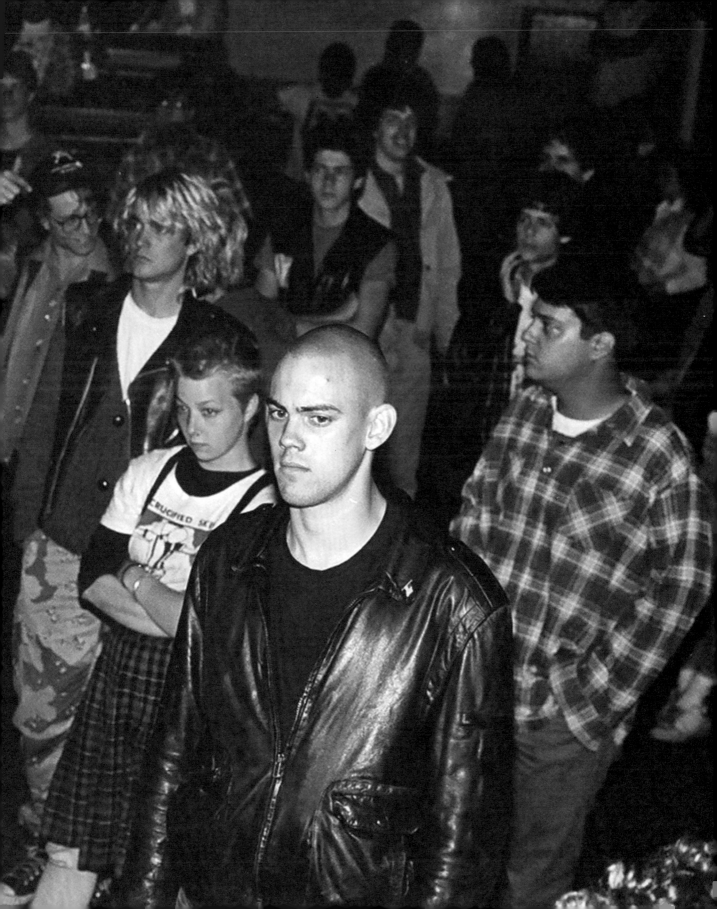

WORLD
of
SKINHEAD

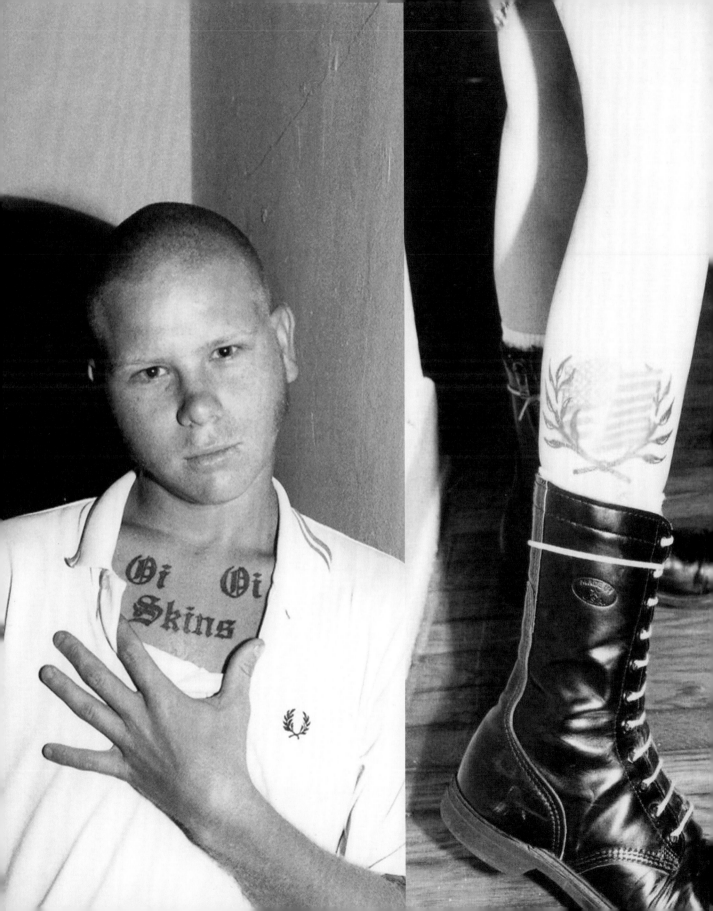

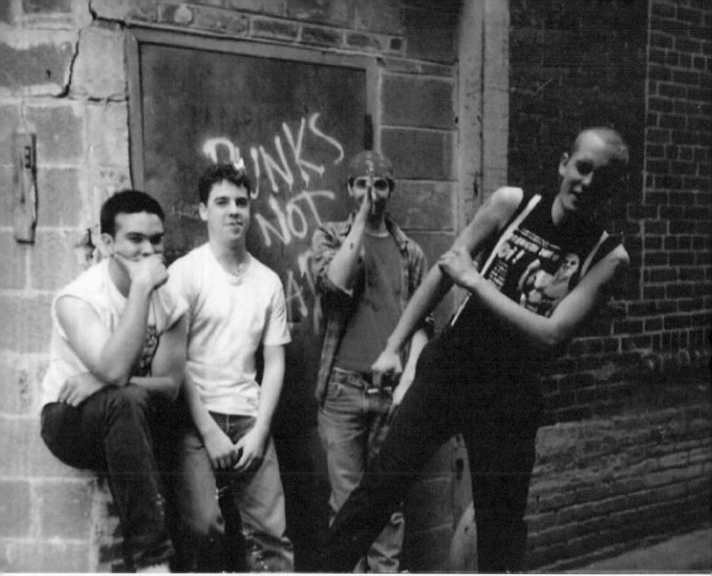

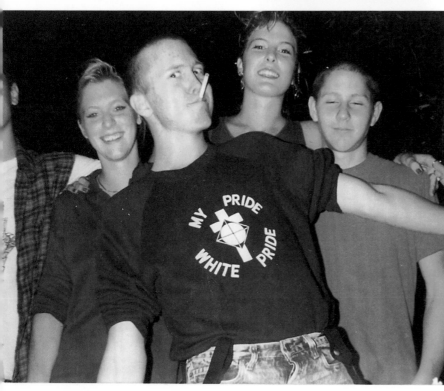

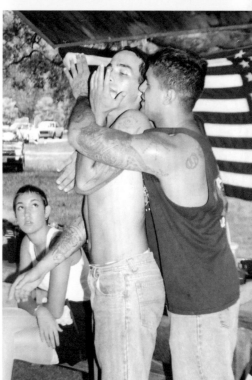

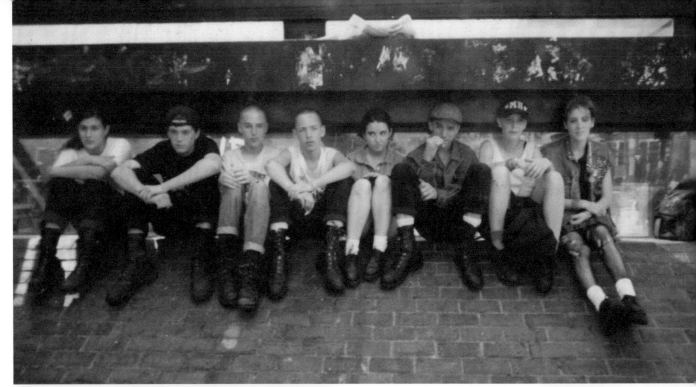

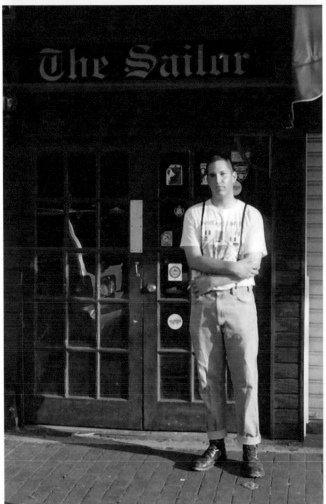

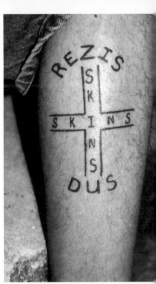

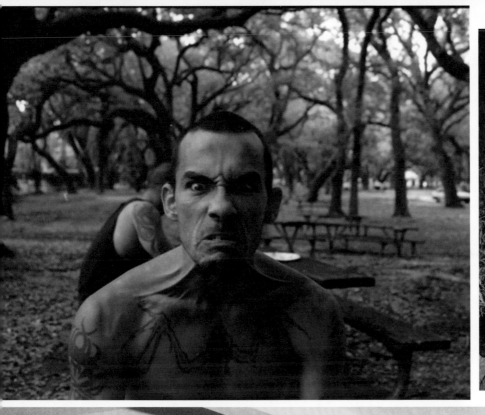
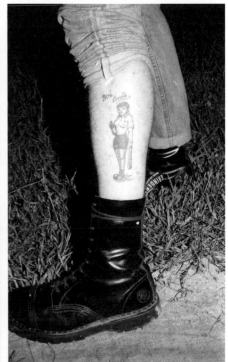
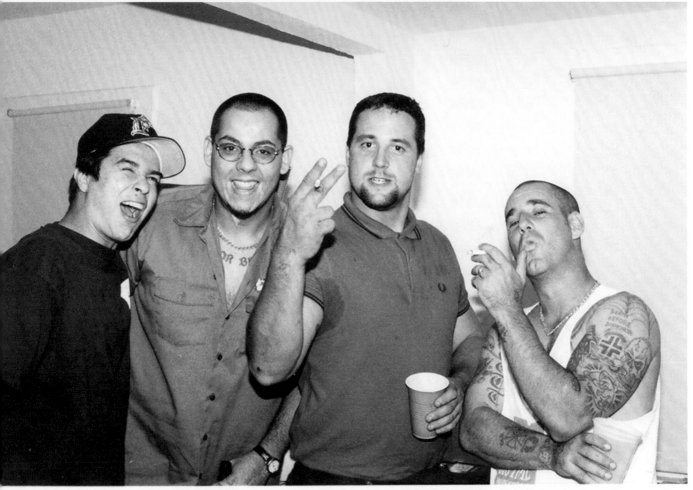

I WILL BE A SKINHEAD UNTIL THE END OF TIME was spraypainted across a fifty-foot expanse of brick wall in New Haven, CT. This was the first time I had read or even heard the word SKINHEAD. i was being herded into an Iron Maiden concert at the Coliseum when I first came across the notion that there was an alternative. I was at the age of Heavy Metal and had been wanting more. A lame Exciter shirt? Dirt weed and cheap beer? I always felt there was more — something to push the limits. Something with meaning. Something more personal and maybe — just maybe — something not so goddamn STUPID. When can a motherfucker graduate this class? Punk hit me. Or was it hardcore? Whatever it was I knew I was quickly approaching the last stop. I kept thinking of that one phrase. I WILL BE A SKINHEAD UNTIL THE END OF TIME. That word.

And there they were. I'd seen those guys and girls before with this look. Short hair, those clothes, and those boots. What was it that drew me toward this? It had to be the music, the uniform, the BLOOD. I learned fast and made this my life. I loved being hated by the people who were the hated. Bands were formed and friendships were made. Those years steam rolled by so fast. Live fast. Not dead, but getting old and still here.

I could never fully describe ~~this life as~~ being a part of the top subculture. The glory and the pride of what we are. The dress and the dread. The might and the fear. From riding so high to crawling through the contradictions. I will be a skinhead until the end of time. I know who I am. And you, I am sure, do not like it.

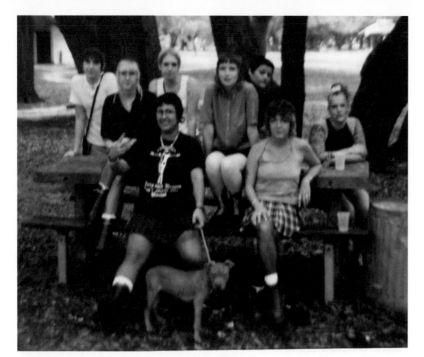

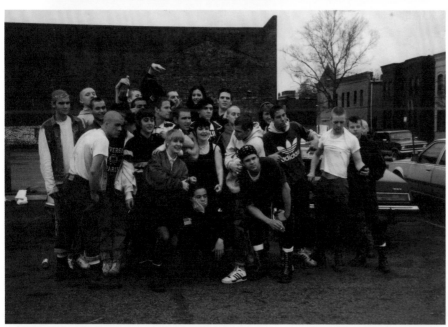

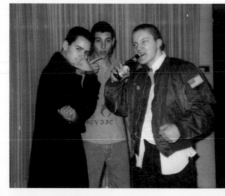

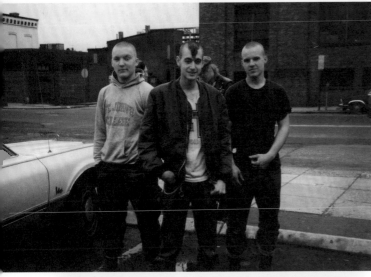
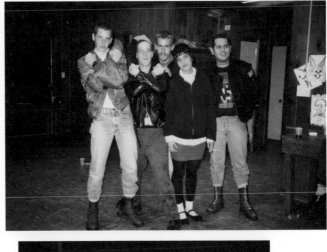
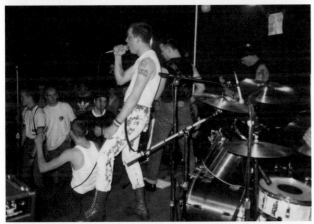
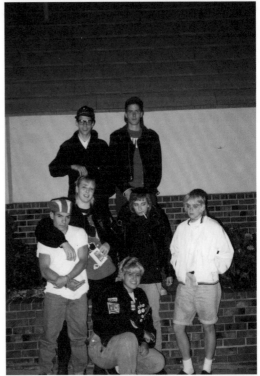
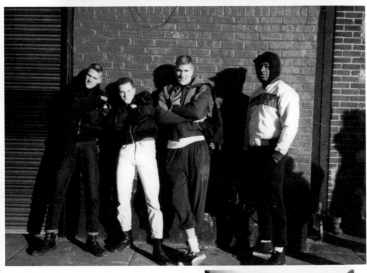
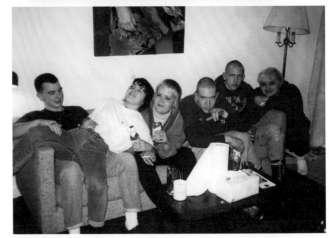

VIOLENCE IN OUR MINDS

Max G. Morton

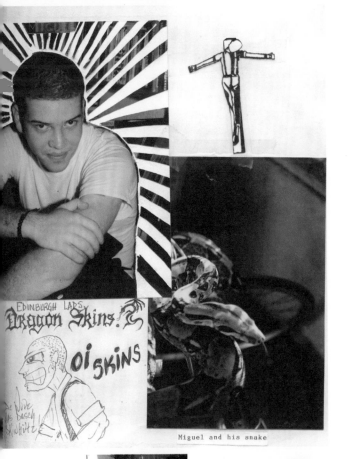

EDINBURGH LADS

Miguel and his snake

There was an aura of suburban rage that accompanied the razors in my gut that first time the pack stumbled upon me. The look in their eyes was Indestructible. It promised violence. Boots, scarred-up knuckles, faded blue jeans, and a shaved head set the young destroyers apart from all other subcultures. The ultimate youth cult.

The American skinhead—pride of both working class culture and dead-end sociopaths. Political or not, they could have been dressed sharp, mirroring the spirit of 69, or sloppy and shirtless with a beer gut at sixteen. Either way you could feel the aggression and lawlessness in the darkness of the 1980s wolf factories.

For love of Oi!; For the love of Reggae 45s; For the love of putting the boot in—being a part of a movement that had a pulse. Friends and fights labeled a new danger to society. This was the voice of a new breed that was not conforming to Reagan's dream...

Not choir boys, but not what your television warned you of. Sure, there were heads going through vending machines, urination on any-slash-everything, running enemies down in public phone booths, drowning of fresh cuts, and parking lot holocaust. Fangs and claws were out indefinitely, but what is youth without some bloodshed? Searching and smashing with no tomorrow for broken noses and knuckle girls. Boots, fists, and total war was rampant. Skinhead is a title not for the weak. Skinhead might be the first time you hear a record that crumbles all your former saviors. Skinhead is that which pushes you into the beast you were always meant to become.

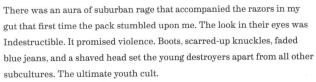

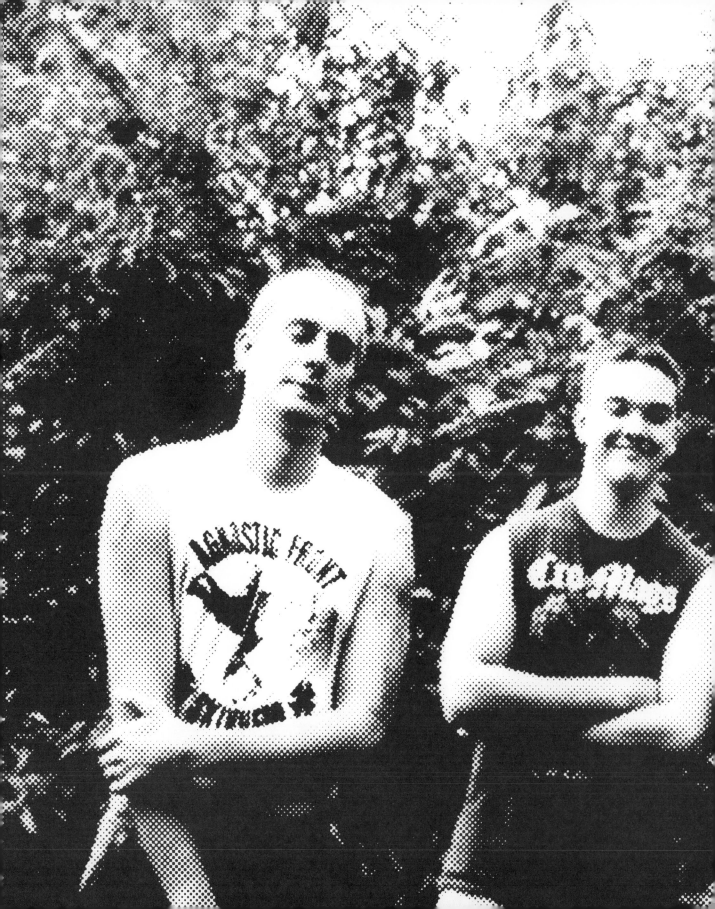

SOME GIRLS
WANDER
BY MISTAKE

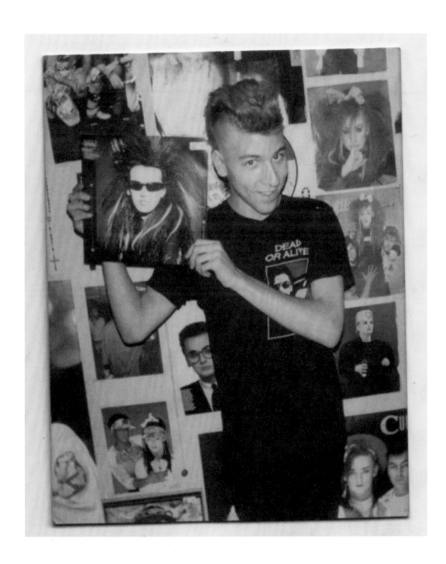

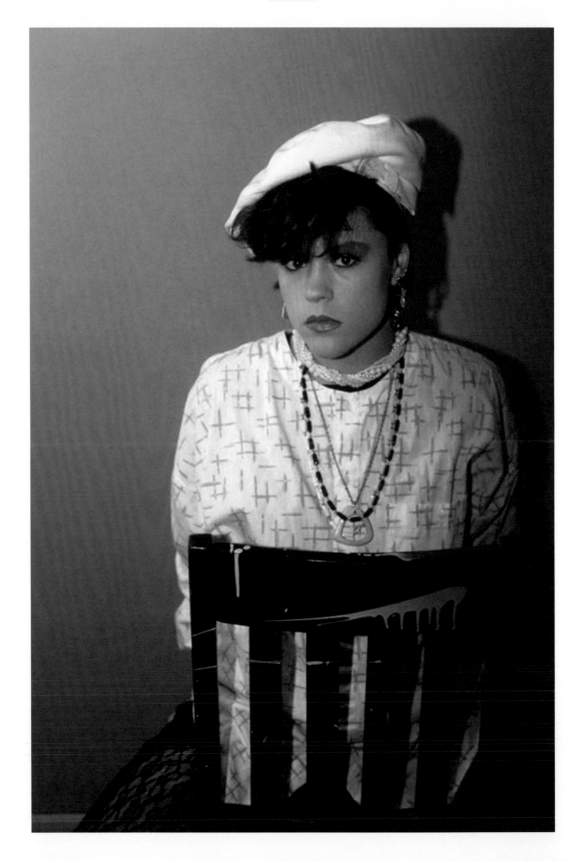

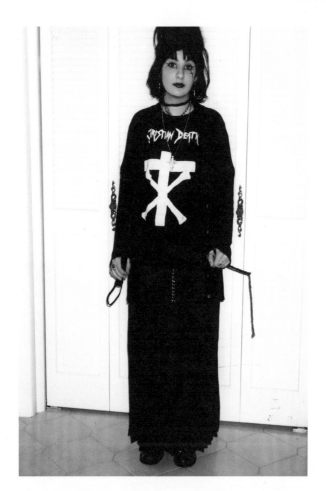

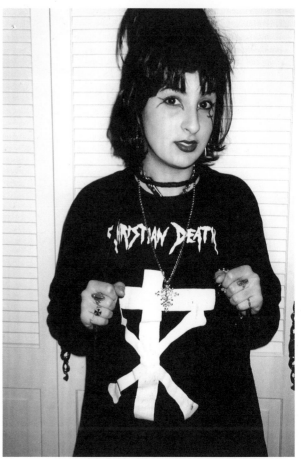

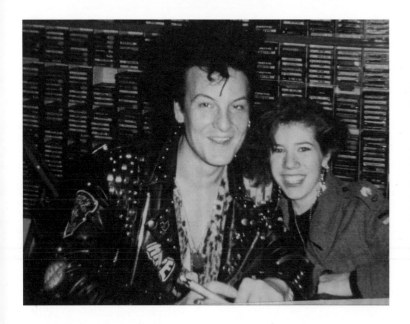

TO THE GIRL FROM GOTH NIGHT AT THE RAMADA INN

Max G. Morton

The first night I must have looked pretty cool with my hands covered in all that blood and gravel. The second night, I must have motored right past pretty cool straight up to stone fucking cool, covered in all the blood and gravel. There were looks. I saw. The third night was the charm. Hearing your unfortunate friend hiss as I walked by, "Weird, your boyfriend isn't covered in half the club's blood," told me nothing other than that you care. You should have seen your face when you finally made your move and I just got up and left. Snubbing, excrement, dirt, whatever it is, it always works. The thing was, I totally loved you. At that point, we had never really spoken, but I loved you nonetheless. We shared meaningful conversations when I was alone at night. Some nights we even shared a flat. I liked your look. Always have been big on other planetary gut feelings and *Valley Girl* endings.

That following morning you drove over an hour to my house just to tape a note to my window telling me that I was "it." How fucking romantic was that? It's the little things like that which kill relationships, because you can never do anything that spectacular again. Youth had no high notes, so naturally I took the bait to think it was something more than it really was. I lost mass notches on your corner pole when I placed that call to your work. You actually sold vacations and I was a customer in need of an escape. Were the roses too much? I had never done anything so cheap and textbook before.

You killed me for dreaming but ironically enough, you still ask about me. That bouquet reigns as your most beloved sniff of romance. If you could still consider the third night a charm, then the fourth night was a rusty nail. All that energy and barely even any tit. I bought you a Happy Meal, cigarettes, and nail polish. I put my hand on your leg in the car and felt death. Your frostiness only made me cling harder. I never left your side once that night. The kids wanted to fight and I walked away. There was a certain way the light caught your eye and, momentarily, I thought you deserved better. Regardless, you let me in your bed and gave me your back. I played with your hair and felt snakes. Chain smoking on the right side, leaning over you to ash while you huffed annoyance, I almost took up

talking to God. I never gave up with the touching and mental persuasion. Just before the sun made it official, you gave in. It was nothing like your cow girlfriends told you it was going to be like. No pulling, punching, kicking, or spitting. Just a couple of cupid-endorsed pushups. You even put it in for me because I was still shaking to the beat that you were something greater. Your last victim's boxers slightly pulled down and your shirt barely pulled up, junior high offered me more passion. Sad thing is you held me back that night like no other. The idea that became you was monstrous. Not even a kiss or grip of your hand back. Coffin case. I'd played dead in the morning too, so I knew. You showered with the door locked and the bed took on the shape of a noose. Sky high with the horrors, I picked up your ancient dialer phone and called for a marriage license but the line was busy. Your hair looked porno-hot wet. You drove me home in silence and I thought about kissing every rig that passed us. Granted, it was only a couple of heartfelt thrusts but there were pieces of me missing in you for years. The stench of your body hardens me to this day, as I replay the conversation that went down right as we passed a symbolic hanging piano on the freeway.

"Some advice. You will never have me again. Honestly don't ever call me, I won't pick up. Girls like guys who fuck and fight like animals, we don't actually want princes and if we already have one, well, we are cheating on him with the guy whose door I drove over an hour to tape a stupid note on. You at the club, stabbing a guy with a bottle over nothing, not you following me around looking all lost and weak. Girls don't want dinner and flowers, they want to be taken, even if they say they don't. I should be waiting by the phone wondering where you are, not the other way around. You killed this for me by showing you were human on the first date. Not what I was looking for."

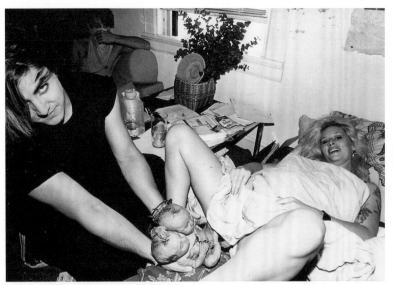

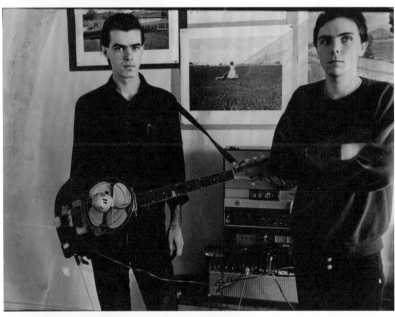

SUMMER TRENCHES

Max G. Morton

The name escapes me but the glow of the white and orange sign is still there, vividly. An all-night grocery store on the border of two towns, not the pretty side of either. There was this guy in a trench coat. In any weather, even the hottest, most humid Florida summer nights, he was sweating in his statement. Taking it, not just from the temperature but from the entire town too. A Throbbing Gristle badge adorned the right breast. Destroy All Monsters was written on the back in white paint. Over time, the jacket would collect more names, pins, and studs. The spike effect was all the more reflective in the summer sun as he gathered and pushed shopping carts around the parking lot. Always wearing sunglasses and headphones, he claimed he was a member of this art collective that held court in an abandoned haunted hotel, naturally entitled the Bat Cave.

He spoke to me over an amateurish cigarette once. "You going to see Alien Sex Fiend down in Ybor City?"

"Nah, I don't think so."

"You should."

"Uh, okay."

The fluorescent glow of that parking lot and the nuance of shadows detailing a forgotten breed visit me quite often. I will always wonder what would have happened if I would have listened to more "Ceremony" and less "Traitor" in my youth.

IVANGILE ROAD

Anthony Pappalardo

I hated the house at 38 Ivangile Road. The American flag guarding the doorbell, the shaky metal railing, the vinyl siding and obnoxious blue shutters, the patchy lawn and overgrown pine trees that pissed sap on my car's windshield, the pile of shoes on the doormat in the foyer, the graduation pictures in the upstairs living room, the neon Budweiser light bouncing off the fake wood-grain of the Zenith television that was too large to ever move, the tacky floral wallpaper covered in faint Ragu bloodstains in the kitchen, the skin-pink double sinks and sugary Plax mouthwash in the "kids" bathroom, the frilly car crash pile-up of pillows in the master bedroom, the trophies in the good son's room, the teddy bear guarding the teenage daughter's room, and the garage's scent of clipped grass, stale beer, and motor oil.

I hated the fucking house at 38 Ivangile Road because it's the same house where everything I've ever hated doing happened. It's the house you get to start a family in but your family is never comfortable in. It has three bedrooms and tight walls, ensuring that no one will get along. Dad will scotch himself to sleep, Mom will read Agatha Christie novels alone in the kitchen, boys will blow smoke rings out of their baseball glove-patterned curtains and girls will sip gin in the basement and talk about crushes. No one is happy at 38 Ivangile Road. No one is happy in Salem, New Hampshire. No one is happy under fluorescent lights standing on shag carpets with piss stains from the dog. The Red Sox never win a big game on that Zenith and Steven Tyler's screech chills every nerve in your body like an audio root canal when "Dream On" blasts from the tinny speakers in the family room. Seventy-five percent of the homes in suburbia are Ivangile Road.

During chemistry class we drew names out of a fishbowl. Whatever name you drew became your lab partner for the entire year. Kim Dawes drew my name and from that moment on I watched her curly head bounce back and forth as we fucked around with gases and flames. Being her lab partner landed me on the porch of a "real" home, unlike anything you'd see on Ivangile road.

Kim's lack of hair spray, IOU sweatshirt, cuffed white jeans, or Candies made her mildly interesting to me. Perhaps Kim wasn't as boring or tragic as the inhabitants of the houses that lined suburbia. She wasn't a new student at my high school, but I hadn't really noticed her until the first day of my senior year. Apparently, a few weeks spent in New York City over the summer visiting her older sister had transformed her look from Contempo Casuals to sort of alternative. I pressed the buzzer and was soon making small talk in Kim's living room before we worked on our chemistry homework.

"You go to a lot of concerts, huh?" she asked. "My brother took us to see Depeche Mode for my birthday. He's pretty cool. I bet you guys like all the same music!" she gleefully continued.

Kim Dawes' older brother was a sensitive jock named Wyatt. He loosely cuffed his jeans, played tennis and had a white woven rope bracelet clinging to his wrist the entire time I knew of his existence. There was a Greenpeace sticker on his red Volkswagen Fox, he wore Bass shoes that were untied, the tips of the laces meticulously knotted, keeping them snug on his sockless feet. His coral polo shirts had perfect collars, a hint of silver always showed on his brace-covered teeth and his curly hair was cropped short on the sides but long in the front. During the course of a sentence, he'd jerk his neck back no less than four times to keep a lock of hair from obscuring his vision. He had friends named Brent, Brett, and Bradley. They played doubles tennis on the clay court behind the Dawes home.

There was a one-lane bowling alley in their basement as well as a pool, hot tub, guesthouse, trampoline, projection-screen television in their theater room, and several sports cars in a garage separate from their home. I felt like I was in an episode of *Silver Spoons* and wondered if they had a car-shaped bed somewhere too. I had nothing in common with Wyatt, and I never wanted to talk to him about "concerts." I didn't really go to "concerts," I went to shows. Shows cost under ten dollars, they took place in small clubs, and you could run up on the stage, grab the mic, and shout your favorite line of the chorus before jumping off and smashing into other humans. Concert t-shirts cost you a minimum of 25 dollars, they had 500 colors on them, and listed every tour date on the back—including that special night where you overpaid to see your favorite band play tired radio

hits behind a barrier. I didn't really go to many concerts. The last one I saw was depressing. A bearded, bloated Ian Astbury Jim Morrisson-ed his way through "Fire Woman" before Metallica took the stage without Cliff Burton. The Cult butchered my favorite songs and Metallica were good but scripted. They scattered mid-song as the stage fake-collapsed before triumphantly returning for an encore. I left with a headache and a t-shirt with an iron cross on it that I didn't want anymore.

"Yeah, I go to a lot of shows," I responded politely. Kim was bubbly and proper. She always smiled and made conversation. You could tell her that you just finished a 5,000 piece puzzle of a grass field and she'd still muster up an enthusiastic response and maybe even tell you about a "cool puzzle" that she once put together at her family's summer home on Cape Cod.

Kim's large bobble head bounced around without a care, but she was not pompous; she was one of the few happy people I knew, and she lived to make other people feel happy too. I wasn't attracted to her round features or the way she over-pronounced the word "literally," but she was a genuine sweetheart. She would ask me a million questions: *What is your dad's name? What nationality are you? What is your favorite color? Do you listen to the alternative station WFNX or hard-rockin', blue-collar WBCN? Where do you want to go to college?* She constantly complimented my "funky" style and asked where I got every article of clothing on my body. If I wore a t-shirt she'd carefully survey every inch of it before asking who Mark Gonzales was or if Youth of Today was a band and if they sounded like the New Kids on the Block.

The questioning was tedious at times, but genuine. Her mother even went out of her way and drove to the closest health food store, which was 14 miles south of Salem, to buy veggie burgers and other snacks while we worked on our empirical chart project because Kim told her I didn't eat meat. Kim wanted to create a patchwork quilt representing the elements composing the chart, so I stuffed my face with organic pizza munchies and carob chips while she was Betsy Ross.

Unfortunately, answering all her questions—questions that no one else in the Granite State asked me—led to her knowing way too much about me. She never forgot anything. It wasn't small talk to her, she absorbed every detail. It wasn't threatening, but it led to a lot of explaining and blank stares. Each question led to five more. I would have rather done all the lab reports myself and gotten a C+, but that wasn't an option.

When Kim first drew my name in chemistry class and began pummeling me with questions, I was happy to answer. She was cute and didn't put hair spray in her hair because she "cared about the ozone." Initially, I enjoyed telling her about my world. This world was so much different than the world of basement keg parties and bonfires in the woods that most kids lived in, or so I thought. I didn't spend my weekends seeing how many jello shots I could consume or who I could beat in an arm wrestling match. I didn't mind spending a Friday night in a basement

with kids from school, but if I had the chance to leave Salem, I wouldn't hesitate.

Hardcore punk was a totally separate planet from Salem, New Hampshire. At that time, there were only two noteworthy punk acts that hailed from the entire state: The Queers and Mr. GG Allin. Neither of them crossed over into my universe. The Queers were a sappy, pop-punk band comprised of men who were a little too old to sing about teenage girls, and GG Allin's songs about underage women, drugs, racism, and other trashy topics didn't resonate with me. I wanted to live fast and live. I wanted to experience everything and remember it the next day in vivid detail. Sniffing glue and pissing on passed-out girls wasn't just completely fucking stupid to me, it wasn't that different than what any all-American burnout would do for fun.

I didn't want to live out some punk rock cliché; I wanted to do something new. In retrospect, the most shocking thing about GG Allin was that, at the core, he was just a typical asshole living in New Hampshire. Every subculture, trend, or thought I embraced as a teen was manifested in hardcore. It was a world of skaters, punkers, taggers, nerds, thugs, BMXers, metalheads, hippies, and even jocks. It was everything and nothing at once. Being at a show was like being inside of a comic book. The band members and guys hanging out each had a unique origin, like a superhero. Some came from broken homes, some squatted in abandoned apartment buildings in New York City's Lower East Side. Some had been to jail, taken lives, embraced religion, denounced religion, smoked pot on-stage, preached sober living and compassion for all living things—not just the ones that are cute. They passed out animal rights literature and Bhagavad Gitas because some life-changing event drew them to this self-governed world where every underdog, geek, idiot, maniac, and regular dude coexisted. When you paid six dollars to see five bands, you had a home for at least five hours. You had a place in which to feel comfortable, to meet new people, to just be. Men who had served time on Rikers Island and had arms covered in green-ink tattoos sternly shook your hand and thanked YOU for coming to their show. Yes, there was violence. Yes, it could be threatening. But it wasn't intimidating, it was inviting. The shock wasn't that you were stuck in a small room with potential murderers and lunatics, the electricity was from knowing that anything—good or bad—could happen at any second.

Everyone was a warrior because they all went back to their respective homes on their respective Ivangile Roads when those five hours expired. You were back to being a minority again. Being the only kid from your suburb who had a shaved head and knew who the Cro-Mags were might be nothing compared to illegally living in a condemned building in New York, but once you paid your admission, you felt like an equal.

My weekends might have consisted of going to three consecutive shows, watching skinheads fight, being chased by police for riding a skateboard on public property, spray painting something, eating a free

meal at a Hare Krishna temple, scouring thrift stores in a new town, or just savoring a bottomless cup of coffee at a Denny's with friends, talking about how great the show was. But every Monday morning, I was just another raised hand in homeroom. Sometimes I'd sit there staring at the backwards white baseball cap sitting in front of me with the word "Cocks" embroidered on it. The hat rested on a guy who just scored the winning touchdown or fucked the hottest cheerleader, but I had just seen my favorite band from a state I'd never been to, bought their new 7" single, and made small talk with the guitarist who had remembered the letter I wrote the band and gave me a pile of free stickers. Each show made me feel like my world was expanding and every homeroom shrunk it back down to size.

The more I talked to Kim, the more I realized that my world was anything but normal. This was magnified on a spring day in 1991.

There's a communal joy that sweeps New England toward the end of March, when the last snowbank has melted and everyone realizes that it's smooth sailing again until November—save for some bug bites and unbearably humid days. Kim and I had spent several classes igniting elements under a protective hood and now had to produce a final lab report that would become 25 percent of our grade that quarter. Before meeting her at Dawes Manor to watch her write our report, I stopped by the photo kiosk that protruded from the Kmart parking lot. The photo lab was barely seven feet tall and four feet wide. Young men worked in these drop-off centers, collecting film from patrons and writing up receipts before handing the undeveloped moments off to an unmarked truck which would return double prints in matte or gloss to the kiosk a week later.

I picked up a roll of black-and-white film taken with my point-and-shoot camera which I would later publish in an awful fanzine that I authored. The roll contained 36 exposures from the various hardcore shows I had attended over the preceding weeks. After paying the ponytailed man in the booth eight dollars, I drove off to Kim's house without even looking at the results. Little things like tardiness would set Kim off. I quickly decided that if I sped, I could be at her house only a few minutes late and avoid any tears of frustration. I'd go through the photos later.

My Ford Escort coasted into her driveway slightly late but not enough to be reprimanded. As usual, Kim's white picket smile greeted me at the door. Quickly, a Crystal Pepsi was placed in my left hand and I was lead to Kim's room where we'd work on our latest lab report while questions were asked and Bono crooned. I tossed my blue, three-ringed binder on the floor and it opened up and spread out on impact. The front pouch bulged with an envelope containing the prints I had just picked up from the photo kiosk.

"Pictures, pictures! What do you have, Anthony?" Kim exclaimed in a singsongy voice.

I quickly responded, "Yeah, it's just a roll of film I took at a

few shows," I replied.

Unfortunately, my colorful retellings of hardcore shows over the past months had piqued Kim's interest. She wanted to see if I had any pictures of Roger Miret, Ray Cappo, Harley Flanagan, or the other folk heroes that I often talked about. When she asked what "concert" I went to, it wasn't enough to simply name off some bands that she had never heard of. Details were required: where the band was from, what they sounded like, what they looked like. And then of course, more questions were to be answered: *Were they good? Did you talk to them? Are you friends with them? Will they ever play in Salem?* And, of course, the dreaded *Could you make me a tape of these bands?*

My honesty and tolerance for Kim had created this situation. I was sitting with my legs folded on the rug in front of her puffy, stuffed animal-guarded king bed while she lay there on her stomach grinning, her giant head propped up by her hands. "Let's see, let's see!" she giggled.

As I opened the sleeve containing the photographs held shut with sticky resealable glue, I realized how many questions 36 photographs would lead to. The reality hit me that I'd be spending the next two hours talking about these photographs, only to have Kim pen the entire report. We'd ultimately get at least an A-, but I would have to explain every inch of every picture. I flipped open the sleeve that housed the photos and began. The upper half of Vinny Stigma's body was poking out and an

avalanche of questions loomed.

Kim immediately gripped the entire stack of photographs and was remarkably quiet. For a moment I thought it would just be enough for her to simply flip through and exclaim a bubbly and extended "Cooooooooool!" This response usually meant she had nothing to say but wanted you to know that she was impressed: the more "O"s present, the more impressed she was. She was so excited that she had to shuffle through the images a few times before beginning her line of questioning.

"These boys really are Hare Krishnas!" she shrieked in a frequency that ensured that my ears wouldn't be able to detect high pitches ever again. "They...they even have those little ponytails on the backs of their heads like the guys at the airport selling flowers...and they have a band...wow...wow...this is CRAZY!"

She thought that Agnostic Front looked like a mix of bikers and construction workers. She laughed when I told her that two of the guys in Killing Time, formerly Raw Deal, were named Anthony. Burn's frontman Chaka Malik's fade with random side dreadlocks shooting out was the "funkiest" haircut she had ever seen and she couldn't believe how many kids were on the stage and questioned if it was even legal. "You took these recently right, like this winter?" she asked. "Yeah, and most of them are from the Channel or Manray with the exception of the last ten, those were taken in a VFW hall in Holliston," I replied.

"That's soooooo weird, everyone is sweating and so many boys have their shirts off," she answered, snickering as she finished her thought. "Are there any girls around? Is that a girl on the stage with a camera?" She asked pointing to a photograph of long-hair-era 7 Seconds.

"Yeah, there are girls, they just aren't all crammed up front getting dived on, moshing all the time. And it gets really hot in those clubs so...I mean...I guess that's why dudes take their shirts off...I don't know, I don't take my shirt off, if you're that hot, not wearing a shirt isn't going to help...maybe they're showing off their tattoos or something," I said.

"These are so cooooooooooool! You're a good photographer! You got a picture of this guy right as he's jumping in the air with his guitar. You should try to sell that to a magazine!" Kim answered with her trademark earnest enthusiasm. "I wanna show these to Wyatt. I think he's home!"

Before I could say no or snatch the photos, Kim had already sprung from her bed and was bolting down the hall to Wyatt's room. The last thing on earth I wanted to do was watch Wyatt flick his hair back as he feigned interest in my photographs and yawned out some snarky response.

My game-time decision was to just stay put. Kim might scream down the hall asking me to join her but I wasn't going to skip down after her like some fucking Disney movie to have some prick named Wyatt mock my entire life. I sat in the middle of the floor and sketched in my notebook. My pen sunk deeply into the pages and formed the words "KILL

ME" in happy bubble letters.

Kim stumbled back into the room awkwardly. Her normally piercing ice-blue eyes were covered in an inch of thick watery glaze. She climbed onto her bed, clutched her pillow and stared off in silence.

"He can be... a real fucking dick when he wants to!" Kim shouted loud enough for Wyatt to hear. I realized this was the first time I had heard Kim curse.

Her fingers were clutching a baby blue pillow and I noticed for the first time that she wore an awful ring that was crafted in the shape of a crude gecko on her left hand index finger. I was about to ask her what happened when she spoke to the thought bubble above my head.

"All I said was that you had some cool pictures from Manray and that you guys went to the same club and he told me to get the fuck out of his room. Just like that, get the FUCK out of his room. What's his fucking problem? I didn't do anything wrong," she said, now staring down at her mattress.

Her house was beginning to feel a lot like 38 Ivangile Road. I tried to smooth things over and stunt the tears that I could see welling up in the large corners of her pool-ball shaped eyes by saying that she might have caught him at a bad time and that seniors feel "a lot of stress because they are waiting to be accepted into college and are at a turning point in their lives," but it wasn't helping. I suddenly found a curly weeping teenage track and field star drenching my left shoulder.

As I touched the back of her head, I instantly noticed that Kim's plight to save the ozone layer was a load of shit. Her hair felt crunchy despite looking free and easy. It appeared that she used some non-CFC mousse that caused her hair to feel like candy ribbon. I made a note to be cautious as I didn't want to make things worse by snapping off a lock.

A few minutes later, she reared back and I noticed that her large head was bright pink. Her nostrils were flared and swollen; it almost looked like she was having an allergic reaction to nuts or strawberries. I was doing a shitty job making her feel better, but I was so surprised and inexperienced at comforting anyone that I was just paralyzed.

"Thanks Anthony," she sniffed before pecking me on the cheek with her salty lips. "I'm sorry I got so upset. Maybe we should call it a night. I'll give you a copy of the report tomorrow and you can spell-check it, OK?"

I nodded in agreement and rose to my feet, slightly stumbling because my right leg had fallen asleep. "I'll let myself out, tell your mom thanks for the snacks. They were awesome," I said calmly before leaving Kim's room.

Upon reaching the circular driveway, I realized that my maroon car was semi-boxed in by a VW Fox and some form of BMW. I debated going back inside for a moment and asking Kim to get one of the cars moved, but realized that it would be better to leave a tire track on the

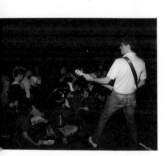

lawn and possibly bump fenders on the way out than to cause more tears.

After the loud click of the key engaging the ignition and the cacophonous buzz of unoiled gears engaging, I heard the voice of a DJ on WFNX announcing the club listings for that Thursday night. As I carefully navigated around the Fox, I heard the disc jockey mention that Manray was the home of the only latex fetish night in the Boston area, and that there was no cover charge. You could hear the best industrial and goth hits while dancing in the "cage," and that you should dress in your naughty best. The only times I had been to Manray were for hardcore shows that ended before 8 p.m. The all-ages crowd would be pushed out the door while the party crowd queued up outside. I knew Wyatt didn't go to shows, but I was wrong about us having nothing in common. We were both escaping the tight lines that made up Ivangile Road.

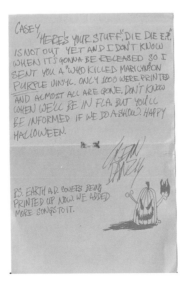

CASEY,
"HERE'S YOUR STUFF, "DIE DIE E.P."
IS NOT OUT YET AND I DON'T KNOW
WHEN IT'S GONNA BE RELEASED. SO I
SENT YOU A "WHO KILLED MARILYN" ON
PURPLE VINYL. ONLY 1000 WERE PRINTED
AND ALMOST ALL ARE GONE. DON'T KNOW
WHEN WE'LL BE IN FLA. BUT YOU'LL
BE INFORMED IF WE DO A SHOW. HAPPY
HALLOWEEN.

GLENN DANZIG

P.S. EARTH A.D. COVERS BEING
PRINTED UP NOW. WE ADDED
MORE SONGS TO IT.

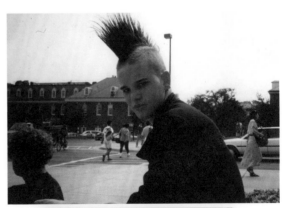

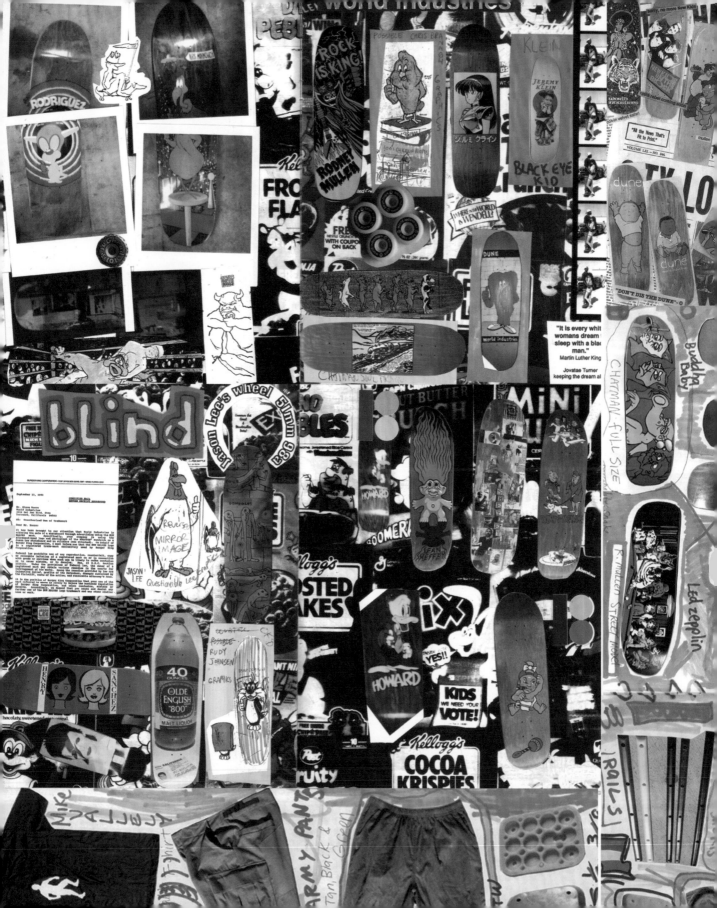

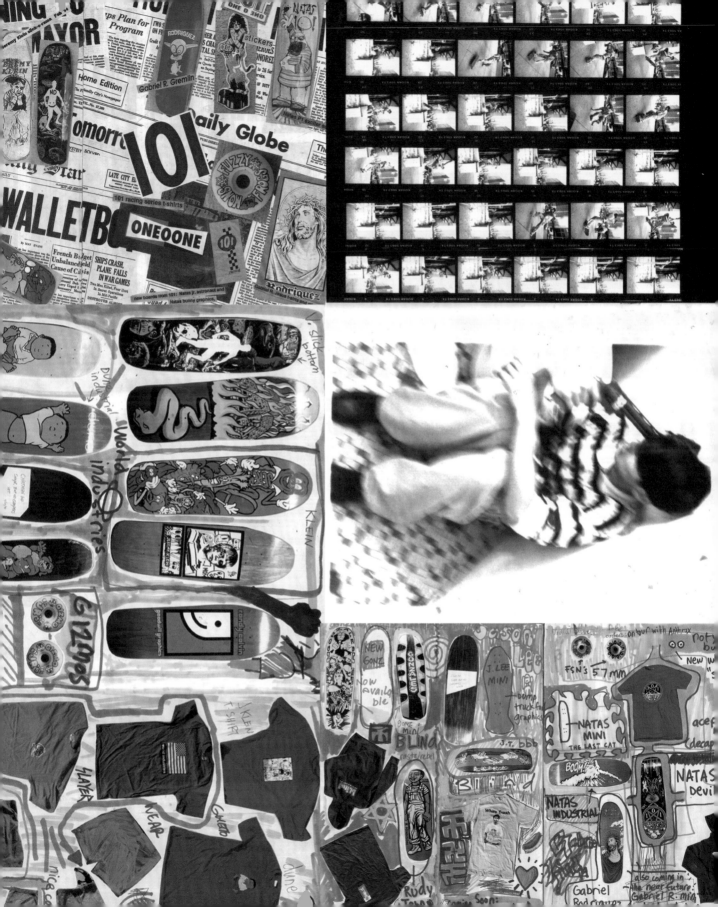

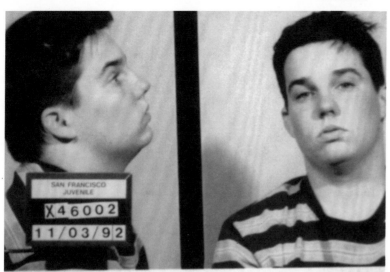

To get list:

leather pants

t-shirts

~~Misfits Album~~

~~earring~~

Hole poster

~~pen~~

Magazine

spiral notebook

Pants
a grip on reality

202

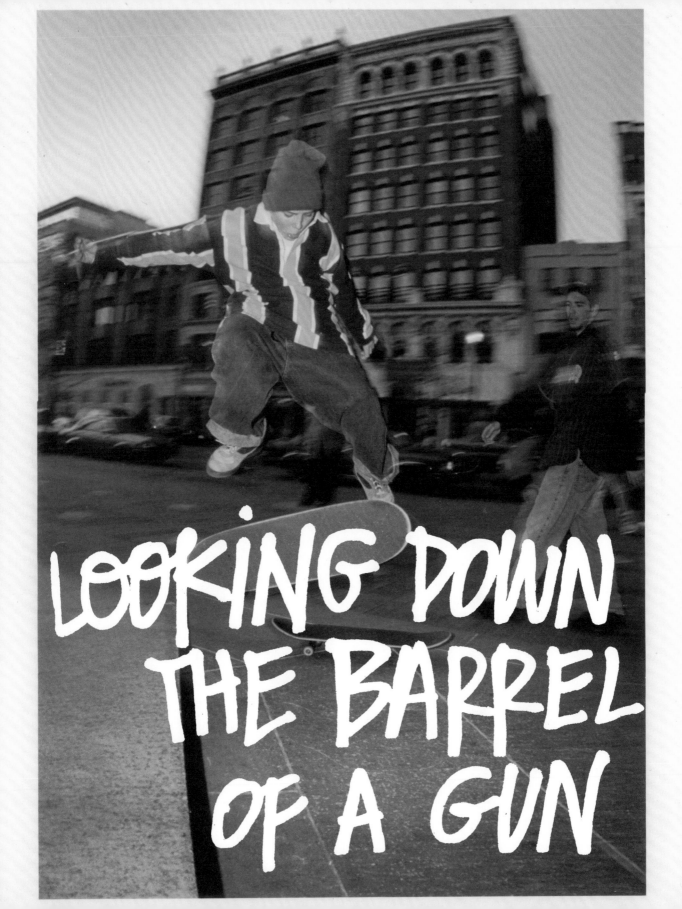

LOOKING DOWN THE BARREL OF A GUN

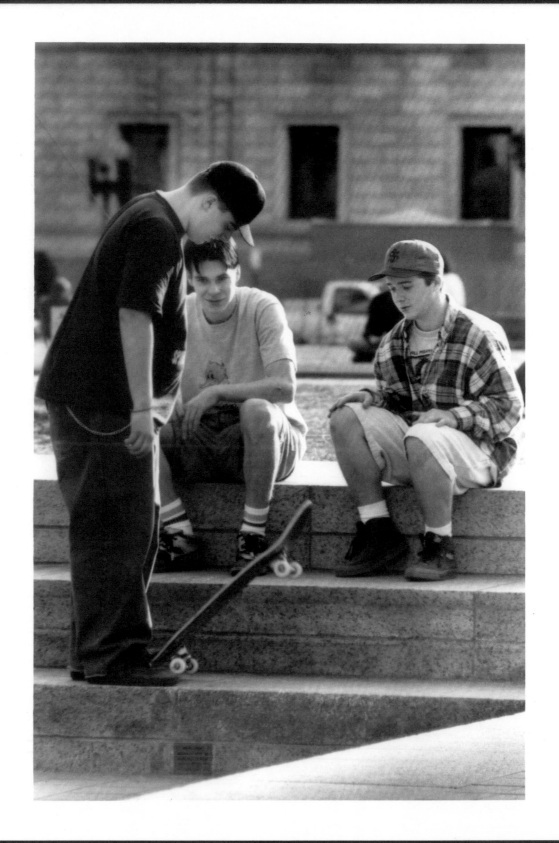

I DON'T WANT
YOUR SKULLS

Anthony Pappalardo

By 1990, I was officially tired of skulls. This included drawing them and seeing them used for band logos and on the bottoms of skateboards. I took a seam-ripper to my Stussy hat and freed it of the tribal skull that was laughing at me for ever thinking he was scary. The sight of a skull conjured up muscle cars reeking of dirt weed, cliché punk bands, and aging pro skateboarders rolling back and forth in a bowl I'd never skate. Skulls had the same shock value as the flexing Bad Boy Club dude or a peace sign. I just didn't give a shit or relate anymore.

Symbols have always been the markings of the suburban warrior. Inverted crosses, anarchy, swastikas, and the classic skull and crossbones were badges worn to show what you were affiliated with or sometimes just to piss off the regulars. Blood and gore were quickly becoming less cool as my teen years passed. The music I liked didn't have anything to do with skulls; members of hardcore bands just looked like normal guys. The lack of vert-ramps in my town or almost anywhere in the Northeast made me a street skater by default. Natas, the Gonz, Matt Hensley, and other pioneers of street skating weren't cut from the old vert-pro mold and they didn't adorn their boards with skulls and dragons. H-Street, the entire World Industries family tree, and New Deal were new companies making graphics that were simple, bold, and sometimes offensive, but without the same visuals every company had beaten to death. Suddenly, my old Metallica shirt paired up with a pair of baggy jeans and yellow rubber Airwalk sneakers was ironic, not pathetic. I don't even know where this sense of irony came from, but I woke up one day and thrift store shirts with iron-on transfers that said "#1 Dad" were what I wanted to show the world—not a curse word, blood splattered femur bone, or band logo. My wrists had once bordered on arthritic from trying to recreate the intense stippling of Pushead's trademark illustrations. Now, my notebooks had simple recreations of Disney and Warner Brothers cartoon characters holding guns and smoking weed.

Skateboarding magazines were our only windows into the lifestyle of pro skaters and other kids around the world. Most importantly, magazines were our only glimpse into the mythical world of California,

where people got paid to ride skateboards. After a week of study hall and detention, I could tell you how each pro laced his sneakers and what was written on their grip tape. *Thrasher* showed me what to listen to, how to dress, and even what to eat and drink. Ultimately, the choice was yours, but it was nice to have a road map. For instance, World Industries was the first skateboard company to play the race card by making boards and t-shirts with graphics called the "napping negro" or simply showing white eyes and teeth on the bottom of a black board. World Industries and its sister companies had the most racially diverse roster of skateboarders and also the youngest. They were their own demographic; their ads were subversive, funny, and deceptively simple. You could get the joke or just laugh at how over the top they were. Either way, you reacted.

When I first got into skateboarding, Powell Peralta's Bones Brigade were its clean-cut stars. Every kid knew who Tony Hawk was before they stepped on a skateboard, but as street skating became more popular, the younger stars broke away and joined younger companies or started their own. None of these companies used the skull-heavy imagery synonymous with Powell Peralta, and we all ate it up. To me, a Wade Speyer board with a knock-off Slayer graphic was more Slaytanic than the band itself. No one wanted to come home from the skate shop with some realistic graphic of a lion or some fucking flames anymore. The phone would ring and I'd answer to a snickering voice of a friend telling me about the graphic on his new board: sometimes it would be an anatomically incorrect naked girl drawn by a boy who had never actually seen a real naked girl, and other times it would be a special reworking of a corporate logo. There was even a Natas graphic depicting the Challenger explosion in a pop-art style that resonated with every kid who watched the shuttle failure live in school. It hit home even more in the Granite State in which I lived.

When one of the most iconic skateboarders of the 1980s, Mark Gonzales, broke away from the neon world of Vision to form Blind skateboards under the World Industries blanket, it was apparent that something new was happening. The name was a stab at his former employer and the

graphics and ads were loose, fun, and satirical. Some of Powell Peralta's
finest riders had defected to various World Industries companies and
when a Blind ad making fun of Powell's graphics was released in 1990,
skateboarding changed forever, or at least in my head. How the fuck could
you not want to wear a t-shirt of a skull holding a banana instead of a
sword?

 With that, our Rat Bones sweatpants collected mold at the bot-
tom of our hampers as we searched every surplus store for ever-popular
army fatigues. Shirts with giant skulls, serpents, and daggers screened
in 10,000 colors rotted on the racks of the skate shops, while t-shirts
with tiny graphics or even just words typed out in Helvetica were sold
out before they even reached the shop. The balance had shifted and kids
responded. The boys sick of skulls were slowly becoming men and looking
for something new. The arrogance of youth is cruel, but telling. Noth-
ing felt better than showing up to a parking lot and seeing some kid who
was weeks away from giving up skateboarding for a hacky sack, riding a
waterlogged Sims deck in short shorts as he tried to one-up you with dated
tricks seen on *Skate TV*. We were total pricks, but who the fuck isn't at
16? Having a driver's license and a little cash from an awful job gave me
enough confidence to at least contemplate being a dick rather than taking
a backseat.

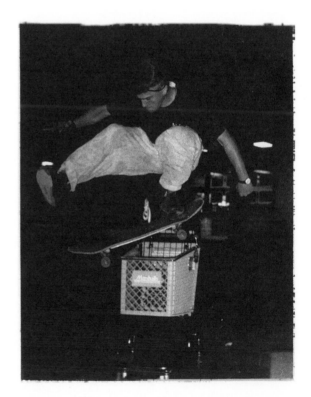

 At the time, there weren't actual clothing brands for losers
who rode skateboards, listened to loud music, or spray-painted words that
you couldn't read on walls. This meant you'd have to potluck your outfits
together if you even gave a shit. Vision Street Wear was one of the only
brands marketed directly to skateboarders, but it was also sold in bike
shops, malls, and, later, closeout stores. Tacky ads showing girls you could
never fuck in checkered berets instantly made them lame. And what
the fuck was with everyone wearing sunglasses and shorts in the 1980s?
We'd suffer humid summers in jeans to protect our shins and look human
rather than project the douchey vibe of some washed-up bro. When World
Industries began selling soft cotton copies of army pants under the moni-
ker Ghetto Wear, it was a masterstroke. None of us lived in real

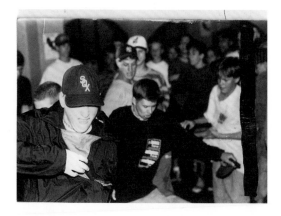

ghettos, but the faux-tagger logo and actual look of the pants clicked. No one in real ghettos was wearing army pants either, I'm sure. It was a slow crawl, but actual clothing brands for skaters were emerging. It was no longer just t-shirts bearing company logos. You could now allocate your Doc Marten money to whole outfits that screamed *America!* much more than British shoes.

Skateboards were getting lighter and narrower, and World Industries detractors thought it was a conspiracy to make boards break easier and send you to the shop more frequently—a theory that gained steam when wheels suddenly shrunk to half their normal size for the same price. The reality was that no one was riding off launch ramps or worried about their board breaking anymore. These new boards were designed for the type of skateboarding that was happening on the pavement everywhere around the globe. Things were progressing so rapidly that it felt like board shapes, clothing and tricks were changing faster than could even be documented.

One by one, my friends and I ditched the tight-cuffed jeans and thin cargo pants and started showing up to skate spots wearing orange, brown, seafoam green, and red pants that were cut off at the bottom to obscure our shoes. T-shirts were double—or triple—extra large and draped on our bodies like hospital scrubs. We didn't bend the brims of our hats because it was funny and that was what athletes who wore Big Johnson shirts did. Our shoes were cut down, modified, colored, and duct-taped. We weren't ravers; none of us had ever been to a rave. We weren't taggers either; our graffiti careers were limited to bridges and the back of the grocery store. We were street skaters: a new breed of human who was simultaneously urban and suburban.

Suddenly, the average skateboarder wasn't some kid who grew up on punk rock and metal and had given up expensive sports like BMX and snowboarding. Toyotas began to approach ledges and ditches blasting rap music that rattled trunks, and boys with gelled hair and braided belts would emerge. Anytown, New England didn't have ramps, natural transitions, or even companies that would give you free skateboards, but

it had restless kids who didn't give a shit about keg parties and the WWF. These new kids thought skulls were some "kill your parents devil shit" and dressed in Cross Colours and Starter jackets. They smoked real weed and didn't like music with guitars. With every push, grind, and drag, Jason Jessee, Tex Gibson, and Kevin Harris seemed less cool.

Kids wanted bigger clothes, and it made sense to wear loose clothing when you were jumping around on a skateboard. This was the new way to stand out. It was easy to go to a big-and-tall store and get oversized t-shirts, but finding pants that were big and didn't taper was next to impossible. You could get pants that had a large waist size but you'd end up with this giant bunch of denim in front of your crotch that bulged out. One day, pants sized to fit skinny teenage boys with billowy stove-piped legs finally appeared on the racks at skate shops with shocking price tags. I had never even thought to buy jeans other than Levis at that point, but now there were these jeans made to offend for 50 dollars—which was outrageous in 1992. The choice was simple: you bought a pair of Blind

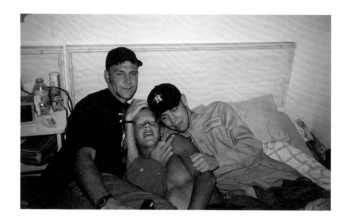

jeans or Big Deals and you wore them 'til they walked away on their own. Sometimes you could save a few bucks by ordering from a catalog or ad in the back of a skate mag. The trade-off was that you had no idea what would appear. It wasn't easy to step out of a beat-up Buick wearing mint green pants, but that's what arrived and they still looked better than some Bugle Boys. Some kids resisted this new trend and like bitchy old men, they'd bash us for being brainwashed and looking like clowns. We did look fucking stupid, but they looked equally stupid in their tight, stained undershirts and old-school Vans high-tops that looked as long as canoes and hurt their feet. We didn't care that they looked like Tom Knox in some Santa Cruz video that you never watched, so why should they care that we looked like a pack of crayons rolling around on popsicle sticks?

Before streetwear was a term and commodity, and back when men's fashion magazines were just places to advertise suits and watches, no one on the newsstand looked like your friends unless Sassy needed some edgy guy to pose with a Punky Brewster-looking girl. Skateboard mags and videos subconsciously served as our lookbooks, and because this wasn't a clever planned-out industry, it meant that we were probably three months behind the times. I remember my friend returning from a trip to San Francisco when we thought we were up on every skate trend, only to be told that no one even wore baggy clothing on the left coast.

It wasn't until an innocent MTV *House of Style* segment featuring the Beastie Boys aired that things became "branded" as the post–2K world would say. Despite what your favorite music critic and rap blogger would tell you, no one gave a shit about the sample-heavy *Paul's Boutique* when it was released. The disco-heavy "Shake Your Rump" seemed to be the nail in the Beastie Boys' coffin. It was too ironic, too kitschy, and too close to the 1970s to resonate. The album came and went and the Beastie Boys were a footnote until *Check Your Head* was released in the spring of 1992. Kids didn't respond to the actual music as much as they did to the impact it had. With its blend of punk, funk, rock, and rap, *Check Your Head* sounded like a mix tape more than a new Beastie Boys album. It made everyone stop wondering if MCA and Booger from Revenge of the Nerds

Hey. I snuck out last night w/ Alfredo and David. Didn't get back until 4 AM. Fucked me up in school today. Oh well. I hate SMMS. I don't hate school, not at all, just THAT school...

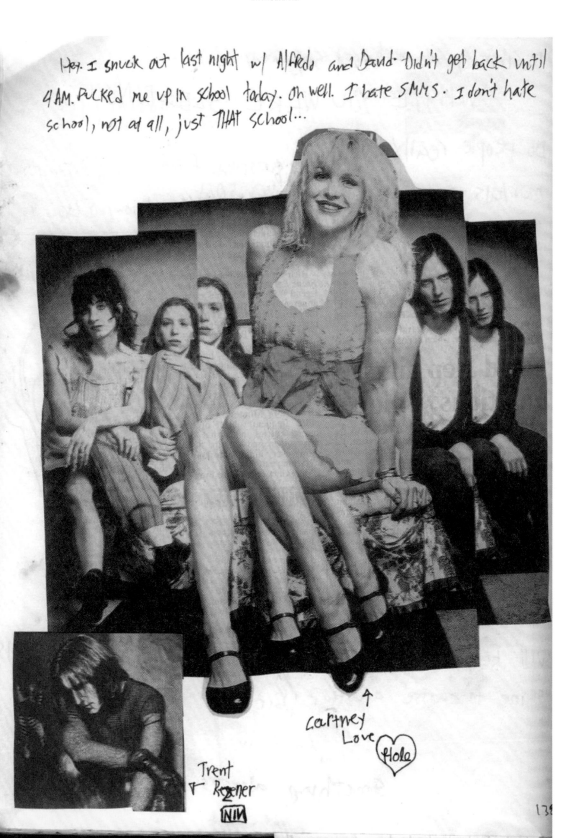

Trent
↑ Reznor
NIN

↑
Cartney
Love ♡Hole

were the same person. Most hardcore punk bands didn't have a chance in hell of going platinum, but quickly, every frat boy whose first album was *Licensed to Ill* would be funneling to "So What Cha Want." It was instant nostalgia and instant suburbia. They rapped wearing old ringer t-shirts, parkas, snowboarding boots, and vintage Adidas sneakers which would later be sold at the X-Large store. Everything was a slight nod to some subculture trivia down to the Bad Brains sample in "Pass the Mic." They even covered one of the only Minor Threat songs with a mosh part for maximum confusion.

Everyone cringed as the squatting valley girl posed on a mini-ramp in the "Freefallin'" video, but when the Beastie Boys and Sonic Youth cut to clips of recognizable, respected skaters, it shared the same weight as Suicidal's "Possessed To Skate." The difference was that you didn't need to stay up 'til the end of *Headbangers Ball* to see these videos, because they were in regular rotation on MTV. Heavy metal and hard rock were becoming clichés, and once the package tour Lollapalooza launched in 1991, boasting a mixed bill of alternative and rap bands, the deal was sealed. Rap and alternative music were rising and metal was sinking. The Beastie Boys benefited from sounding like virtually every band on the tour. While Nirvana garnered attention for "killing hair metal," their music ultimately only inspired other bands. The Beastie Boys inspired entire genres by making hip hop white enough for suburbia yet having enough cred not to look like they were "acting like life is a big commercial."

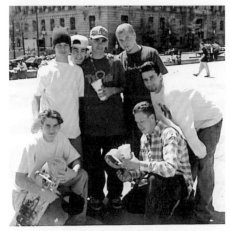

Instead of feeling pissed off that Jason Lee was 360 kickflipping on my television to Thurston Moore's pseudo-rap cadence via Iggy Pop, I just thought there was a better chance for me to get laid. I was still public enemy number one in malls and parking lots, but now, in dorm rooms and college campuses, I was "cool," or at least fuckable.

Up until the early 1990s, all you wanted was the most faded denim possible, but I was now getting the crispest bluest jeans possible from stores that sold Carhartt clothing for the proletariat, and scouring Salvation Army stores around the tristate area for Puma Clydes and old Air Jordan t-shirts. Like popular culture around me, I was intentionally all mixed up and it was OK. My t-shirt had a circle on it that looked like a target with the word FUCT in the middle, but it didn't really matter. Soon enough I'd be in college, modestly mentioning that I saw Green Day in a small club before they made it big, just so I could touch a girl in Mary Janes and striped tights who really just had a crush on Trent Reznor anyway.

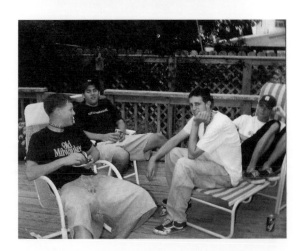

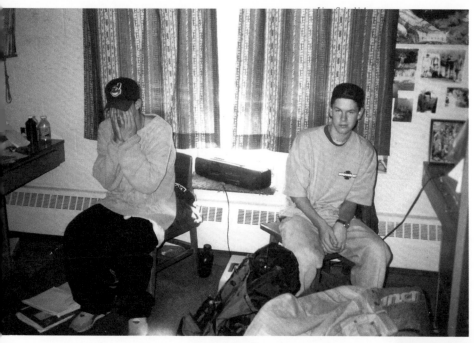

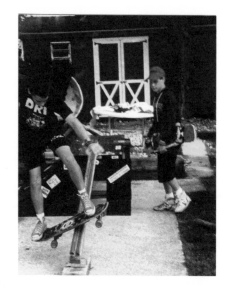

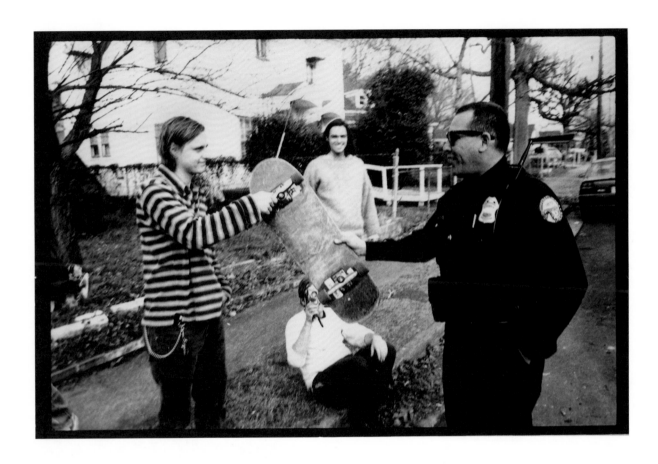

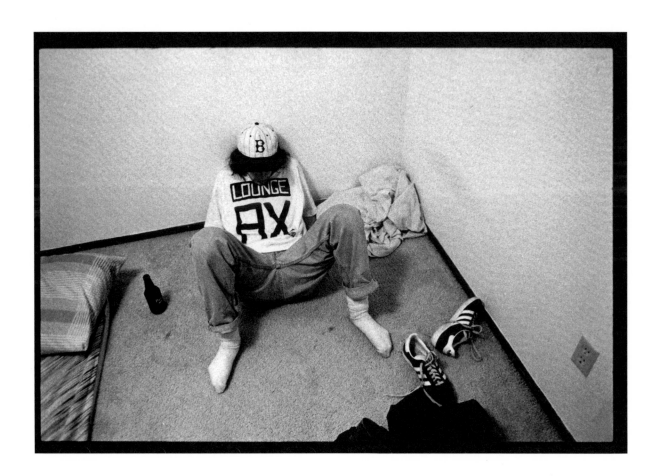

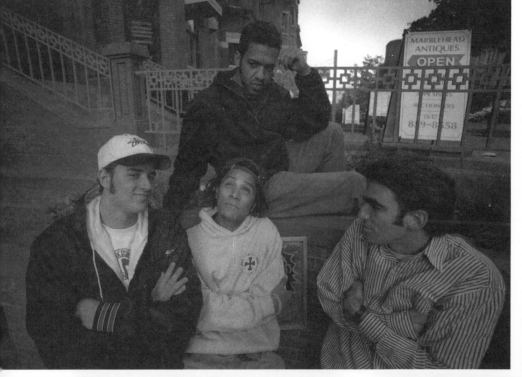

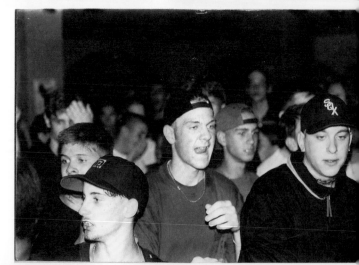

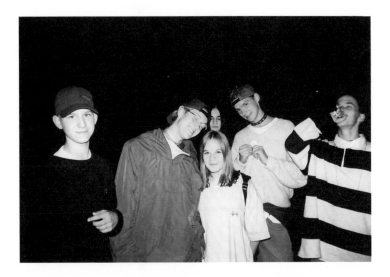

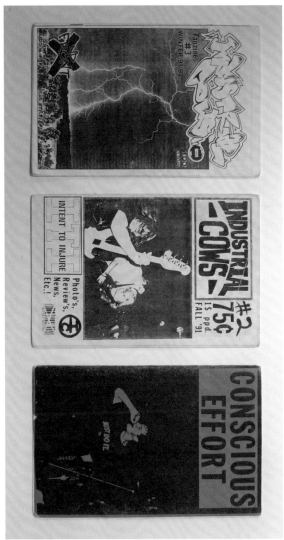

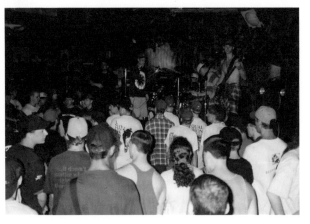

ACADEMY FIGHT SONG

Anthony Pappalardo

In college, my quest for finding records overshadowed my studies. Massachusetts College of Art has a policy, like most schools, that freshmen must live on campus, so in the fall of 1993, I found myself sharing an oddly shaped dorm room with a 25-year-old former-member of the U.S. Army from Maine. It would make perfect sense for an art college to have a triumph of modern architecture to house and inspire the students, but unfortunately MassArt opted for a building with tight triangular rooms and pastel yellow walls. The front of the dorm faced the campus and my corner overlooked some projects in the then-undesirable neighborhood of Roxbury. The combination of occasional gunshots and close proximity to the projects gave boring white people plenty of cringe-worthy stories to swap about the "ghetto," ad nauseum.

The morning of my first full day as a college student was spent mapping out my record-shopping route, which would begin in Harvard Square and migrate back over the river to Kenmore Square and then to the Newbury Street area. The itinerary consisted of about ten stores, but expanded to over 20 as I found new places with every trip. Boston is known for confusing one-way streets that complicate the simplest journey, but these twisting paths lead me to dusty record bins packed with promise. Anyone who has stepped into a used record store knows that you're never going to hear anything resembling pop music being played, and that the job of the clerk is to be a pretentious asshole and to eat really pungent takeout food. Boston has always been synonymous with Aerosmith, the J. Geils Band, the Cars and, of course, its namesake prodigal sons Boston —but there was this rich history hiding in the shelves of these stores that was far more interesting than skinny ties and bar rock. There's nothing exciting about seeing a copy of *Don't Look Back* in a used bin because there are ten billion copies of that record and you already know every tired note. Finding a La Peste single for a dollar or some other needle in a haystack was special and more important than air. There were gems hidden everywhere that most flipped past and ignored.

Frequent record store trips in high school resulted in a lot of success in the local bin, and nothing was more rewarding and exciting

than finding out about the bands that shaped Boston hardcore. The names were powerful acronyms like SSD and DYS. There was an instant connection to the look and the sound, and it was a direct link to the past, just 20 minutes south of where I grew up. The next revelation was learning that the influence of these Boston bands wasn't just isolated to Massachusetts, and that they were storied bands who influenced several waves of hardcore, up to the current bands that were playing T.T.'s, Bunratty's, and the Channel. Finding this link in the late 1980s was an epiphany but also bittersweet, since most of these bands had broken up or staggered on in forms barely resembling their former selves. The new crop was exciting, but what was it like to hear the first new notes of "Glue" ring out in a VFW hall, knowing that in five seconds the place would erupt? It was nice to know that there was more to Boston's musical history than Evan Dando's dreamy looks and Aerosmith's bloated classic rock.

Since the Boston area is home to the most colleges in the United States, plenty of noteworthy bands formed there. Dorm friendships and classified ads created The Pixies, Galaxy 500, and the Lemonheads. College rock bands weren't comprised of burly, menacing men who looked like they worked construction jobs and hated the Yankees, they were academic kids writing pop songs—very important and well-crafted pop songs that contrasted the hard rock, power pop, and hardcore punk that came before college rock.

I became obsessed with the local bin because there was an off chance that one of the out-of-print classics would end up in there for a few dollars, instead of on the wall for a then-astronomical amount of money. In the early 1990s, a copy of SS Decontrol's album *The Kids Will Have Their Say* would be priced around 50 dollars, which seemed ridiculously high considering the majority of the pressing probably lived somewhere in Boston and its 'burbs. Currently, the same record fetches upwards of 300 dollars on eBay. A semi-punk looking record from 1984 could be trash or treasure, but you could minimize your risk if you looked at two key elements of the sleeve :

1. What t-shirts are the band members wearing and what stickers do they have on their equipment? If they liked bands you liked, there was a good chance they were influenced by or emulated them.

2. Who was on their thanks list? Maybe they thank some great band they toured with or just have a list of bands you like and recognize. Shitty local bands thank a lot of family members, bars, girlfriends, guitar shops and other shitty bands.

Like the flute in Zelda, occasionally the purchase of a record would open up a new door. The menacing clerk would ask if you liked the record you were about to buy—which still seems like the most asinine question ever—and in some lucky situations, might lead you to the un-priced records lying behind the counter to emerge. Sometimes you were allowed to buy them, other times, you were just allowed to hear them. These records were the Pop Group, the Nils, the Saints, Die Kreuzen, Can and unfortunately, Captain Beefheart. One clerk who was unpredictable but surprisingly helpful at times was Peter Prescott. He was a stalwart behind the counter at Mystery Train Records on Newbury Street. I always felt the most pressure in this store: the ceiling was low, it was dimly lit, it always seemed to rain when I went there, and most importantly, Peter was the drummer of Mission of Burma: the nail that stuck up in Boston music. They prematurely broke up in 1993, but their classic track "That's When I Reach For My Revolver" (which would later be desecrated by Moby in 1996) was a staple on Boston's alternative rock station WFNX. It wasn't a local hit, it was a hit. You'd hear it sandwiched between "Boys Don't Cry" and "Driver 8" during your morning commute. I never realized this was happening across America on other alternative stations

Burma were my heroes because they did something as impor-tant as all the storied New York or Detroit bands, and they were from my city. They were the Red Sox winning the World Series, Red Auerbach's cigar, John F. Kennedy, and the two weeks of New England fall a year that are actually comfortable and beautiful. They were name-checked,

respected, challenging, oftentimes catchy, and completely influential. "Academy Fight Song" and "Revolver" were the hits—the catchy, jangly pop songs that bit you and cast a spell—but once you dug into their catalog, you realized that these anthems were just a rather linear introduction to a very complex band. Had they moved to New York City, they might have had a storied career like Sonic Youth—but isn't that the tale of bitter Boston? Fucking New York...always cooler, better looking, more successful, and so much more arrogant. Much like Bill Buckner's ankles, guitarist/singer Roger Miller's tinnitus became a scapegoat for the band's demise. But as any true Bostonian will tell you, it wasn't Billy's error or some ridiculous curse that cost the Red Sox a world championship, there was plenty leading up to the tragedy. So they disappeared and left behind a catalog that I digested slowly from foam cov-ered headphones on class trips and later, within the hollow cement walls of my sparsely decorated dorm room.

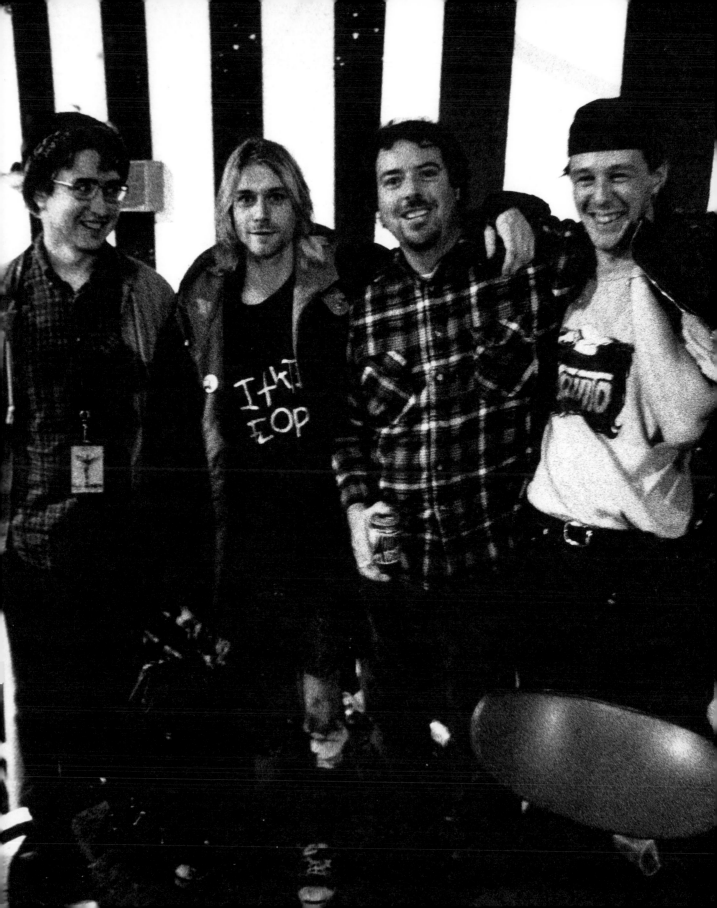

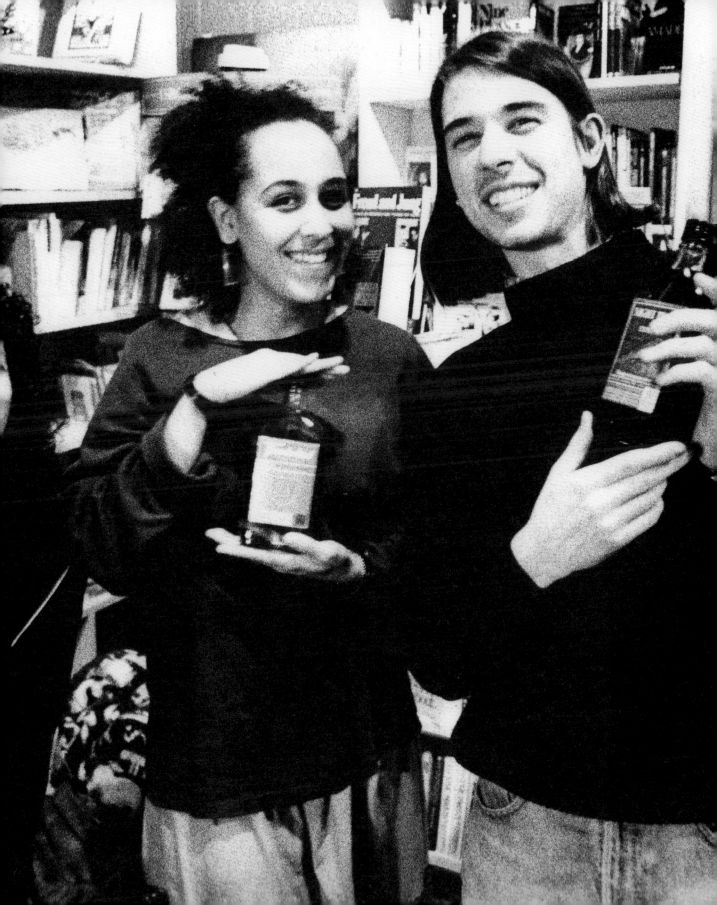

By my second semester of freshman year, I was able to get a single occupancy room due to my "allergy" problem. Rather than pollen or mold, what I was actually allergic to was my creep roommate who enjoyed watching me have sex with my alternative girlfriend while he fake-slept, a.k.a. jerked off. He didn't listen to music but owned one CD: Enya. In addition to being a complete introvert, he admitted to me that he started jogging so he could trail behind a girl he had a crush on. He'd start a few strides behind her and stare at her "perfect bottom," watching it bounce rhythmically as he kept a slow and steady Armed Forces pace behind her. After his run, he'd return to our dorm soaked in sweat, ready to clog our drain with a long "shower." I was completely over this human and played up my vicious allergies to the point of convincing my doctor to recommend that I live alone so that I could clean more regularly and get out of the moldy dormitory room that was causing me so much discomfort.

I was rewarded with a new single room that resembled a jail cell with its cinder block walls, cement floor, and single window facing a parking lot. In my cell, there were fluorescent lights, a dresser unit with a clothing rack cleverly attached to its backside and a twin bed. I provided crates of records, stacks of books, art supplies, and a hamper. It was barebones, but would only be my home for a few months. Why the fuck did people need plants, rugs, and couches for a place they would only live in for a few months? This hippie sculptor cat on my floor—who had a lazy eye and a loose ponytail that he never let down—even had a fish tank. I never understood that level of dorm decoration.

I liked how sparse my room was and the acoustics were perfectly melancholy and dramatic. My plastic stereo unit and speakers sent their thin signals to the dense cement walls, but the natural echo of the room, coupled with the lack of furnishings gave these dying transmissions a tragic depth. Stephen Patrick's lush croon became distant and even more morose; Milo's basement screams sounded more dire and bleak; and Mr. Iommi's bluesy crunch lost its depth and instead sounded like it was being pumped into a casket. This was my intentionally bleak womb. All I wanted to do was to leave the mundane 'burbs and go somewhere that had

something, anything, but I had been duped. My best friends were at home, working jobs they hated, but laughing over overbrewed coffee, while I was drowning out guys in paint covered jeans with entry-level dreads talking about Ministry while stinking of patchouli. It also snowed every Thursday that winter, heavy nor'easter snow. When I was younger, while most kids were dreaming of taking acid and watching fireworks, I dreamt of being in a city, being around music and art, skateboarding until my legs burned, and meeting new people daily. I thought this place was called Boston and Massachusetts College of Art was my gateway to city life. Unfortunately, art school is a collection of every person at your high school who was annoyingly different, like the kid who showed up one day wearing a monocle or spelling his name "Mychale," instead of his given name, Michael.

Even the upperclassmen who were into music saw me as a reflection of their salad days of punk rock: that idealistic sober kid who still wanted to buy every new record and didn't quite appreciate jazz yet. Luckily, a kind soul named Jason— who also had a Roman nose and vinyl addiction—lived in my dorm and was stuck in a similar limbo: liking art but hating artists. He played me his high school thrash band's demo. They were called Chapless Skülls, and were somewhere between Hazel, Sentridoh, and Guided by Voices. He too grew up on metal, punk, and hardcore, but like any former skate–rat college student who loved comic books, coffee, and Camel cigarettes, he found indie rock. Indie rock in the early 1990s wasn't a cute soundtrack to a car commercial about not getting a girl that you'll eventually get, it was exactly as the Sebadoh tune "Gimmie Indie Rock" wittily described: "Hardcore wasn't doin' it for me no more/Started smoking pot/Thought things sounded better slow.... Taking inspiration from Hüsker Dü/It's a new generation/Of electric white boy blues." I turned Jason onto new hardcore bands and the ones he never gave a chance, along with non-punk odds and ends from my collection. Jason peppered my curriculum with classics, currents, and bands that I feel lucky that I knew but happy I forgot. I'm sorry Grenadine, hope you aren't bummed.

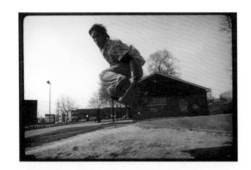

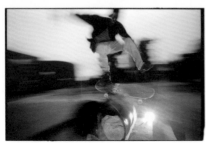

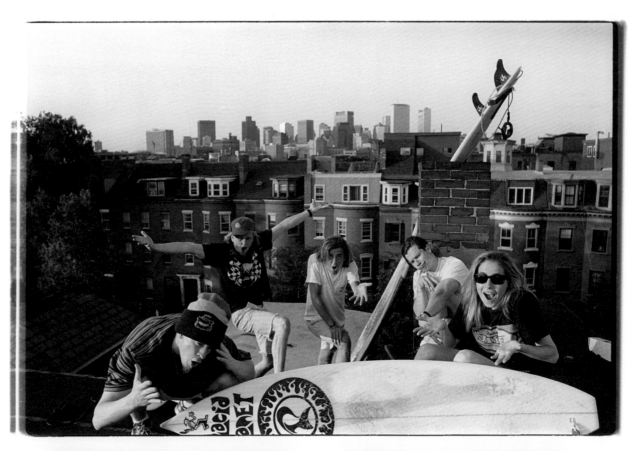

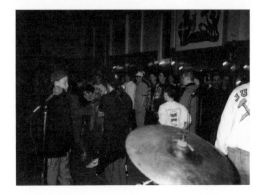

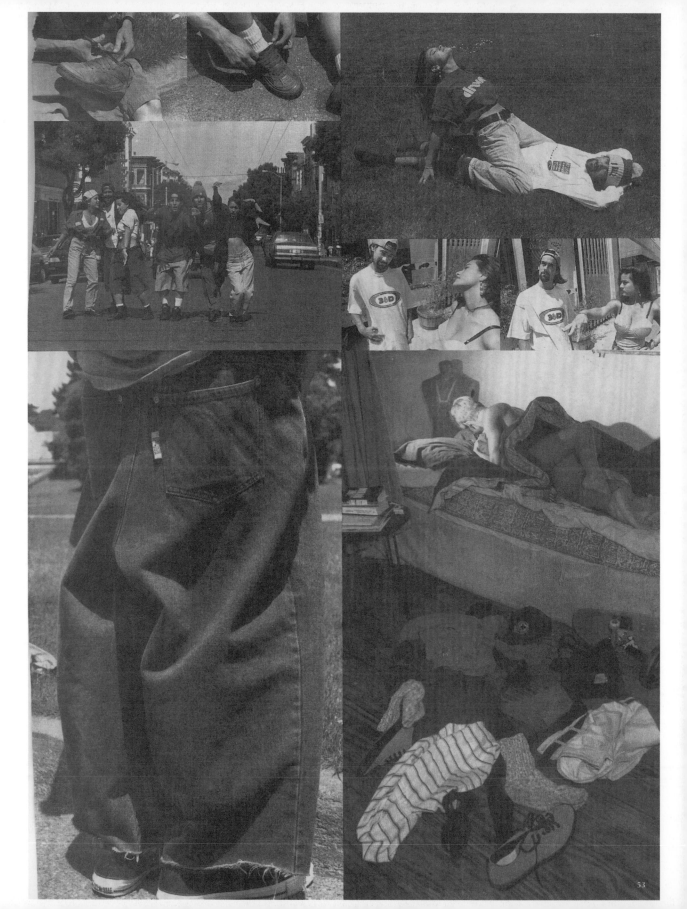

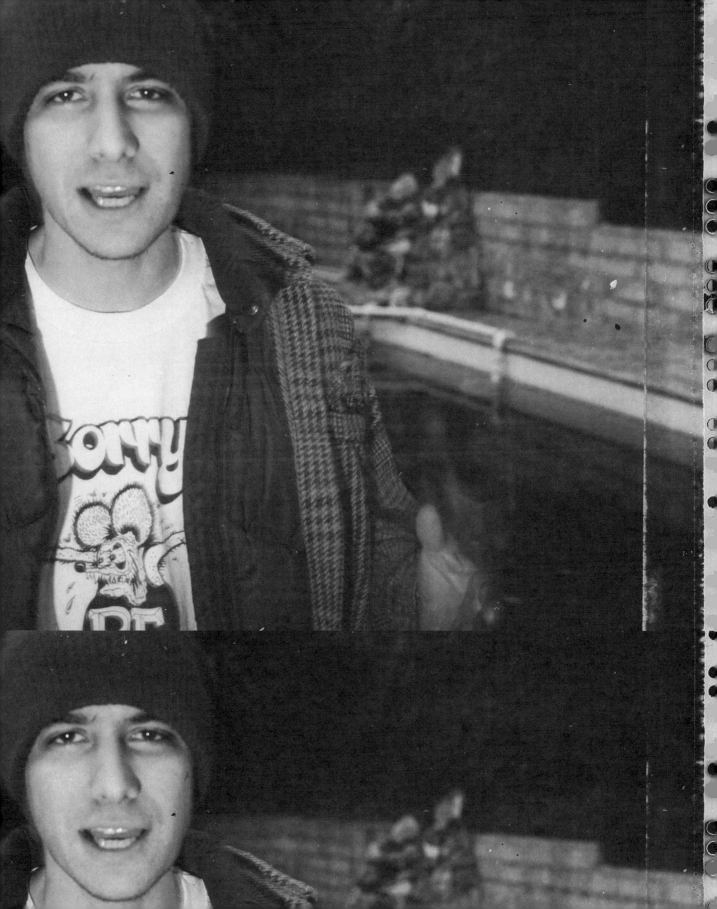

LOST ANGELS OF SUBURBIA

Max G. Morton

Bigger! Better! Suburban parents were constantly at war over these two words. From pills to pool boys; what one did, the other had to do more. Your friend went to Disney World, you drove cross-country to Disneyland. There's always an upgrade to be made in suburbia.

Bruce Lee gets phased out by Cannon Films' line of ninjas. KISS paint turns into King Diamond paint. The Farrah Fawcett obsession fades into the Traci Lords obsession. Cigarettes transform into joints which become dipped with PCP before magically morphing into syringes right before your very eyes. At some point, the rites of passage and shape-shift ritual grows tiresome and last year's Drug Free Youth die in their sleep of "natural causes" at nineteen.

By 1992, there weren't many bridges of my youth left standing. All drugs to be taken had been slammed, smoked, and snorted. All youth crew records to be traded to younger dudes for drug money had been swapped. I'd become an apartment complex magician. I played *Midnight Cowboy* in NYC more than once and had brought some culture back home with me each time, slowly trying to make my hometown more tolerable for my ultimate return when I would finally bottom out. No one cared about my souvenirs which led me to more solitary excursions.

I wanted to do something no one else was doing so naturally I did something every other peer was doing. Magically we were all on our "own" paths, thinking we were alone in a crowd. I was never *Licensed to Ill* but I went to *Paul's Boutique* at least twice a day between '89 and '92. There were three years to *Check Your Head* after becoming a regular. And in those three years a lot happened to permanently alter suburbia. It was through the hard work of these suburban psychonauts that the whole world transformed into an alternative school's smoking section.

In the midst of trying to get a mystical upgrade on my life, I somehow regressed back to my youth and all I wanted for Christmas was a leather vest like they wore in *The Warriors*. I started wearing khakis, flannels, winos, baseball hats, and was constantly armed with a Glock, a Mean Streak, and a quarter ounce of weed. All stages of the suburban life cycle require a soundtrack and '92 was producing a few classic records

a week in the hip-hop arena. Other hardcore kids were jumping around with their hands on the pump, too.

Punk had been reborn and baptized underwater chasing a dollar on a string. It was a sloppier, toned down, Clinton-supporter adult-endorsed version of the rebellion that sent my generation to rehab, jail, and the grave. It wasn't dangerous, but much like those early punk shows there was an element of the unknown that came with dealing minor league substances, hanging in the projects, and going to rap shows. We all went our way via skateboard or Impala for the next year. Robbing kids dressed like Cat in the Hat at warehouse parties with fake drugs so that we could buy real drugs and maintain our upgrade. Bigger cannons and better rims. It's funny to think how all this behavior was handed down from our parents.

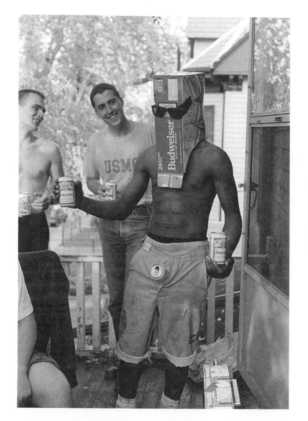

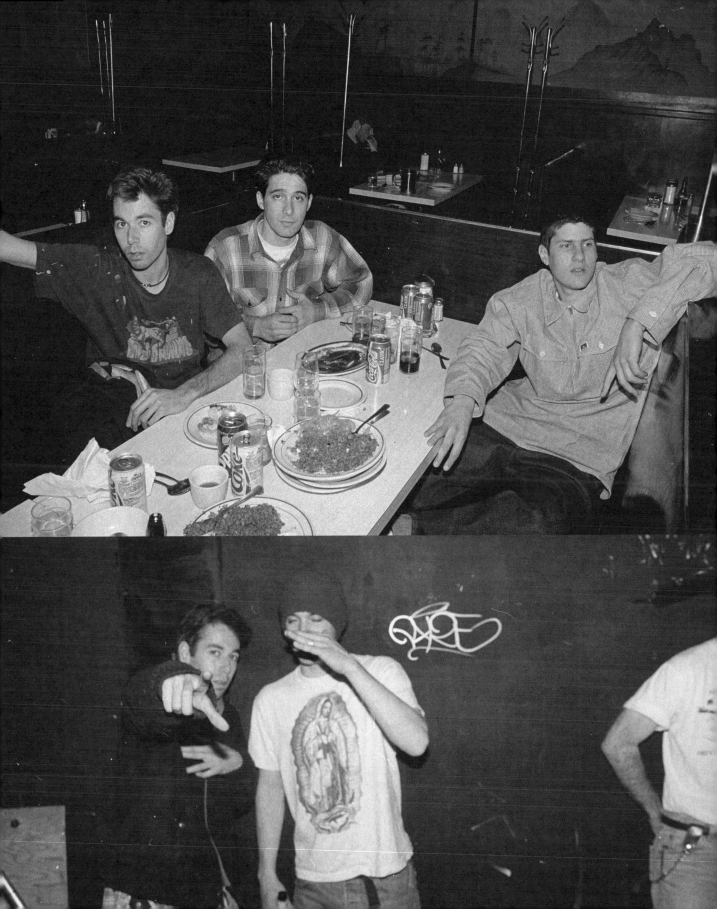

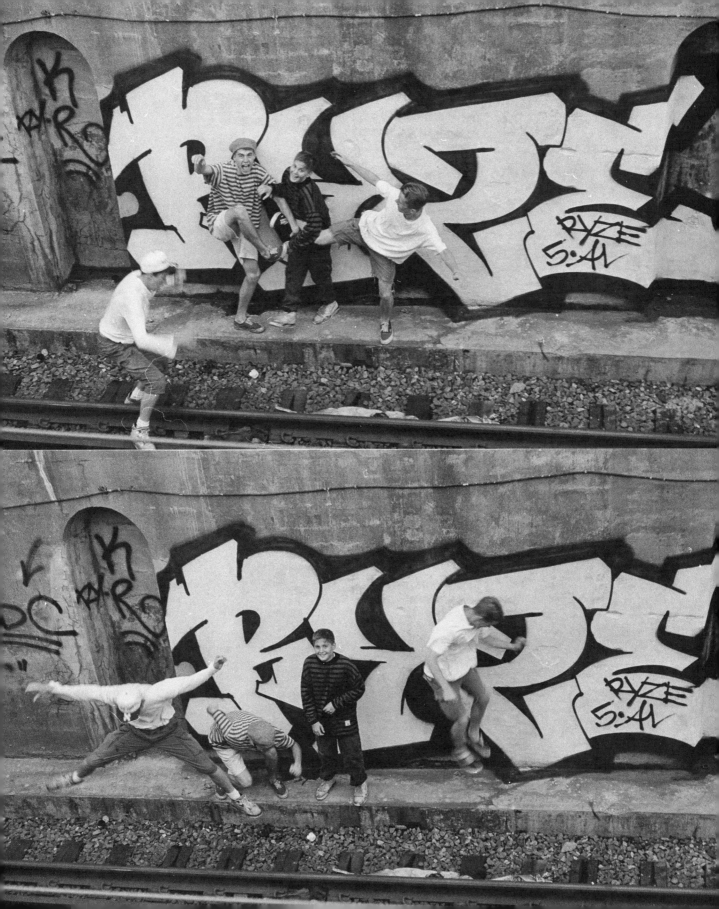

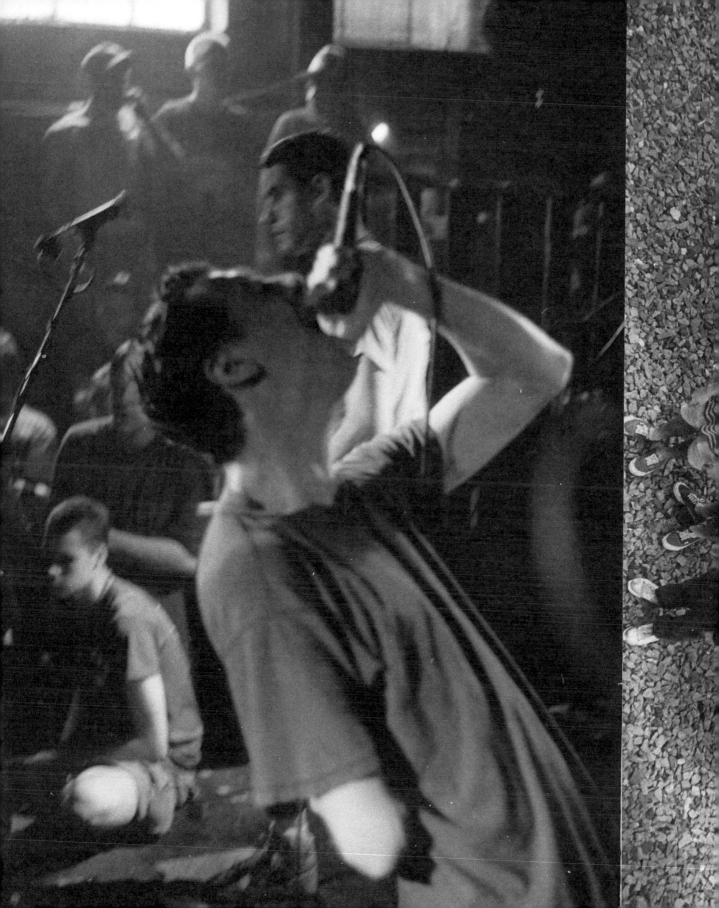

THE UNDERGROUND IS OVERCROWDED

Anthony Pappalardo

I woke up swimming in a sea of plaid, surrounded by boys with slick advertising agency hair, grounded by deck shoes. There was a sales pitch coming, I was sure of it, but they quickly spread like ants to various coffee shops to freelance. Somehow, the nerds of my youth had wired the brains of thirty-something-year-old men and *Weird-Science*'d together throngs of women wearing everything that was and wasn't cool from the 60s, 70s, 80s, and 90s, all at once. I rushed to the newsstand to see what year it was, as there were no clues around me other than a calendar date that appeared to be a misprint. Cars weren't flying and sidewalks weren't moving, so it couldn't be the future. Everything was familiar, but nothing felt real. I was sure I was just tired. What the fuck was this pop culture pastiche I was stuck in? I couldn't look anyone in the eyes as they masked their robot circuits with boisterously colored Ray-Bans and text-message focus.

A baby carriage wheeled by and the man steering it looked like a action figure. His hooded sweatshirt matched his new jeans which matched his uncreased Nike sneakers. He was just taken out of the box and had to play Dad. I counted the rings on his fingers, measured his crow's feet and knew he was older than me. My eyes were fixated on the baby's t-shirt which said "Motörhead" and had the band's violent skull logo underneath the text.

"He hates Spongebob," the father said. "Motörhead is his favorite band. He can't sit still when I play 'Ace of Spades!"

"Well yeah, it's pretty aggressive music for a..." I stammered before the baby interrupted me. Years prior, babies did talk occasionally in movies, but now that the Fox network regularly showcased sarcastic talking babies, it had become commonplace.

"I like Maiden more," the baby added.

"Me too," I replied to the baby. "I always thought Motörhead were kind of boring, actually."

"Fucking poser," the baby commented as his dad wheeled him off.

As I continued to scan walls, magazines, and humans, I noticed that every novelty from my childhood was now a movie and a sequel. All bands, dead or alive, were back together and playing festivals in deserts where they charged you for water. The food around me was either grass-fed by an urban farmer or the triple-kick-ass-fuck-you-burger. I was in New York City, but I suspected this phenomenon was spreading through America and maybe all of Earth. Somewhere, trendy Japanese teenagers were giggling at us. I was sure of it.

Suburbia was once my home, where denim sentinels guarded the arcade games I wanted to play and sold herbs and powdered prescriptions. There were two types of girl there: one wore a popped-collar polo shirt and the other a t-shirt from a rock concert I never wanted to attend. Both types hated me, so I chose to fake-hate them too. I rode a skateboard, a BMX, kept weapons in my locker, cursed a lot, liked heavy metal, didn't like heavy metal, lit things on fire, jumped off of stuff, and if anyone I knew would have surfed, I could have been a walking Black Flag lyric.

I knew my suburbia. When car stereos blasted "Hells Bells," or "Jump Around," my skateboard became a broadsword. I dodged rocks, fists, chubby-cheeked kisses, BBs, parents, and teachers. The back patch on my jacket protected me from being blindsided and showed the world the Number of the Beast. Neil Peart was the greatest drummer and Mr. Rhoads a master of the polka-dotted axe. These were actual facts, even if you hated Rush. I knew suburbia.

The athletic boys in my school had no secrets and used any holiday as an excuse to cross-dress. Girls with Aqua Net sculptures shooting from their skulls had many secrets that came out with drags of stale cigarettes and swigs of peppermint schnapps.

As a boy, all I wanted was the next vehicle that could take me out of suburbia. Anything with wheels took me another stride away until I was old enough to drive an unsafe four-cylinder automobile covered in stickers away from my fucking town forever...or at least to a college campus. Every day, I X-ed out a square on the calendar and thought about living in a city where there was every type of human and they didn't have segregated malls in which to pace. Guys would show me places to buy things they didn't have in suburbia, and girls would be impressed by the band names on my shirts and not the brand name on the tag. I didn't know shit about San Francisco, New York, or Los Angeles other than that they weren't suburbia.

Leaving suburbia was a blur. I remember learning one day that I could control Tony Hawk with a joystick and that KISS wore makeup again. Straight edge men threw baseballs and wrestled on television. The one-dollar bill had a Crimson Ghost on it. No hardcore record had sold a million copies but every dorm came with a copy of *Check Your Head*.

In the present, Cyndi Lauper rang up my groceries. A man who was once kicked out of every skate spot and punk show for being annoying designed propaganda that aided the election of our current president. All the humans I wanted to meet as a suburban teenage boy in the late 1980s had become franchises in my hometown mall. The convenience was great but still confusing.

I ran into an old friend in a bodega as I tried to purchase some water. Even water was cool: it took me a while to find a regular bottle and I felt old fashioned.

"Poland Springs?" he questioned. "Who the fuck drinks that anymore? What is this, nineteen eighty..."

My choice triggered something in his brain. He asked me why every activity that got us beaten up in suburbia was now a career. Flashes of awkward fashion, questionable hobbies and fads raced through my brain. The bandana Saturdays in the mall, loudly cursing radio trips to splintered skateboard ramps, and basement heavy metal seances that once drove us further from rural normalcy now were comical, admirable, and fashionable all at

once. I couldn't answer him, but I knew the underdogs won and were abusing their power. The villain of *Reality Bites* invested his money in energy drinks and became a hero. He made our youthful dreams real with minimal work and a corporate budget. Slackers had lost and been eradicated. They disguised themselves with conviction and integrity, but the new decade exposed them as truly lazy and stubborn. It was impossible to be lazy now, as ideas were commodities and cool a currency. Nostalgia could be downloaded to a mobile telephone and stashed safely in our pockets while we checked the weather and the stock market and moved forward into the past.

I took a snapshot of 2011 with an actual film camera and buried the print in the ground an hour later. Bob Dylan, the full cast of *Less Than Zero* and *Beat Street*, James Hetfield, Juliana Hatfield, Andy Warhol, Woody Allen, and a homeless man were all in the picture doing boring everyday things. Someday someone will find it and not know what fucking year it is. They'll just know that it's not suburbia.

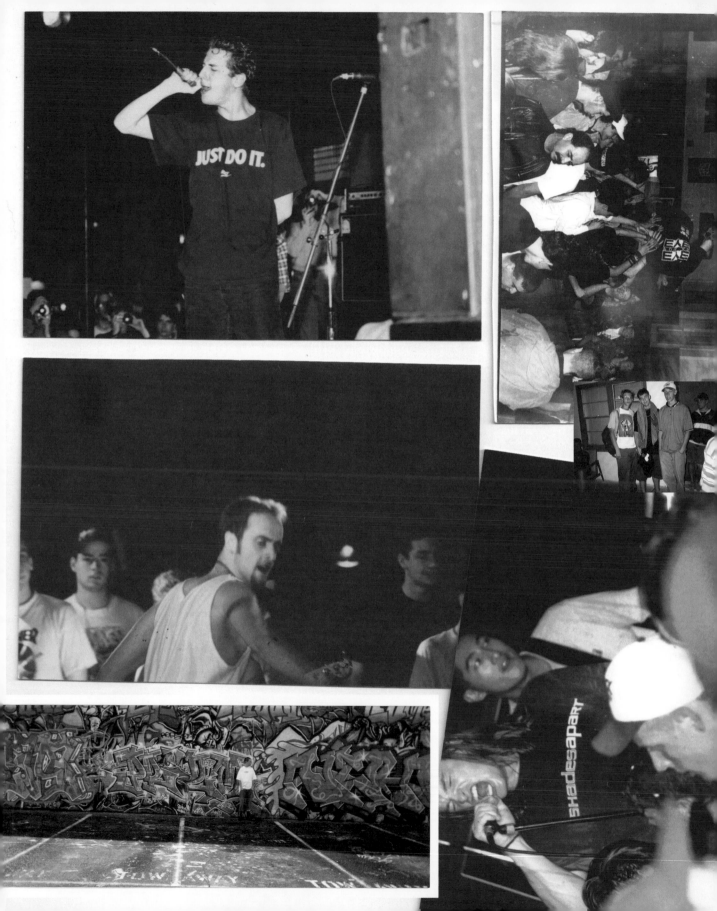

PHOTO CREDITS

Aaron Malejko

Adam Souza

Al Barkley

Al Quint

Alex Barreto

Andy Jenkins

Angela Boatwright

Anthony Venticinque

Bob Franko

Boyd Rice

Brett Barto

Brian Ploetz

Brian Ryder

Bridget Collins

Casey Chaos

Casey Jones

Chris Kelley

Chris Minicucci

Chris Shary

Dan Altieri

Dan Zimmerman

Danielle Edson Pierce

Darren Walters

Dave Brown

David Wasnak

Davo Scheich

Drew Stone and the Stone Films NYC archive

Ed Walters

Eric Ricks

Eric Swisher

Erik Brunetti

Eva Talmadge

Ezra Martin

Frank White

Fred Hammer

Gail Rush

Gary Vincent and The American Classic Arcade Museum

Geoffrey Kula

George Savas John

Gibby Miller

Guav

Harald Oimoen

Howie Abrams

Howie Pyro

Jason Farrell

JJ Gonson

Jeff Terranova

Jeffrey Colwell

Jesse Caldwell

Jimmy Policastro

John Lacroix

John Porcelly

Jon Roa

Josh Luf

Julianna Ness

Justine Demetrick

Kelly Maxey

Kenneth Gibbs

Kevin Egan

Kevin Hodapp

Kim Baskinger

Larry Ransom

Lissi Erwin

London May

Mark Maxey

Mark Ryan

Marnee Resnikoff

Marti Wilkerson

Matt Henderson

Matthew Jay Landon

Michael Galinsky and rumur.com/malls

Mike and Randy Slipped Disc – slippeddiscrecords.com

Mike Bell

Mike D'Amico

Mike Down

Mike Gowell

Mike Martinez

Nathalie Shein

Nick Zinner

Noah Butkus

Otis Ball

Patrick West

Peter Morcey

Rachel Tarmy

Ray Lemoine

Ron Grimaldi

Rusty Moore

Ryan Martin

Ryan Murphy

Ryan Richardson

Steve-O

Sammy Winston

Shaun Ross

Shawn Leahy

Steven Hertz

Tim McMahon

Theresa Kelliher

Thomas Dupere

Traci McMahon

Trevor Silmser

World Industries